Scenes from the Revolution

Scenes from the Revolution

Making Political Theatre
1968–2018

Edited by
Kim Wiltshire and Billy Cowan

EDGE HILL
UNIVERSITY PRESS

and

First published 2018 by Pluto Press
345 Archway Road, London N6 5AA
www.plutobooks.com

and

Edge Hill University Press (EHUP)
Department of English, History and Creative Writing
St Helens Road, Ormskirk, L39 4QP
www.edgehill.ac.uk/university-press

British Library Cataloguing in Publication Data
A catalogue record for this book is available from the British Library

ISBN 978 0 7453 3852 1 Hardback
ISBN 978 0 7453 3851 4 Paperback
ISBN 978 1 7868 0336 8 PDF eBook
ISBN 978 1 7868 0338 2 Kindle eBook
ISBN 978 1 7868 0337 5 EPUB eBook

This book is printed on paper suitable for recycling and made from fully managed and sustained forest sources. Logging, pulping and manufacturing processes are expected to conform to the environmental standards of the country of origin.

Typeset by Stanford DTP Services, Northampton, England

Simultaneously printed in the United Kingdom and United States of America

For Jamie – BC

For the Bailey Boys – thanks for all the love and support – KW

Contents

Introduction

A VERY BRIEF HISTORY OF POLITICAL THEATRE IN THE TWENTIETH CENTURY UP TO 1968

Kim Wiltshire and Billy Cowan

There has always been theatre that is political. An argument often put forward by theatre-makers is that all theatre is political because in some form it holds a mirror up to the society in which it is created. That may to a certain extent be true, but there is of course theatre that is specifically political; theatre that looks at issues and asks the audience to think further about those issues. Theatre that uses forms and ways of working that build on what has gone before, whilst subverting ways of working that actors, directors and writers have got used to over the 2,500 years since the dithyramb first produced a theatrical scene. Political theatre companies have in the past experimented by using collaboration and cooperation, by taking socialist or communist ideals and applying these to the way they created theatre, and this concentration on form and ways of working can also be classed as political theatre, regardless of the subject matter (although very often the subject matter is also political). Then there is theatre that is made by, about and for certain groups of people – those who are not male, not white, not straight. By focusing on the issues that affect these groups, the theatre-makers create political theatre through a critique of the status quo.

These are the types of theatre and the theatre-makers we are exploring in this book. These are political theatre-makers.

Over the past 50 years there have been many, many theatre-makers and theatre companies who might fit this description. Of course, not every one of these can be included in a book like this. Catherine Itzin, in 1981, attempted a survey of all the political theatre companies from 1968–80, whilst John Bull and George Saunders have edited a three-volume collection that surveys a range of 'alternative' theatre companies from between 1965 to 2014, considering their work from Arts Council England documentation. These books make the brave attempt to include as many theatre companies as possible. However,

when creating a book about political theatre, editors and writers have to make decisions about which companies to include and which to leave out. Questions have to be asked about a company's remit and objectives, about the body of work produced. Sometimes the size and longevity of the company, the reach and the influence of a company's work, has to be considered. To document and survey the political theatre landscape over 50 years would be a near impossible task without making some of these decisions. And as there are texts attempting this, there is no point attempting to do a similar job.

Also, it was never our intention as editors for this book simply to list a range of theatre companies who did something political once. Instead, we wanted to create 'scenes' from political theatre past and consider what they might mean in the present. Our aim is to highlight a few companies who have made, continue to make or are beginning to make political theatre, and hear their stories, their ideas and their considerations about whether political theatre still matters, still exists or is even still relevant in the modern world.

To do this, we looked at six areas of theatre-making (agitprop theatre; working-class theatre; theatre in education; women's theatre; queer theatre; and theatre and race) and considered which theatre companies we would concentrate on for those sections. We chose companies we believe have had a major impact on the political theatre world, often by being the first of their kind. We also considered whether the theatre companies and/or founding members were still making theatre in some way today. We researched extracts of their early plays, in some cases interviewed those early theatre-makers, alongside those who are still working in the theatre companies now, and we commissioned academics who research political theatre and current theatre practitioners to write about how and why political theatre is still relevant. These 'scenes' work to create a scrapbook that builds a picture of political theatre then and now, giving students of theatre, those interested in political activism through the arts, and those who are simply interested in the social history of political theatre an introduction, a sense, a taste of what it was all about – and why it is still relevant.

Why Start in 1968?

1968 was a year of great political change across the Western world. It was the year of protest, people power and pleas for peace. The war raged

in Vietnam, while many Americans had no idea why their country was involved. In Paris the students marched against capitalism and what they saw as American imperialism, marches that were swiftly followed by a series of general strikes. The Biafran War reached a stalemate and those in the West were confronted with harrowing images of starving Nigerian children, and urged to send what they could to help. The Prague Spring saw the Soviet Union invade Czechoslovakia. Robert Kennedy was assassinated in the US, and US athletes Tommie Smith and John Carlos gave Black Power salutes as they stood on the podium to receive the gold and silver medals for the 200m sprint at the Olympics in Mexico. In the UK, whilst Enoch Powell made his infamous 'Rivers of Blood' speech,* abortion was legalised, and – only the year before – the Sexual Offences Act 1967 legalised homosexuality.

Another, much more minor – but for our purposes, no less important – event also happened in the UK during this year. The Theatres Act 1968 abolished censorship in theatre. Since 1737 the Lord Chamberlain had wielded power over which plays could and could not be legally performed on the British stage. Each new play had to be scrutinised by the censor before it could be produced. The removal of this power allowed a range of theatre-makers to create new types of theatre, devising and writing plays that could attack the status quo politically, plays that would no longer have to be approved by government to be produced. This change to the way theatre could be made had a profound impact on young writers, directors, producers and actors at the time, and over the next few years a wide range of new theatre companies sprang up across the country. And, as Catherine Itzin puts it, 'this was the period when the war babies came of age – including "products" of the 1944 Education Act which had opened the doors of higher education to the working class.'[1] All of this created a crucible for new and exciting theatre to be made, theatre that went to the people, that asked questions of the state and the political world and was created by theatre-makers who were not 'just socially committed, but committed to a socialist society. They were the writers of agitational propaganda and social realism, who had not and who probably would not "sell out" or be sucked in by the establishment.'[2] It was a time of political upheaval, a sense of change hung in the air, and those who advocated for active political protest could use art and theatre as a way to get their message out to more people.

* The full speech can be found here: https://tinyurl.com/yaqzg2cf

Pre-1968 Political Theatre

Of course, political theatre did not just happen in 1968. As the range of historic events listed above highlights, the rise of political theatre usually coincides with major social, cultural and political upheavals in the 'real' world, and one of the most significant events to have an impact on political theatre, and indeed on every aspect of the industrialised world in the twentieth century, was the Russian Revolution of 1917, and the rise of Marxism and communism across Europe that followed. This had a great effect on many theatre practitioners, including two of political theatre's most influential innovators: Erwin Piscator and Bertolt Brecht.

In the context of post-World War One Germany, and the rise of fascism, it is not surprising that artists such as Brecht and Piscator were looking to alternative ideologies such as Marxism, which offered 'solutions' to the cycle of war and tyranny that seemed to grip Europe. Influenced by his reading of Marx, Brecht also believed that German theatre was too bourgeois and no longer capable of exploring the complexities of modern life. His solution was to create a new type of theatre, based on Piscator's film montage theory, that 'rejected linear narrative in favor of seemingly disassociated scenes, of which spectators had to make sense in much the same way as they make sense of cuts, dissolves, and flashbacks in film'.[3] For theatre to be relevant and powerful as an instrument for social change, Brecht believed audiences needed to be able to respond to the ideas put in front of them intellectually and not emotionally. The aim of theatre was therefore not to create emotional catharsis for the audience, as in the theatre of Ancient Greece, which since the Renaissance had been the benchmark for all dramatic form, but to allow them to respond rationally. To this end, he developed what became known as 'epic theatre' borrowed from Piscator's idea of 'the text of the play disclosing its socio-political circumstances'.[4] This epic theatre also borrowed some technical innovations from Piscator, such as the use of film-clips and still images, and agitprop devices such as the use of placards to disrupt narratives. Brecht was also interested in popular culture and incorporated song and dance, cabaret-style performance, circus and vaudeville into his 'epic' narratives. All of these techniques were later adopted by many of the political theatre companies that came after him, including many of the post-1968 companies discussed in this book.

In the UK during the 1930s, Brecht's and Piscator's influence as well as Marxist ideology extended to the political theatre of the Workers'

Theatre Movement (WTM), a national network of various agitprop troupes and companies, which was initially set up in 1926. Allied more with communism than socialism and the Labour Party, the WTM's task was spelt out in the February 1932 edition of their official magazine, *Red Stage*:

> Our task is to bring the message of the class struggle to as many workers as possible. When we want to reach the masses it is not enough to wait until they come to us or call for us. We have to go there where the masses are: in meetings, in workers' affairs, on the streets, at factory gates, to parades, at picnics, in working-class neighbourhoods. That means we must be mobile.
>
> Our organizational structure, our plays, the form of our production must be such that we are able to travel with our production from one place to another, that we are able to give the same effective performance on a stage, on a bare platform, on the streets.
>
> We cannot wait or look for a ready-made style for our new theatre; we have to develop the style of the workers' theatre by bringing it in conformity with its tasks and its means of expression.
>
> The organizers, players, writers, and directors of workers' theatres are workers, the audiences are workers. Both are not prepared by a long literary and cultural education, which is only available to the members of the bourgeois class who have the leisure and the money for it.
>
> Worker players are not able to express, and worker audiences are not able to understand, complicated structures of ideas and refined intellectual language.
>
> The workers' theatre plays must be simple, so that workers can produce them and workers can understand them. Simplicity, however, does not mean crudity, does not mean absence of art.
>
> On the contrary: the more artistic our productions are, the more effective they are, and the more efficient is the political education and propaganda we carry.[5]

Although the WTM was short lived, ending in about 1935, many important political theatre practitioners and companies grew out of the movement, the most significant of these being Joan Littlewood, Ewan MacColl and London's Unity Theatre.

MacColl, a writer and poet, was creating street-based agitprop theatre in the streets of Salford and Manchester with a company called the Red Megaphones. Littlewood, who had come up to Manchester from London as an actor for BBC radio, met MacColl in 1936, and together they created the Theatre Union. In these pre-war years they worked on a range of agitprop theatre work, often creating what they called 'Living Newspapers'. These shows were often performed in the street; indeed, in 1940 the police halted a performance and the pair were bound over for two years for breach of the peace. This work set the foundation for their future collaboration.

Following World War Two, Theatre Union changed its name again to Theatre Workshop, and began touring extensively across the country. In 1953 the company moved to what would become its permanent home, the Theatre Royal, Stratford East, an almost derelict building that the Theatre Workshop members had to rebuild themselves. Littlewood and MacColl, who had written many of the early plays, went their separate ways (with MacColl becoming more famous as a folk singer and father to 1980s pop star, Kirsty MacColl, while the Theatre Workshop continued to work in Littlewood's distinctive style). The company's most famous plays – Shelagh Delaney's *A Taste of Honey, Fings Ain't Wot They Used T'be* (a musical written by Lionel Bart) and, of course, *Oh! What A Lovely War* – all had political messages, all had working-class heroes and asked the audience questions about their community, their society, and what that community valued. So the question might be asked, how did the work post-1968 differ from the type of work Littlewood was already doing? As Itzin comments, '[a]ll theatre is political. But the significant British theatre of 1968–1978 was primarily theatre of political change.'[6]

Littlewood always had to look to the establishment to get her messages across, because she and her theatre company had to make money. *Fings Ain't Wot They Used T'be* had a very successful West End run, and both *A Taste of Honey* and *Oh! What A Lovely War* were made into films. Her work of course carried political messages, but as she perfected her theatre-making style she began to focus less on 'political change' and more on 'theatrical change'. Of course, it can be argued that this widening of the audience spread the political message further, that it inspired young theatre- and film-makers to create work that was more socially grounded and politically active. And it can also be argued that without Littlewood, theatre-makers like Shelagh Delaney, Brendan Behan and a range of actors famous in the 1960s and 1970s would never have had the

success they went on to achieve. Littlewood set up a political ethos to theatre and a new way of working, collaboratively, experimentally and thinking always of audience experience, that changed the usual writer/director duality of power. It was political theatre, but not necessarily theatre of political change – it served to highlight, not change policy.

Growing out of the Workers' Theatre Movement, London's Unity Theatre, formed in 1936 by the Rebel Players, was one of the most influential political theatre companies to produce work throughout the post-war years up until circa 1975, when a fire seriously damaged their premises on Goldington Street near St Pancras. For over 40 years they were the premier venue for hosting and producing some of the most important political, working-class plays of the era, and giving a platform to some of the most political new work from both British and international writers. In 1938 they produced *Waiting for Lefty*, 'a landmark in the history of left-wing theatre'[7] by the American writer Clifford Odets, which was about a group of New York cabbies who go on strike 'to get a living wage' when their leader, Lefty Costello, is shot. They also presented the first Brecht play in the UK with *Señora Carrar's Rifles* (1938) and British premieres of Sean O'Casey's anti-fascist play, *The Star Turns Red* (1940), Jean Paul Sartre's *Nekrassov* (1956) and Brecht's *Mother Courage and her Children (1958)*. In the late 1960s and early 1970s, Unity Theatre became an important venue for the alternative theatre movement, and this is where Roland Muldoon, Claire Burnley (later Muldoon), Ray Levine and David Hatton set up CAST (Cartoon Archetypal Slogan Theatre).

CAST is often acknowledged as the first agitprop theatre company, although Muldoon described it more as 'agitpop'.[8] CAST used a range of theatrical techniques, such as comedy and satire, to explore the culture and counterculture of the times they were living in. Using the archetypal character of 'Muggins' in many of their plays, 'the early CAST aesthetic was developed through collective improvisation: a style developed for the public meetings and working-class social clubs that were the group's venues.'[9] They became part of the rock and roll lifestyle of the 1960s, looking into the audiences' faces and bridging the gap between theatre-maker and theatre-viewer, with a standard Everyman central character that offered immediate recognition and allowed the political message to come across in an uncomplicated, direct manner. In his exploration of CAST, Bill McDonnell defines four periods of the company:

The first, 1965–1971, was the highpoint of the company as a feted guerrilla troupe, mixing experimental and agit-prop forms to produce a distinctive, hybrid aesthetic. The second, 1971 to 1974, was a period of splits and reformations in which, for a while, CAST lost their way, distracted by their counterculture celebrity. Rebirth came in 1975–1976 in the form of Arts Council subsidy, and lasted until 1979. This year would mark another watershed presaging the slow phasing out of touring shows and […] took the company in a new direction […] in their stewardship of Hackney Empire, 1986–2005.[10]

CAST effectively stopped touring in 1979, although the Muldoons continued to make work and, as McDonnell highlights in the quote above, moved towards thinking about what they termed 'new variety' as being political entertainment – a venture they still work on today, organising comedy tours and gigs that run alongside Labour Party activism.

Building on the work of these earlier companies, often with a socialist message and heavily influenced by Brechtian methods and ideals, the change in censorship law allowed new companies to form, companies that would use theatre and art as a form of direct political activism, finding new ways to work and new messages to take to new audiences.

The Companies and Theatre-makers Explored in this Book

As mentioned above, this book is divided into six sections looking at key areas of the alternative theatre movement since 1968: agitprop theatre; working-class theatre; theatre in education; women's theatre; queer theatre; and theatre and race. In each section we have endeavoured to focus on one key company that existed in those early post-1968 days and invited current companies, theatre academics or practitioners working in those key areas today to talk about their work and experience. We've chosen companies who are recognised as key players in their particular field by scholars and theatre practitioners. No value judgement has been made on the quality of their work compared to other companies that we have not had the space to explore fully here. We simply looked to companies we believe complement each other in the range and breadth of their work.

Within each section we have also chosen to publish an extract of an unpublished or out-of-print play to give a flavour of the type of work these early companies were creating. For the agitprop section, we have

chosen an extract from *Apartheid: The British Connection* by Kathleen McCreery, a founding member of Red Ladder, who later went on to found Broadside Mobile Workers' Theatre, who produced this play. The piece explores the British response to apartheid in South Africa during the 1970s, followed by an exploration of South Africa's form of political theatre, known as protest theatre, by South African playwright and academic David Peimer and completed with a piece by Rebecca Hillman on why agitprop theatre can still be relevant to today's political theatre-makers.

The political nature of *Apartheid: The British Connection* contrasts nicely with the work of John McGrath, who we've chosen to explore in the working-class section. Many of McGrath's plays are well known. However, we have chosen to concentrate on a play called *Blood Red Roses*, originally written for 7:84 Scotland and adapted for an English audience in 1982. Bob Eaton, who directed this production of the play at the Liverpool Everyman, gives a sense of that moment in time in Liverpool and how this was a personal 'micro' story that highlighted the larger social issues of the period. This is followed by an essay by playwright Lizzie Nunnery, who contrasts the themes of her own work on *The Sum* and her growing exploration of political theatre with a capital 'P', linked to McGrath's plays, especially *Blood Red Roses*. The section ends with an essay by Lindsay Rodden who considers what the future of theatre might have looked like if all theatre-makers adhered to McGrath's theatrical ethos.

In the Theatre in Education (TIE) section, we publish an extract from *Farewell to Erin,* a piece devised by Belgrade Theatre in Education Company in September 1979 for junior school pupils. The play is set in nineteenth-century Ireland and deals with land-ownership and Irish emigration. It exemplifies the kind of TIE participatory event that actively engaged children in learning by allowing them to enter into genuine dialogue, negotiation and debate at key moments in the play. This extract is supported by an interview with Justine Themen, who runs Coventry Belgrade's TIE department, and Tony Hughes, one of the original members of M6 Theatre Company – a company that has been at the forefront of TIE and theatre for young audiences for over 40 years. Julia Samuels from Liverpool's 20 Stories High also gives us an insight into how the company creates exciting and political work with young people today.

The extract from the Women's Theatre Group is called *Work To Role*, and is an early example of the type of consciousness-raising theatre

(similar to TIE plays) that was taken into schools during the 1970s. This play aimed to explore with schoolgirls the realities of the world of work that was waiting for them when they finished school. The work of two women-centred theatre companies, Clean Break, who were formed in the 1970s, and Open Clasp, a slightly newer company, is also explored and the question of whether women-centred theatre is still relevant today is considered by theatre-makers Anna Hermann, Catrina McHugh and Jill Heslop.

Although we focus on Gay Sweatshop in the queer section, we decided to publish an extract of a General Will play, *Men*, by Don Milligan and Noël Greig, which was produced in 1976. This play is typical of many 'gay' plays from that time that looked at life in the closet. What makes this special is that the protagonist, Richard, a closeted homosexual, is also a trade unionist and the play, according to Milligan, explores 'the tension between the emancipation of homosexuals and the more tradi- tional concerns of the labour movement'.[11] This is complemented with an essay from Chris Goode about queer theatre and interviews with Ruth McCarthy, artistic director of Outburst, and Julie Parker, formally of the Drill Hall, London, who discuss LGBTQ theatre, then and now, and what it means to them.

Finally, in the theatre and race section we have an extract from *Tainted Dawn* by Sudha Bhuchar, who founded Tamasha Theatre Company, and who speaks about her experiences as a theatre-maker from the 1980s onwards. This section is introduced by May Sumbwanyambe, who explores his (and an audience's) relationship to mainstream 'white' theatre and stories. Finally, Jingan Young considers, through an explo- ration of her theatre company, Pokfulam Road, the political stance theatre-makers of British East Asian origin have to take against the mainstream theatre world.

Special Thanks

The editors would like to acknowledge a considerable debt to Susan Croft and Jessica Higgs, and all the contributors to the Unfinished Histories project, which has set about recording the history of British Alternative Theatre, 1968–88. The wealth and breadth of valuable archival information and materials gathered here is extraordinary, and has helped considerably in the writing of this book. Catherine Itzin and her book *Stages in the Revolution* supplied the original source of research

material, and we would also like to thank Lyn Gardner, whose article '1968: Year Zero for British Theatre' was the inspiration for the book. We would also like to thank all at Edge Hill University, especially the student interns who worked so tirelessly on the book, the Corporate Communications team and the Creative Writing team who supported us along the way. Finally, thanks go to all at Pluto Press, but especially our editor, Anne Beech.

NOTES

1. Catherine Itzin, Stages in the Revolution: Political Theatre in Britain Since 1968 (London: Methuen Publishing Ltd., 1980) p. 2.
2. Ibid., p. x.
3. Carol Martin and Henry Bial, eds, Brecht Sourcebook (London: Routledge, 2000) p. 2.
4. Ibid., p. 2.
5. 'Workers Theatre Movement', Working Class Movement Library, viewed 4 March 2018, from https://tinyurl.com/ybgg2fgn
6. Itzin, Stages in the Revolution p. x.
7. 'Political Theatre in the Early 20th Century', Victoria and Albert Museum, viewed 4 March 2018, from https://tinyurl.com/lk3rlh9
8. Itzin, Stages in the Revolution, p. 14.
9. Bill McDonnell, 'CAST', British Theatre Companies: 1965–1979, edited by John Bull (London: Bloomsbury, 2017) p. 124.
10. Ibid., p. 122.
11. Don Milligan, 2017, email, 20 December.

Prologue

Lyn Gardner

1968 was a momentous year. It was the year of the Prague Spring and the Soviet invasion of Czechoslovakia, the year of the Tet Offensive which contributed to growing protests against the Vietnam War in the US – and in the UK, where the Grosvenor Square protest ended in violence.

It was also the year in which the Civil Rights movement gathered pace and Martin Luther King was assassinated. Meanwhile, the crushing of civil rights protestors in Derry in Northern Ireland marked the start of what would become known as 'The Troubles'.

Valerie Solanas shot Andy Warhol in the US; in England, Enoch Powell made his 'Rivers of Blood' speech; in Germany, the Red Army Faction placed their first bomb; and French students took to the streets of Paris in support of striking workers.

Change was in the air, and British theatre was changing, too. Censorship had just been abolished, giving artists the freedom to write and say what they wanted on stage. Numerous small theatres and spaces sprang up, from Jim Haynes' Drury Lane Arts Lab to Thelma Holt and Charles Marowitz's Open Space Theatre in Tottenham Court Road.

Ed Berman founded Inter-Action, which brought theatre and participatory arts projects to London's disadvantaged, and a group called the Agitprop Street Players—two years later changing its name to Red Ladder—began performing at political demonstrations and tenants' association meetings.

Over the subsequent decade, British theatre was to change out of all recognition as fresh theatre spaces were colonised and bold new companies appeared, including Welfare State, Pip Simmons Theatre Group, Belt and Braces and 7:84. The latter was the touring Scottish company founded by John McGrath that took theatre to local communities in the back of a van and which took its name from a stark statistic published in *The Economist* that 7 per cent of the population in the UK owned 84 per cent of the country's wealth.

By the late 1970s there were numerous new companies including the Women's Theatre Group, Monstrous Regiment and Gay Sweatshop, all interrogating contemporary life with restless vigour as they questioned existing hierarchies, scrutinised inequality, probed at issues around gender and work and domestic labour, and challenged the inequalities of capitalism.

The work was often made using techniques devised by companies who rejected the traditional structures of theatre. It frequently drew on agitprop and popular forms of theatre, including song and dance. It ensured that audiences – many of whom thought theatre was not for them – were guaranteed what John McGrath called 'a good night out'. Almost all these companies worked outside British mainstream theatre, and while many benefitted from funding from the Arts Council, they were never afraid of biting the hand that fed them.

1956, when John Osborne's *Look Back in Anger* landed on the Royal Court stage, is often cited as the moment when modern British theatre began. But many of the theatre-makers of today owe more to the collective experiments of the class of 1968 and their offspring than they do to the railings of Jimmy Porter and the later angry young men of British theatre.

The alternative theatre-makers of the late 1960s and 1970s were no less angry, but instead of whining about it from their on-stage armchairs as Jimmy Porter did (while his wife, Alison, did the ironing), they were actively trying to bring about change. That manifested itself not just in the theatre they made and in its form, but also in how they made it, and the way in which they engaged with audiences.

The irony is that in 1968, Osborne, once hailed as the great radical playwright, was premiering a new play at the Royal Court. Now barely remembered, that play was called *Time Present* and took the form of a drawing-room comedy set amongst the theatrical glitterati and the upper classes of the kind that *Look Back in Anger* was supposed to have killed off forever.

The history of British theatre is often, like any history, a narrative told by the dominant – in this instance, those playwrights who followed in the footsteps of Osborne and who found it relatively easy to push at the doors of the theatre establishment and its buildings. Those doors swung wide open, as they forged highly successful careers writing state-of-the-nation plays. It is no surprise: British theatre has long been text-bound, and it is always easier for a theatre building to respond to the script that

lands on its desk than the great idea that requires two weeks R&D in a rehearsal room to see if it has legs.

It was these state-of-the-nation playwrights such as David Hare, Howard Brenton and David Edgar (all white men) who defined what political theatre was for many years to come until the arrival of Sarah Kane, Mark Ravenhill and others in the 1990s.

But significant numbers of theatre-makers from much more diverse backgrounds have in recent years been reimagining political theatre with shows that in form and practice owe more to the late 1960s pioneers and their practice rather than the British play-writing tradition.

This more recent work sometimes proclaims itself loudly on the big stages in flagship institutions, but is more often to be found operating on the outside rather than the inside, and in non-traditional spaces. It is not always participatory, but it almost always understands the difference between theatre that is made for an audience and theatre that is made *with* an audience.

It sometimes takes the form of a play, but often doesn't, and it constantly asks what is it that theatre might be, even as it questions the function and purpose of theatre in the early twenty-first century, and reflects on the state we are in and the world we want to dream.

Speaking in 1976, Welfare State's co-founder John Fox, said: 'It is possible, I think, in the West now, still to make a concrete alternative.' Today's theatre-makers are still trying.

Scene 1
Agitprop and Political Theatre

INTRODUCTION

Kim Wiltshire

There is theatre that is political because it is addressing something new that has not been addressed before – theatre by women, for women, about women, for example – and there is theatre that is agitational, that takes an issue and works with those who live with the issue in an attempt to create change. This type of theatre is often known as agitprop. As Catherine Itzin puts it, 'AgitProp was formed for "the application of the imagination to politics and the application of politics to the imagination."'[1] Agitprop may at times overlap with other types of political theatre, theatre that might not necessarily agitate for change but perhaps tackles political issues with a different theatrical focus. Often, as the needs of the society and community around those theatre companies change, different ways of working may be explored and borrowed, and so agitprop comes in and out of fashion, in the cyclical manner of many theatre trends. However, there is something very specific about the early work of companies like Red Ladder and Broadside Mobile Workers' Theatre that highlights what making agitational propaganda theatre means.

One of the differences, as a theatre company, that Red Ladder brought to agitprop was that the group of people who started the company were not necessarily theatre-makers, but rather saw themselves as political activists who used a range of creative and direct-action activities to get their messages across. The early founders included Chris Rawlence, Maggie Lane, Sheila Rowbotham, Kathleen McCreery, Steve Trafford, Madeline Sedley and Richard Stourac.* All acted, wrote and devised the work, as Itzin explains, '[i]t was part of the ideology of AgitProp than [sic] anyone could and should learn to do it.'[2] This ideology immediately places these creatives outside of the 'normal' theatre world, a world

* For more on CAST, Red Ladder and Broadside, visit the Unfinished Histories website at www.unfinishedhistories.com

where the emphasis was on theatre craft and audience experience rather than using theatre as a tool to highlight particular social and political issues.

The *way* of working, the process, was often seen as more important than the end product. The theatre group would work with a group of people about an issue, for example a tenants' association about rent rises. The group would attend tenant meetings, research the issue, be aware of the national and local politics behind the rent rises. The group would then work with the tenants to create a play about the rent rises, perform it to the tenants' association and then visit other tenants' associations with the play, to raise awareness about the issue. From this, other creative activities might be explored or indeed other direct-action activities, including discussions and workshops with the group. Quoted by Itzin, Kathleen McCreery explains:

> The sketches had to be short, twelve to fifteen minutes was the maximum since they had to be fitted into the tenants' meeting – first restriction. With so little time to say anything, they had to be simple in the extreme: we could only put over a few ideas, clearly. ... They had to be topical and flexible since the situation of the tenants was changing constantly. ... The function was morale-boosting, unifying, but also to contribute to a tactical debate because there were different forms of action the tenants could take at each stage.[3]

So, the engagement that the theatre company had with the group extended beyond a simple rehearsal and performance: get in, perform, pack up and go. The theatre company's relationship with the tenants' associations was long lasting and continued in a range of forms. It was during this time that the company used an actual red ladder (hence the company name) 'as a visual device to attract attention – a cheap and portable way to elevate themselves outdoors – and a useful metaphor of the class structure'.[4]

As McCreery says, the shows were very simple and often used a direct address or music-hall-type style, often broad in humour and avoiding the complications of subtle character and plot development. The shows were created and performed quickly. In an unpublished interview, McCreery said, 'lots of workers saw our work, but the "intelligentsia" did not'.[5] This perhaps explains the lack of information and academic work on these

early plays – and the reason we are choosing to include extracts of those works within this book.

The reason Red Ladder has been chosen as one of the theatre companies explored in this brief historical overview is because they started in 1968 and are still making theatre today, 50 years on. But of course, their work inspired many other companies across that half century. In 1974 Kathleen McCreery and Richard Stourac left Red Ladder to create Broadside Mobile Workers' Theatre (also referred to here as Broadside) as they felt the connection to the working classes was being lost at Red Ladder. As time went on, Red Ladder moved from London to Leeds and began to work on theatre for young people. This is a direction many of these early theatre groups took – for example, in the early 1970s, the Women's Theatre Group worked in a similar way and moved for a while into theatre for young people. But Broadside wanted to keep the original focus on work that concentrated on issues that affected working people, issues that were often imposed on workers with little consultation from those in power.

Other organisations, such as Welfare State, 7:84, Belt and Braces, Monstrous Regiment, General Will, Joint Stock, North West Spanner, Banner, Black Theatre Co-Op, Clean Break, Pip Simmons, the People Show (also still operating after many years), and Graeae, through to newer companies like Take Back Theatre and Mighty Heart (amongst many others) still make this connection, and some of these companies are explored in later sections of this book. However, the process of being 'active' in the political issue explored through making theatre was a very clear part of the creative method used by agitprop companies.

The main argument against the methods and delivery of agitprop is often that the shows are underdeveloped and 'on-the-nose' – that there is no subtlety and therefore no depth to them. Often, those involved with the early companies will admit that this was true, for the reasons detailed by McCreery in the above quote. The performances were often in non-theatrical spaces at non-theatrical times, in the coffee break of a tenants' meeting for example. Messages had to be formed into something that could be entertaining but potent. Performances of between 10 and 30 minutes were the norm, although many theatre-makers point to the fact that as this type of theatre developed, went into theatre spaces and played to theatre audiences, the entertainment factor often suffered. Having a free performance during a meeting is a very different prospect to going out for the night, spending hard-earned cash after a long day

at work to watch a play. Some theatre-makers felt agitprop could come across as 'worthy' or even 'preachy' and that the theatre-maker's agenda often superseded the actual group's issues. However, with a company like Broadside, the success was again in the process, not the end-product. Broadside wanted to involve the workers, and as the company name suggests, they targeted workers for their themes and plays. Again, quoted by Itzin, McCreery explains the process on Broadside's first show, *The Big Lump*:

> Here we tried something we'd been aiming for – we decided we actually wanted to make the play with workers. After some effort we got together with half a dozen building workers. They didn't take us seriously at first – they asked if we were 'Trots'. But the battle won – we were not Trots – they were giving up their Sunday mornings and more.[6]

Broadside explored a range of political issues throughout its life, and one show that focused on a larger political issue, perhaps one that still resonates throughout the Western world, is a play Kathleen McCreery wrote in 1978, called *Apartheid: The British Connection*. She says about this play:

> The programme was widely performed in conjunction with the Anti-Apartheid Movement's dis-investment campaign, for trade unions, colleges, etc. It was a montage of scenes, songs, narration, rather than a play.[7]

Of course, the fact that a white theatre company was making a play about the political situation in South Africa at this time speaks more to the cultural historical moment and the title itself made it clear that this was about the *British* connection to apartheid. However, it is also important to note that a company like Broadside was willing to take on such a huge issue, and one that was very divisive; it says much about the work that MPs like the late Bernie Grant booked the show for his constituents in Tottenham.[8]

The extract from *Apartheid: The British Connection*, previously unpublished, is followed by an essay by David Peimer, South African theatre-maker and writer, exploring what political theatre means in South Africa today, alongside an essay by Rebecca Hillman that considers

what political theatre means in the UK today, and whether we can still examine these large political issues in a meaningful way that engages with the communities for which it aims to fight.

But first, in the summer of 2017, I interviewed Rod Dixon, current Artistic Director of Red Ladder, a company that celebrated its 50-year anniversary in 2018, and Kathleen McCreery, one of the founder members of Red Ladder, who went on to form the highly influential Broadside Mobile Workers' Theatre.

INTERVIEW WITH ROD DIXON (RED LADDER) AND KATHLEEN MCCREERY (RED LADDER AND BROADSIDE MOBILE WORKERS' THEATRE)

Kim Wiltshire

Q: How would you define 'Political Theatre'?

Rod Dixon: I suppose it's any piece of theatre that sets out and/or seeks to provide a platform for people to think differently; to provoke conversation about social change; and to raise awareness of oppressions. Any piece of theatre that does that can, I think, be considered to be political theatre.

Kathleen McCreery: Some people would say that all theatre is political, that it either implicitly or explicitly supports the status quo, or challenges it. But if we are to be more specific, we should start with the content, which must not be limited to individual or personal experiences, worldviews, or narratives. That does not mean political theatre can't tell an individual story, but it does not stop there. It has implications for, or links to political, economic, and social structures.

Political theatre is usually critical, but it can also be celebratory, commemorative, remind us of our history. It can encourage campaigning on a single issue, inspire unity. Or it can be more complex: it can present challenging problems, ask difficult questions, provide analysis and conflicting perspectives about a wide range of subjects, and uncover connections between them. At its worst, it's didactic, and finger-wagging, and tedious; at its best it provokes thought, creative discussion and debate, and yes, sometimes action.

But political theatre isn't just defined by its content, one needs to consider the forms – do they help, or hinder, in achieving the objective, are they appealing and relevant to the spectators, are they unpredictable, do they keep the audience awake, on the edge of their seats? I go back to Brecht and the idea that you shouldn't pour new wine into old bottles, you have to try to develop forms that can express the material you're working with. Do they arouse curiosity? Do they stimulate? Do they satisfy aesthetically and emotionally, as well as intellectually?

Then we have to ask who is a piece written for? Is it written for an audience with an interest in the subject that is not just academic? In order to ensure that, we may have to ask where the performance is taking place? Is it accessible to that audience?

For me, those are the key questions.

RD: From my perspective, it is work that doesn't overtly agitate; but which is uncomfortable for the comfortable. If the comfortable are sitting in a velvet chair in a theatre feeling uncomfortable, then that's highly political. If they're just sitting back going, 'Oh, what a wonderful piece of Noel Coward,' then it's a waste of time.

Of course, if the position is that political theatre is theatre that provokes, it often means it falls largely into positions that would be taken by the left; which is obviously a position where we're not happy with the status quo. But equally a political piece of theatre could be from the right.

KM: Yes, most people assume political theatre equals left-wing theatre. However, the Italians had 18 BL, named after the first truck to be mass-produced by Fiat, a response to Mussolini's call for a theatre of the masses. The Nazis had their Thingspiele movement, staging mass spectacles. *The Merchant of Venice* was produced twenty times in Germany in 1933, and another thirty times between 1934 and 1939, with decidedly anti-Semitic interpretations. They tried to develop agitprop that could rival the enormously popular workers' theatre movement in Germany, but failed miserably. We were told by veterans of the movement that was because dialectical thinking was contrary to fascist thinking!

Q: What does political theatre mean to you, personally?

KM: When I make political theatre it always involves research. *Theatre as a Weapon*, the book I wrote with Richard Stourac, required an enormous

amount of historical digging. We were going to write about theatre all over the world, before we realised that was impossible. But we still went to the States and travelled across the country interviewing and observing political theatre companies. We found examples of political theatre when we were on holiday in Greece; we looked at theatre in India; we were interested in Africa, and Latin America. We couldn't go to all those places, but we collected material, and acquired some of the discipline and skills required by historians.

Of course, in Red Ladder and Broadside, we had to make sure our plays were based on sound foundations, accurate and specific, and that meant interviewing and reading books and newspapers and pamphlets. When I began to write to commission, I researched: what exactly does a chambermaid's job entail? How has parenting changed through the ages? Why are there so many street children in Brazil?

I would also say that I'm an internationalist. I have dual Canadian and Irish citizenship; I have lived in the US, UK, Austria and Germany, and spent time in several African countries, but I've never been in a place long enough to identify fully as a national of any country. That has given me an international perspective. I'm interested in what is going on around the world, not just on my doorstep. And that has influenced my practice.

RD: The bottom line for me is that political theatre has got to be interesting to audiences – but also entertaining!

We did a double bill of plays in London. One play was about Muslim extremists, and the other play was about the EDL.

We sold hardly any tickets.

Nobody wanted to come!

If you live in London and you can go and see two plays about extremism, or you can go and see *Wicked*, you're probably going to go and see *Wicked* – you've had a hard day at work, you want to relax; the last thing you want to do is spend the evening watching somebody blow themselves up.

It's a balancing act – you can take on the political, but it might not attract audiences or entertain them. There's a play we toured the unions, about three women and the miners' strike. I went to talk to a mining village to see if they would want it to be performed in their pit club, and the first thing they said was, 'We lived that bloody strike, we don't want to watch it as well.'

And then I said, 'OK, but it's a comedy.'

Their reaction changed completely: 'Oh wow, it's not going to be a play about pickets being bashed by police – brilliant, that's a new take.'

So, you need find a hook that's highly political but also entertaining. That piece of work did really well with the mining communities; people came who wouldn't go to the theatre normally. We told their story in such a beautiful and sensitive way, we had grown men weeping.

But you have to be careful that you're not making nostalgic political stuff. I would hate it if Red Ladder was seen as a sort of trade-union-sponsored, socialist-workers'-party-selling, donkey-jacket-wearing, fascist-punching, lefty-company. I would hate that. Unfortunately, that's the pigeon-hole we sometimes get put into. I would rather be seen as a theatre company that makes really high-quality theatre that actually provokes useful conversations – after the audience have had a nice sing-song or a laugh.

I want to attract the sort of people who hadn't decided whether they were voting Leave or Remain in the referendum, or the sort of people who vote Conservative one time and Labour the next, just for a change. Those are the people I want to see our work, so that there is an educative element to it and people think slightly differently afterwards, rather than say, 'Oh politics has got nothing to do with me, I'll just vote for them because they're nicer.'

Q: What is it about political theatre that interests you creatively, as a theatre-maker?

KM: It's no accident or coincidence that many of the greatest writers, directors, composers, designers and actors have chosen to make political theatre, from Euripides onwards. The rewards are immense when you make connections on stage, and with audiences, but of course you're never satisfied because your subject matter is not static. I don't believe in universal and eternal values, so that means the ground beneath your feet is constantly changing, and you have to keep learning. And that's exciting.

I would add that we're not just artists, we're citizens. If we care about the world we live in and the other people who inhabit it, then of course we want to wrestle with the wrongs we see through whichever medium we work in. I don't believe art can change the world on its own, but I

do believe it can have an effect as part of a movement. I can't think of anything else I'd rather do.

RD: Politics doesn't want to engage with us, doesn't want ordinary people to think deeply, and I think that's what our job as political theatre-makers is: to get people to think from a different or a deeper perspective.

KM: I remember going to hear an extraordinary soprano from the German Democratic Republic (this was before the Wall came down) called Roswitha Trexler, who was performing a concert of Eisler music in London. We were talking afterwards, and I asked, 'Are there a lot of younger singers in the GDR who are interested in the music of Eisler and Dessau?'

She shook her head sadly and said, 'No, it's too difficult.'

It's not just that it is difficult musically, it's that you must *think* about what you're doing. You can't just produce beautiful sounds. You need a point of view. The words are vital, and you have to bring understanding and intelligence and clarity to your interpretation of the songs. She said that too many young singers can't be bothered; they don't want to work so hard. The same is true for political theatre – it is extremely challenging.

RD: My starting point is that, without being depressing, I think the world is insane! And I've been proved right in the last couple of years – it's totally insane.

And so, I could either wallow in my pit and weep, or, like a lot of people, go out on a Friday night in my best clothes and get totally drunk. We know what an insane world this is, and one of the only ways to cope with it is to indulge in what we think is a good night out.

But I'd like a good night out to be the theatre. Then people don't just anaesthetise themselves, but actually stay a bit more sober and say, 'What are we going to do about this? I'm not putting up with this anymore!'

Q: How did you first start working in political theatre?

RD: I went to drama school, because I knew I wanted to work in theatre, and whilst there we did some invisible theatre. I remember queuing up outside a butcher's, because they were selling veal. We had a big argument at the front: me pretending I really wanted to buy veal, and somebody

explaining to me what veal was. The butcher was furious and called the police. We didn't get arrested, but we got a caution for causing a public nuisance. You probably would be arrested now, but in 1980, or whenever it was, you just got told off for being a daft idiot.

KM: My mother was left-wing, and my father was conservative so there was always friction in the house. When I was eight years old, I came down with rheumatic fever and was put in a hospital room with a woman in her forties, which outraged me. Well, Dorothy June Newbury turned out to be wonderful. She was a lecturer in education at the local college, and the town's only communist. She became my mother's best friend, and a very good friend to me.

At the age of 14, I was cast in the role of Mary Warren in Arthur Miller's *The Crucible* – an eye opener for me. I hadn't done anything except school plays before, and this was a serious production. It made me realise that theatre could be about important issues, which were thought-provoking and stimulating, and I wanted to be a part of it. I made up my mind I was going to be an actor.

I studied at the University of Minnesota in Minneapolis. Dr Arthur Ballet was on the staff, a brilliant director, and he staged a production of Brecht's *The Private Life of the Master Race* (as it was known in the US), or *Fear and Misery of the Third Reich*. Once again, I encountered a playwright who was writing about something momentous, in a way that was theatrically innovative and aesthetically satisfying – and that combination interested me. Politics does not have to be dry and boring.

After university I was asked to work with girls at the Hallie Q Brown Community Centre in an African-American area of Saint Paul, Minnesota. The children were 10 or 11. They taught me an enormous amount about poverty and the discrimination they faced. I got invited to their homes and met their families. This made me aware that political theatre isn't just about challenging subject matters and experimental forms; it is about where you make theatre and who you make it for; and it can also be about facilitating others, so they can get involved and develop their own abilities.

That's how it started.

Q: What do you think the early work of political theatre companies from the late 1960s and the 1970s can teach those who want to make political theatre now?

RD: I wasn't there, I was about 11 probably, but 1968 to 1972 was an interesting time politically. Companies like Red Ladder and Broadside worked with some big factories. Kathleen has some amazing stories about that time.

KM: *The Participation Waltz*, originally *The National Air Show*, was a play we made about the aerospace industry with Lucas Aerospace workers. One of the plot devices involved the hiding of a vital technical drawing. In our play it was hidden outside the boss's office. Miraculously, when negotiations were successful, the drawing reappeared, but they couldn't accuse anybody of stealing it. The imagination and humour was wonderful, and we were able to tap into them because we had respect for our audiences.

One of the most important things, we realised, in making political theatre in those early days was that we did not have a monopoly on knowledge or ideas. Our audiences knew first-hand about the environments in which they lived, the structures they had to contend with, the discrimination they faced, the obstacles they had to overcome. In Red Ladder, and more intensively in Broadside, we developed methods that allowed us to learn from our audiences. The discussions after the plays became as important as the plays themselves. You could see people's minds opening, not just because of what we did on stage (the play introduced the issues and provided a stimulus), but because the audience had an opportunity to respond creatively to the play and to each other. I can remember a fellow turning to the man sitting next to him and saying: 'I didn't know that's what you thought.' They had worked together for ten years!

So, we began insisting on discussions whenever possible, and we began to learn how to facilitate them in such a way that the professional politicians and the people with large egos and mouths did not dominate. We had to make sure that women's voices were heard, that young people could speak, and that the quiet, less confident people in the room got a chance.

People talk about giving a voice to the voiceless. They have voices! It's about creating conditions in which those voices can be heard. That is what I would say to young people in political theatre today: listen to, and learn from, your audience.

RD: There are pieces of theatre that are lovely, and enjoyable, and give you a warm feeling, and you go home, and you forget all about them until someone says: 'Oh, have you seen so and so?' And you go, 'Ah, yeah it was lovely.' There's a place for that theatre and I think that's great, but it's not political. The conversation that's provoked by a piece of work afterwards is almost more important than the piece of work. That's why I don't think all theatre is political.

KM: When we made our first play with Broadside, *The Big Lump* for UCATT, the construction workers' union, we spent hours on Sunday mornings in workers' kitchens, drinking tea, and talking with them about their experiences on building sites. The stories we got, the political understanding, meant that when we came to write the play it was based on sound research. When we performed it, the building workers were surprised we knew our stuff. But they recognised that they were watching an authentic portrayal of their lives. The play had humour – their humour – because we had heard their stories.

We asked them, 'What do you do when you have a work-to-rule in the building industry?'

And they said, 'Well, we dust down the bricks.'

So, in the play, one of the actors came on stage in his hard hat, with a pinny over his donkey jacket, carrying a feather duster. They knew immediately what it meant and would fall about laughing.

Of course, it's very theatrical and very funny, and we couldn't have invented this stuff. Thinking that you can create a believable and relevant world on stage without consulting the people you are writing about or telling them how to solve their problems is frankly arrogant. The research cannot be superficial or hasty, it has to be thorough.

RD: I was doing some work with people in their eighties a few months ago. I said, 'I'm not going to do nostalgia, I want to talk about you, now. What's it like living in this society in your eighties? Do you want to die?'

They said, 'No, we're very much alive, but we're invisible.'

And funnily enough there was a 16-year-old work-experience girl sitting in the room and she said, 'Hey, wait a minute, I'm invisible too! What you're describing is exactly my experience. We are at either ends of our lives where we are not contributing to the economy. We just don't count.'

You don't count until you've gone through all of those hoops, and you're £50,000 in debt for your education. That's what still draws me creatively – the desire to put on stage people's struggles, people's stories, and people's lives. The same desire that drew those who came before us.

KM: When we did the Red Ladder play *Strike While the Iron is Hot*, we interviewed a lot of women working in both the public and private sectors and at home. We spent many months on the research, but that play required us to do a new kind of investigation. We began to talk about our own lives, our families and histories, our experiences and attitudes; that hadn't happened before. It led to disagreements, conflict, and people were sometimes upset, but it was necessary. We couldn't possibly do a play about women if we did not understand women's liberation personally as well as politically. It changed the group. It was uncomfortable, but it was worth it.

That play made an impact. I remember being on a campsite in Portugal, on holiday with Richard Stourac, my first husband, when a man in the tent next to ours said: 'You're the people in that play. It changed my life. I really had to think about how I was behaving, and about my relationships.'

I also remember, after one performance, a woman who was sitting in the audience next to her husband, when he made a sexist or belittling remark during the discussion. She stood up, picked up her handbag, and hit him over the head. Not that I recommend violence, but you could see her frustration. The atmosphere was charged, but it was also supportive, and it happened again and again – not the handbag, but that play touched a lot of people.

RD: Everybody goes on about John McGrath, but if you listen to Kathleen's stories you realise that Red Ladder and Broadside were doing things that were remarkable. Some of the work might have been quite on the nose, but there are young people now who want to make immersive theatre and those early stories, really important theatre stories, are ones young people should be inspired by.

KM: If you ask: 'What can we teach those making political theatre now?' You don't need to reinvent the wheel. Learn from the past and from other groups around the world. When I taught at the University of Sunderland, we had students coming from college drama courses who had never seen

a straight play, let alone political theatre. They had only performed in and seen musicals and pantos.

That is partly why Richard and I researched and wrote *Theatre as a Weapon*. We were aware that there was an extraordinary tradition that most of us knew very little about.

RD: We had a play about a dock strike, but it was a pantomime called *Sex and Docks and Rock and Roll*. We had it in the Balne Lane Working Men's club in Wakefield the day after students had been kettled outside Tory headquarters around 2010. This lad got on stage and said to me, 'Can I use the microphone at the interval?'

The interval came, he got on stage, and he said to the audience, 'I was kettled yesterday and I missed my train. I had to borrow £240 quid to get back to Wakefield. Now I've got to pay all those people back, and I haven't got any money.' And he burst into tears.

We passed a bucket round and raised the money for him, and then one by one the audience said: 'It's outrageous how young people are being attacked by the state in this way!'

We had to extend the interval, and then finally we had to say, 'Can we do the second half of the show now? Have you calmed down? Can we have a bit of a laugh and do the second half?'

I thought that was amazing that the audience came together for that young man. That our platform was used to galvanise people, and had nothing to do with the play.

It's sad that those kinds of social spaces are closing down everywhere; those kind of working-men's clubs, and pubs, and places to gather to have a drink and to talk to each other.

Q: So, is political theatre still relevant today?

RD: The piece of work we're currently rehearsing, *The Shed Crew*, is being put on in a warehouse, because we don't want the audience to sit and watch it; we want the audience to be recruited into it, because it's about extreme poverty. And yes, it's about young kids in the 1990s, but it could equally be about now. Those young people are now in their early thirties and they're still struggling with extreme poverty in a city where there is so much wealth. The life expectancy between North Leeds and South Leeds has a difference of ten years.

Our piece is trying to say: 'Have some empathy for the people sitting on the floor with a pot in front of them.' You hear all this stuff about not giving beggars money because it is sponsoring their habits – fine, don't give them money, but give them a pie or sit alongside them if they want you to. Give them some human contact. I think that kind of solidarity amongst us is powerful. Thatcher said there's no such thing as society because she didn't want us to do that kind of thing. But that's why the 1960s-70s influence is so strong, because it fights against that and allows us to say: 'We share your struggle.'

KM: We are facing so many issues today: human rights abuses, refugees, racism, child abuse and climate change. There are predictions of human-itarian disasters on an unprecedented scale in Africa because of global warming. The nuclear threat is a major concern, with Trump in the White House and Kim Jong-un in North Korea.

The battles are there to be fought, and art always has been and always will be a means to help us make connections. It's not something that can be done in isolation.

RD: It's about reclaiming the thing that the late 1960s and 1970s were doing. Kath, and Marion Sedley, Peter Dukes, Richard Stourac, Richard Seyd and Chris Rawlence (amongst others) formed Red Ladder and made work. Somebody was saying to me not so long ago, 'Oh I want to form a theatre company, but we can't get funding.'

I said, 'Sod funding, make a piece of work in your front room, get it sorted and get it out there!' If you can't get a venue, do it in a shed, do it in a garage, do it in a square in a town, you know. If you've got something to say, make a piece of theatre about it.

Q: Is there any other advice you'd give to someone who wanted to start making political theatre today?

KM: Work with people you know to be honest, genuine, sympathetic and committed team players, not divas. Take it slow. Don't be afraid of taking on big subjects. Get trained. I am not interested in work that is worthy, but weak. Political theatre-makers have to have high standards. There will always be people pointing the finger, and ready to say, 'You can't take this seriously.' Our audiences deserve the best.

I worked in Vienna, with Die Komödianten, and in Berlin for two years with another Brechtian company, Theatermanufaktur. They took months to produce plays! The Berliner Ensemble would work for *years* on a production, and that's normal on the continent. In Vienna they said, 'We work on a play until it is ready.' I've heard people say if you rehearse longer than three weeks, you get stale – I'm astounded by that. I think, you are either working with superficial material, or you have only scratched the surface. You are not going deep enough.

RD: Have something to say. What pisses you off? What are you struggling with? What is the point of your life and have you ever thought of that? I think that's the advice I have for young theatre-makers: what is the point? You've got to have some kind of aspiration and ambition for the work.

KM: I remember a man in one of the discussions after a Red Ladder performance, who said, 'I've seen myself on stage today. I've been a cabbage all my life, and your play has shown me that. I'm not going to be a cabbage anymore.' He was able to make that admission because we didn't shame our audiences. The plays were compassionate. They explored human frailty and foibles. We would use parody and humour, but we never made fun of our audiences. Again, I come back to that word respect. You have to care about the people you are working with and for. There are going to be people for whom your subject is a life and death issue.

RD: It's the classic thing of: you don't want to give answers, you want to raise questions. But equally, you need to know the answer, yourself, to those questions. That's another thing to say to young theatre-makers: what are the questions you want to ask? What's your answer? Don't put that answer in the play, but be prepared to take your position and defend it if somebody comes at you.

KM: I'm 73 and I've been doing this for a long time. I joined Agitprop Street Theatre in my mid-twenties and have rarely stopped since then. But one of the projects I am proud of is a play called *Flight Paths,* which I wrote and directed. It was about the situation of asylum-seekers and refugees in the north-east of England. It was commissioned by Sunderland Education to introduce citizenship into schools. Fiona Evans invited Neil Denton and Rizwan Sheikh to a performance and they said, 'We need this for Newcastle.' They raised the funds to mount a second

production. There were 35 performances in Sunderland the first year and 60 in the second in both cities.

It was designed for transition-year pupils leaving primary school and going into secondary school, so they were 11 or 12. But it appealed to older teenagers and adults too. It was used as a training tool for youth workers and city council employees in Newcastle; we took it into colleges and youth centres. We performed it at the Sunderland Bangladesh International Centre and for Holocaust Day commemorations, and at a public performance for hundreds of people at Newcastle Civic Centre, and for councillors in Sunderland, as well as in many primary and secondary schools.

Before I sat down to write the play, I ran drama workshops in a number of schools. My brief was to explore racism, but for the kids that meant asylum-seekers and refugees. So, they helped us to determine our direction. When I asked where they got their ideas from, they frequently mentioned their grandparents.

We also interviewed refugees and asylum-seekers from Congo, Colombia, Turkey, Iran, Guinea, Rwanda, Ivory Coast and Zimbabwe – their journeys informed the play. My daughter assisted with the research and the workshops, because she speaks fluent Spanish and French, which allowed us to speak to some interviewees in one of their languages.

The young asylum-seekers in the play were from Iran and Congo. The first year the Iranian role was played by an Iranian asylum-seeker, and the second year the role of the Congolese girl was played by a Zimbabwean refugee. There were three British-born characters, one of whom had come from a Pakistani family of economic migrants, and another of whom had had to flee London with her mother because of domestic violence.

We received letters from children telling us about their own experiences of discrimination, of bullying, of domestic violence, a theme in the play, and of standing up to racism. One in particular stood out for me. It was from a little girl who wrote: 'My dad doesn't like refugees or asylum-seekers, he doesn't want any more to come in to this county. Maybe if I tell him this story it will make him think twice about refugees.' It was wonderful, to see that we were having such an impact, and children's eyes were opening.

RD: My wife was in the solo show *Wrong'Un*, about a suffragette. We came out of a gig one night, and there was a woman sitting on the steps

crying her eyes out. We said, 'Aw god, that's not supposed to happen when you see a show.'

And she said, 'No it wasn't the show. It's just, I've got a PhD and all I do is wash the bloody dishes and change nappies. I feel so angry about it, but what can I do? What you've just done is political activism. That play has woken me up to how my life is, at the moment, pretty pointless.'

I started saying, 'No it's not pointless! You're a mum, we need mums!' But she felt that she'd put years of her life into being highly qualified and then done nothing with it, and it really made her look at herself as a woman in society, and question what benefit she was. She'd just watched a woman who had been force-fed in order to get the vote.

KM: Recently, I went to South Africa and worked with Dinganga Theatre Creations, a dance theatre company. We made a play called *Matters of the Heart,* which told the story of twenty-four hours in the life of a woman taxi driver in Soweto. (The 'taxis' are mini-vans that ply a given route.) It was created in collaboration with the company. I worked with them for a month and then came home and finished the script.

It took a few years for them to get the funds to produce it, and I had resigned myself to it never happening. Then the company contacted me to say it would premiere at the Soweto Theatre. They said, 'It's going to be really good, you must come.'

After my first day in rehearsal – they had been rehearsing for some time – Thabang Ramaila, the Artistic Director, said, 'Right, you're directing now.' All the elements were there, including fantastic choreography by Thabang, so I just did the fine-tuning.

The opening-night performance was a triumph – there were women screaming with laughter and raising their hands in the air and cheering. There were men with their hands over their faces, but they were laughing because they recognised themselves. We got a standing ovation.

There are thousands of talented people in South Africa who don't get opportunities. But they persevere. During the collaborative phase, one of the actresses in the company was getting up early and taking three taxis to rehearsals. One day, Thabang said to me, 'Have you noticed that she is not eating lunch? If she pays for her transport to get to work, she doesn't have money for lunch.' So, we had to sort something out. Because at that point they could not pay them; the infrastructure was minimal. Working with people with this kind of dedication, commitment and desire to learn

and to develop is a joy, despite the frustrations caused by lack of funding, and the many problems the performers face outside the rehearsal room.

RD: If we didn't get any audiences, and people stopped coming to see Red Ladder, and we were struggling, and we had like five die-hard trade unionists selling a newspaper outside, then I'd say to the Arts Council: 'Yeah, stop us, we're awful.' But the fact is, we're getting good audiences and people want to see our work and are engaged by it – from right across the political spectrum! We don't deserve to keep going just because we're 50 in 2018, but while we're still having moments like that woman on the step, like people asking us to come back, then we've got a reason to carry on.

APARTHEID: THE BRITISH CONNECTION (EXTRACT)

A play by Broadside Mobile Workers' Theatre
Excerpt: The narration for a shadow play focusing on investment, by Kathleen McCreery.

Narration: *(Not necessarily all done by the same voice. Some parts might even be done chorally.)*

It pays to invest in South Africa.
Four million whites with money to burn
Provide a ready market.
It pays to invest in South Africa.
22 million blacks
Sell their labour for starvation wages.
It pays to invest in South Africa.
It pays to invest in South Africa.
The government is tripling its expenditure
On arms, aircraft, ammunition.
They'll buy your radar, rifles, radios,
Mortars, missiles, mine detectors.
They'll buy your napalm bombs.
It pays to invest in South Africa.
Profit rates are high. You'll get a good return
On your investment.

Gold
For Consolidated Gold Fields
Diamonds
For Anglo-American
Platinum
For Lonhro
Copper and uranium
For Rio Tinto Zinc
Precious stones for the London market
Precious metals for South African industry
Uranium for nuclear power
For nuclear bombs.
400,000 men in the pits
400,000 migrant labourers
400,000 'guest workers' digging gold in the pits of South Africa.
Digging gold for £13 a week.
Digging gold worth £2,000,000,000 a year.

We dig to live
But digging die
An average of three deaths a shift.
Accidents
Pneumonia
Diseases of the lung
Loneliness – for our families far away in the Bantustans.
Anger – because we are called 'foreigners' in our own country.
We strike – because the price of gold is rising
 because Zimbabwe and Namibia are rising.
We strike – because we don't want to live on our knees
 and we know how much you need us.
 That's why you shoot us when we strike.

Chemicals
For ICI, British Oxygen, BP
Steel
For GKN and British Steel
Electronics
For GEC and Plesseys
Computers

For ICL and Anglo-American
Motor vehicles
For British Leyland
For British companies building up South Africa's industrial base.
For British companies helping South Africa become self-sufficient.
For British companies helping South Africa create an economy
that can withstand a civil war.

Soweto people rise at dawn
Light the coal stove
Empty the chamber pot
Roll the sleeping mats
Wash in the communal tin tub
Eat their porridge without milk
Feel for their pass books in pockets and handbags
Spill out into the grey Soweto streets
Stumble across a corpse or two –
Did Jonathan come home last night
Watch out for the pickpockets
Hurry for the buses. Hurry for the trains.
200,000 crowd onto the trains going to Johannesburg.
The machine of the white economy is waking
Waiting for black hands to turn its wheels.
Black hands labouring
Welding
Grilling
Riveting
Grinding
Driving
Black hands
Cooking
Cleaning
Washing
Making kettles, fans and heaters
Nylon, plastic, ammonia
Trucks, steel tubes and turbines
Tear-gas for Soweto
Weapons for the war in Namibia.
Black hands weaving blankets they cannot afford to buy.

Salt
For Rank-Hovis-McDougall
Tobacco
For British American Tobacco
Grapes
For South African Distilleries and Allied Breweries
Maize, oil, cotton, poultry
For Associated British Foods
Oranges, apples, bananas
For Sainsburys, Safeways, Tescos, the Co-op
Thousands of human ants.
Men, women, children
Move steadily across the fields
12 hours a day
7 days a week
For £3.23 plus food.
The food is just enough to keep them working
Digging, sowing, harvesting
Children with distended bellies
Pick peaches, pears, pineapples
For stomachs far away in America and Europe.

The farmworkers of South Africa
Are prisoners.
Laws chain them to the land.
Mr Tshilwane, engineer
Finds the labour bureau where he's registered has been closed
To all recruitment
But that of white farmers in the district.
Mr Tshilwane is forced to work as a farm labourer
For a fraction of his previous earnings
There's no escape.
He'll stay on the land
For the rest of his working life.
On the grape farms of the Western Cape
Cheap wine chains the coloured workers to the land.
They're paid 'in kind'.
Alcohol addiction ensures their 'loyalty'.
Even if they could escape

They won't.
But for some farmers
£3 a week plus food is still too much to pay
When African convicts will do the work for nothing.
The white plantation owner happily contributes
Towards the building of nearby prisons.
The harvest will be good this year.
At this moment
In South Africa
We gather
To prepare the liberation.
In the crowded mining compounds

Hide homemade weapons, bricks and lumps of coal
Watch out for spies.
The Chamber of Mines is preparing too.
Dogs, teargas, batons
Armoured cars
Walkie-Talkies, loudspeakers, closed circuit television
Computers to identify 400,000 fingerprints.
Have they such powerful enemies?
In Soweto
We lay plans.
As night falls
Children leave their studies
For more serious business
Run through the darkness
To a meeting.
No time to mourn a thousand dead companions –
Eleven Soweto students are on trial.
We must protest.
A 16-year-old is wanted by the police –
He must be smuggled out.
The campaign against shebeens and beer halls
Must continue.
Write the slogans large upon the wall
'Less Liquor, More education'
'Away with Boozers!'
Give our parents back their self-respect.

In Soweto
Between the hours of 2 am and 5
Police prowl the streets
Kick down doors with their heavy boots
Flash torches on bewildered frightened faces
Pull blankets off the naked women.
'We're taking your daughter!'
'But she's only 13!'
'Old enough to burn down the police station!'
On Robben Island
A 14-year-old boy and five 15-year-olds
Serve sentences for sabotage.
A fellow prisoner, Johannes Matsobane, dies – of a 'heart attack'.
He was 21 and in good health.
Hundreds of school students are in detention,
Many in solitary.
A 16-year-old schoolboy from East London dies of multiple injuries –
The soles of his feet have been burnt off.
The authorities sentence an 8-year-old child to five cuts of the cane –
For attending 'an illegal gathering'.
Have they such powerful enemies?

*Version One**
Our newspapers banned
Our organisations banned
Our leaders' dead or in detention
They force us to use
The same means they use against us.
At camp sites in the forest
In village huts
In factories and squatters' camps
We gather to prepare the liberation.
Ranged against us are the most formidable weapons money can buy
Weapons made with help from British companies
Weapons fuelled with oil from BP and Shell
Weapons bought with loans from Barclays Bank.

* There are two versions of the rest of the narration. The first is written as if spoken by South African voices. The second is written as if by British voices.

Don't tell *us* about the fruits of foreign investment.
Half the babies in the Bantustans die before the age of 5
A record number of Africans are unemployed.
While the flow of foreign capital reaches new heights.
And your government vetoes economic sanctions at the UN.
Tell your government to stop its trade missions.
Tell your government to step giving credit guarantees for exports to
 South Africa.
Tell your government to withdraw all state-owned and nationalised
 industries.
Tell your government to plug the loopholes in the arms embargo
 Halt all new investment.
 Halt all new bank loans.
 Stop shipping oil to fuel apartheid.
We don't want pity, prayers and platitudes.
We don't need Codes of Conduct and crocodile tears.
If your government won't help us
Make them stop helping our oppressors.
Tell them to get out of our country.

Version Two
Their newspapers banned
Their organisations banned
Their leaders' dead or in detention
The people of South African have been forced to take up arms.
At camp sites in the forest
In village huts
In factories and squatters' camps
They gather to prepare the liberation.
Ranged against them are the most formidable weapons money can buy,
Weapons made with help from British companies
Weapons fuelled with oil from BP and Shell
Weapons bought with loans from Barclays Bank.
Where are the fruits of foreign investment?
Half the babies in the Bantustans die before the age of 5,
A record number of Africans are unemployed.
While the flow of foreign capital reaches new heights.
And our ambassador vetoes economic sanctions at the UN.
The people of South Africa don't want pity, prayers and platitudes.

They don't need Codes of Conduct and crocodile tears.
If our government won't help them,
We must stop them from helping Botha.
We must make them get out of South Africa.

PASS SCENE, A SHADOW PLAY

Worker: At all the villages I ask for my wife, my children, nobody has seen them.

Police: Show your passbook.

Worker: Here is my passbook.

Police: You were in Johannesburg.

Worker: I was in Johannesburg in the gold mines.

Police: You have no stamp for the last week. This is punishable.

Worker: I had no time to get the stamp. I was looking for my wife, my children.

Police: Show your money.

Worker: I have no money left. The rest of my wage just about paid the train fare.

Police: Travelling without money is punishable.

Worker: I wanted to work at home near my wife, my children.

Police: You have no permit to stay in this district. This is punishable.

Worker: I had no time to get a permit. I was looking for my wife, my children.

Police: Don't you know that you go to prison if your pass is not in order?

Worker: I have just done six months in the earth beneath Johannesburg.

Poke: Because you are a vagrant and without work and without money, you will be taken to prison, where you will be taught to fulfill your legal obligations.

CONTEMPORARY PROTEST THEATRE IN SOUTH AFRICA

David Piemar

'You theatre people are very political!': Nelson Mandela (1994) after seeing *The Island* by Athol Fugard, John Kani, Winston Ntshona in Johannesburg

'The most potent weapon of the oppressor is the mind of the oppressed':
Steve Biko (1971); banned interview, Port Elizabeth, South Africa

'The danger of a Single Story ... of what books are ... of what Africa is
... of how to show a people as one thing ... is it creates stereotypes ...
binaries ... and so are incomplete ... one story becomes the only story':
Ngozi Adichie (2009)[9]

Context

During apartheid, the term 'political theatre' was rarely used. Notions of
fringe, mainstream, agitprop and other categories were barely applied.
Instead, the phrase 'anti-apartheid protest theatre' encompassed the
genres that were seen as comprising the notion of political theatre in
other countries.

Taking this as a starting point, I am proposing that since the end
of apartheid, this approach to theatre-making resonates as strongly as
before and that the term 'post-apartheid protest theatre' is appropriate
for what is known as political theatre elsewhere. The chapter suggests
that this is a type of theatre which challenges the contemporary South
African status quo, current global debates on identity politics, national-
ism, neoliberalism and reflects recent post-colonial discourse.

Noting the above, the important question to ask is: how is this challenge
represented in new South African theatre? In this context, I argue that
post-apartheid protest theatre has evolved, from anti-apartheid theatre,
to include specific changes in thematic concerns and aesthetic develop-
ments that challenge contemporary societal realities.

For example, the subject-matter of anti-apartheid protest theatre
focused mainly on the crime of institutionalised racial injustice and
military dictatorship. By contrast, post-apartheid protest theatre mostly
focuses on contemporary themes of corruption, extreme poverty with
attendant crime and violence, a disillusionment with aspects of the new
democratic dispensation, and contesting or re-writing the memory/
history of the apartheid period's hegemonic narrative. Thus, in relation
to aesthetic approaches, current protest theatre includes specific new
dramaturgies of form.

I further argue that protest theatre is not merely a legacy but *remains
core*, in its on-going evolution, to what is termed political theatre
globally. The two aims of protest theatre run as both a counter-narrative

to apartheid (and its memory) and as a critique of the current South African experience, are achieved through the collapse of the colonially/apartheid arranged binaries.

In illustrating this argument, I investigate the above in relation to the historical context and notion of protest theatre and the ways it has evolved in contemporary times.

Historical Anti-apartheid Protest Theatre

After centuries of colonisation, the apartheid period saw the rise of protest theatre, which, in essence, was a theatre protesting against the injustice of the crime of apartheid. More than merely opposing institutionalised racism, it located itself in countering the colonial/apartheid processes of othering difference and the singular hegemonic narrative of the era which was founded on the binaries of: primitive/civilised, inferior/superior, servant/master.

The Althusserian sense of ideology or master narrative of the colonial era found its ultimate expression during apartheid in the way state apparatuses inculcated and enforced this singular narrative, with its binary arrangements. The need for a counter-narrative not only to engage with this process, but to resist and protest against it led to the development of protest theatre. This was further characterised by the subject-matter and its aesthetics were located in the intertextuality of two primary influences: township-made theatre and poor theatre.

'Township-made theatre'[10] is a term used to reflect theatre made by black South Africans which emerged from their forced removal into townships to provide cheap labour for the mines and other areas requiring manual work. It is influenced by traditional African song, dance, and story-telling approaches which involve sudden changes in space and time, as well as call and response techniques.

Aspects of poor theatre included a focus on the *physicality* and *orality* of the performer, whereby one performer transforms to become numerous characters who represent social types in a heightened/exaggerated satiric style, rather than characters with psychologically complex inner lives.

Importantly, this and the deployment of satire, functioned to see *protest as a counter-narrative* to the hegemonic ideology of the inherited paradigm of colonial aesthetics (the ideology contained in the aesthetics of form, to paraphrase Adorno). This sense of parodic, heightened social

bodies embodied a counter narrative, forged through protest theatre, in order to subvert, resist and agitate against the master narrative of apartheid/colonisation. As Fleishman observes:

> Each performer plays a variety of parts as the stories … of South Africa … come to life on the stage. The transformation of the performers into this multiplicity of characters is not aided by complex make-up, designs or elaborate costumes. Most transformations take place in front of the audience with perhaps a single item of clothing, a hat, a coat, a simple prop, a pipe, a newspaper, a pair of spectacles to aid the actor. It is the performer's body that changes most to suggest the age, the build and the essential quality of the character. The physical transformations are visible to the audience. These transformations refashion and re-invent the material body into extraordinary and often grotesque forms by which they subvert and parody aspects of the society. The transformed body contains its own logic which can unsettle 'given' social positions and interrogate the rules of inclusion, exclusion and domination which structure the social body.[11]

This theatre was mostly devised and influenced by Gibson Kente's work and teaching in Soweto. It led to globally renowned anti-apartheid theatre works such as: *Woza Albert!*, *Sizwe Bansi is Dead*, *The Island*, *Gangsters*, *eGoli-City of Gold*, *The Hungry Earth*, *Bopha*, *Asinimali*, *Sarafina*, *Sophiatown* and others.

Contemporary Post-apartheid Protest Theatre

Current protest theatre constitutes both a counter-narrative to apartheid and its memory, and a critique of current South African realities. This is mostly achieved through the collapse of the colonial/apartheid binaries by the:

- Opening up of the inherited master narrative which consists of a racially-defined homogeneity of binaries of races (black/white seen as inferior/superior, primitive/civilised etc.)
- Focusing on the subjective (and his/her memory) as a contemporary site of protest, whereby the group is represented in the subjective; this reflects a reversal of protest theatre during apartheid where the subjective was represented in the group.

- Increasing focus on a literary (writerly) and visual theatre which gives rise to multiple and intertextual approaches to story-telling.
- The focus on the performer's orality and physicality, and his/her transformation embodied in sudden multiple character/identity changes. This continues as a core element in contemporary protest theatre. The device further enables narrative structures to be constructed in a non-linear way (sudden shifts in space and time, sudden shifts in character as social role/s). Interestingly, the negotiated interaction between a grotesque physicality/a satirical parody of the social body and an emerging realism can also be observed as a very new aesthetic development.

Post-apartheid Protest Theatre in the Context of Current Global Notions of Political Theatre and Post-colonialism

Political theatre, Harvie notes, suggests a call to 'engage audiences socially',[12] and Bishop's phrase, the 'social turn in contemporary art',[13] is helpful as well.

Harvie locates her notion in the context of 'neoliberal capitalist ideologies'[14] which includes the privatisation/welfare state debate. This notion further aligns itself with Foucault's proposition that power needs a theory of knowledge that citizens internalise as not only natural, but as their society's beliefs and values; in short, a knowledge paradigm used by power to control a society's citizenry.

Thus, this is the global master narrative that contemporary political theatre seeks to engage with, or to be more precise, resist and counter under current neoliberal structures of power. This suggests that contemporary 'socially engaged art ... in broader and material contexts'[15] in South African protest theatre is in dialogue with this global knowledge/power paradigm.

This is a concept that seems implicit in Kershaw's notion that political theatre can be seen as 'oppositional ... a form of cultural intervention'.[16] In terms of aesthetics, his focus on agitprop and Bakhtin's sense of the carnivalesque[17] further align themselves with satire and the embodied grotesque in anti- and post-apartheid forms of protest theatre.

It is important to recall that anti- and post-apartheid protest theatre never focused solely on institutionalised racism but on the structures of power that enabled and implemented the primary 'singular narrative'[18] of colonialism/apartheid via the creation and propagation of the binaries.

As noted, in certain Western cultural contexts, political theatre is still framed as fringe or in a dialectic of mainstream/fringe theatre; in South Africa, it primarily constitutes the mainstream. Given over 350 years of colonisation/apartheid (and its wars, struggles, binaries, cultural infantilisation, Foucauldian power/knowledge structures), and only two decades of democratic independence, this is perhaps not surprising.

Kershaw contends that theatre is an ideological transaction between hegemonic ideologies and counter-narratives. I would propose that South African protest theatre is aligned to this approach but takes it a step further in how it represents protest as counter-narrative to the great master narratives (colonialism and neoliberalism) by collapsing the colonially arranged binaries (articulated in the colonially framed singular story) and global currents of privatisation/welfare state, citizen/immigrant and other racial/religious binaries.

As part of South African satire, the carnivalesque can be seen, as Eagleton notes, reflecting on Bakhtin's notions, as 'a temporary liberation from the prevailing order … a suspension of rank, norms, prohibitions' or as Eagleton further comments: 'a permissible rupture of hegemony'.[19] Thus, satire and irony inform protest theatre and combine to rupture the binaries: hegemony is protested against, encountered, countered, and seen as parodic, grotesque – a mockery of ideology naturalised.

Thus, classic and contemporary South African protest theatre does not merely represent an 'agitation for change'[20] but presents a grotesque, satirical mockery of the binary construction of colonial/apartheid arranged identities and in this way, breaks open the binaries, helping to constitute the core of the counter-narrative.

Post-colonialism and Current South African Protest Theatre

Noting the work of Fanon, Said, Homi Bhabha, Foucault, Spivak and others, I would propose that the notion of Ash Amin is helpful in linking post-apartheid protest theatre to the great post-colonial counter-narrative which is rooted in collapsing the binary arrangements of identity construction.

Amin notes: 'Postcolonial thinking liberated the periphery from the centre … revealing … the colonising project, the intersections and distances of hegemony and resistance … and the narration of counter-histories.'[21]

This leads to a decolonising of the mind, to a resistance, to the subaltern narrating his/her stories, and locates protest as activating multiple identities that give rise to counter-narratives which are entangled with the hegemonic, inherited and singular master narrative.

How Post-apartheid Protest Theatre Challenges Current South African Realities and Collapses the Colonial/Apartheid Binaries

While most recent theatre embodies some or all of the notions outlined, in discussing the following plays, analysis will focus on one key feature, in each case.

Binaries and a False Homogeneity

Hallelujah! by Mxolisi Norman was first staged in Johannesburg in 2001. The narrative follows the lives of one black family in the huge, sprawling township of Soweto; in their home, the streets and in a jazz club. We see how one random murder devastates the family and community. Ironically, as we identify with the characters' very human stories, the one murder represents a social critique of the violence consuming the country; 'the silences in the euphoria of the new democracy',[22] as Norman puts it.

But within this story of family life, love and generation conflict, lies a sense of life full of vivid, personal experiences forged during apartheid but discovering that the new structures of power have left many people abandoned. The murder is random and the characters struggle to locate rationality in the irrational. Lady, for example, begins the descent into community collapse as she starts to imagine murderous criminality in her lover, her family, her society. Fear blurs into a terrifying paranoia as the township implodes.

Jazz music plays throughout the production and serves as an uplifting, softening and soothing counterpoint to the harsh, violent reality most South Africans live with daily. The haunting music combines blues, jazz and Xhosa pastoral sounds and functions as a counter-narrative to the play's critique of the violence that engulfs post-apartheid South Africa.

On a deeper level, the play challenges the partial lack of delivery of what the new democratic dispensation of freedom offers: hope over despair, belonging over abandonment, improved material conditions (jobs, sanitation, water, electricity, homes and poverty alleviated).

The play depicts the interregnum between the apartheid past and the dream deferred in post-apartheid for large numbers of South Africans. As in classic protest theatre, we see the collapse of the legacy of a false homogeneity; the old binaries break as we witness the breaking of the cultural, ethnic and racial stereotypes that had been at the core of apartheid ideology.

We are drawn into a stage world of characters who happen to have black pigmentation and live multiple identities, a complex set of psychological inner conflicts, traumas and realities: characters who live in the liminal intertextuality of a racialised, colonial past and in the present, multi-faceted subaltern world. This is more of a protest emerging from an entanglement with the decolonisation of the mind than an ideological transaction.

In this context, we further observe the rough, fluid movements of identity construction from the periphery to the centre, counter (not singular) narratives being forged in the post-colonial era. The characters grapple with these unceasing shifts in the form of a profound inner, psychologised set of emotions and thoughts that stimulate the activation of character in response to the violent events of the harsh township streets. In this way, the false homogeneity, forged by the binaries that stereotypes create, is collapsed in theatrical character construction.

Further, the gritty realism engages with the satire of the grotesque of classical protest theatre and this helps develop intertextual approaches to story-telling.

Thus, overall, the play aims to combine a counter to the legacy of apartheid with a critique of aspects of post-apartheid societal constructs.

The Subjective as a Contemporary Site of Protest

A recent play that exemplifies this contemporary development of the classical protest theatre approach where, during apartheid, the subjectivity of the subaltern was represented in the group, is *Volume Please* by Mxolisi Norman (staged in the UK in 2018). This is achieved by subjective memories being narrated by a single character.

We see this in the play as the character wrestles with his inherited trauma of his part mixed race, part black Xhosa, racially constructed identity. Growing up in an apartheid township, we hear his story of being in the violated, framed, colonised black body. As the play unfolds, we witness the historical echoes of his inner struggles, how the world frames

the stereotyped black body, and how he feels being in exile/invisible in his country.

Much of this internal conflict is located in the character's relationship with his father, who constructed himself as a mixed-race person during apartheid in order to have a 'better life than the black man' as the apartheid phrase went. The character contrasts his inner contradictions with his diamond-smuggling, outgoing, township gangster, streetwise, finally imprisoned father.

Ultimately, we observe how multiple identities, multiple paradoxes, and multiple histories are portrayed in the one character as he relates to his imagined father. This gives rise to an in-depth exploration of the group being represented in the subjective who contest 'history's insistence on singular narratives' (to adapt Adichie's phrase) with its colonial/apartheid constructed identity arranged to ensure that power is served by the servitude of the racialised body.

As the author puts it: 'the autobiographical form triggers multiple narratives and invokes a fluid movement (between the inherited binary and its counter narrative) ... which subvert ... the inculcated legacy ... and ... embeds a diverse, fluid subjectivity.'[23]

This constitutes a significant, contemporary protest theatre aesthetic which exhibits a rough, ceaseless dialectic between the periphery and the centre. The poor theatre traditions of protest theatre are employed in the aesthetics:

- a few props
- one actor employing numerous 'voices' (the son, father, the streetwise township boy, the intellectual, the poetic in song, the rural memories, hip hop, jazz, history/memory as site of contest)
- a musician who sings in Xhosa and plays jazz
- minimal set
- ancient story-telling techniques
- sudden shifts in space and time

But it is the notion of multiple identities and memories in a single subjectivity that frames the theatrical experience. It does not only locate itself in the context of socially-engaged art or an ideological transaction, it is a protest against the legacy of the naturalised binaries and critiques the only partly-achieved South African drive to decolonise the colonial/apartheid master narrative fully. It is protest as a counter-narrative,

which also profoundly develops further the traditional post-colonial discourses of resistance/oppositional performance.

Further, the jazz music subtly underscores most of the performed text, and the audience experiences this in negotiation with protest theatre's aesthetic of a satire of the grotesque. The gentle jazz sounds ironically heighten our sense of imagining the parodied, grotesque coloniser white figures who are located in the character's memory.

Another important play in this genre is *He Left Quietly* by Yael Farber (2002). It tells the story of Duma Khumalo who spent four years on death row during the last years of apartheid. He was released as the negotiated revolution was beginning in secret. He committed no crime, and the subjective trauma of his life on death row is similarly told in the way protest theatre negotiates the terrain between the social autobiographical turn, trauma, and memory in a similar aesthetic as experienced in *Volume Please*.

A Literary and Visual Protest Theatre

Anti-apartheid protest theatre employed devising as one of its core approaches to theatre-making. One of the primary areas of contemporary protest theatre is the ongoing evolution of a focus on the literary text with an attendant aesthetic focus on the visual which incorporates stage images in story-telling. This enhances, not replaces, the traditions of devising which continue to be core in theatre-making. South Africa has eleven official languages and the writerly and visual text and staged action, further helps to collapse binaries of the past as the 'dialogue' of languages and images posits a staged fluidity of intertextuality of identity formation in the characters.

This destabilises the binary of stereotypes as the hegemonic dominance of one language (formerly used by power to frame, categorise, interpret 'reality' and knowledge) now engages with multiple languages and identities. Through this, cultural and individual agency is enhanced, a counter-narrative to apartheid's singularity of narrative challenged and history and contemporary experience literally 'rewritten'.

For many years, the global shift to an emphasis on what Marranca[24] has called a 'theatre of images' is well known. In the South African context, the multiple meanings of visually staged images as part of constituting story-telling not only reflects this global and technological influence, but also engages with counter-narratives. It achieves this as the images

created suggest multiple meanings, multiple histories and memories as well as multiple interpretations of the constantly evolving collisions of post-apartheid realities.

Armed Response by David Peimer, first staged in Johannesburg in 2007, reflects this emerging trend. The play is about a young German photographer who is on assignment in Johannesburg to film the music scene. Excited and free spirited, she meets Vusi, who works for the armed response security company.* Vusi is a streetwise, youthful, inventive man who is trying to sell her a contract.

As she meets her neighbours, corrupt police and gangsters, certain strange, frightening experiences affect her. She gets caught up in the corruption, real fear becoming paranoia, as well as pressure from the company to take out a contract for her protection.

The play's themes of freedom and fear within the new democracy are located within the context of the neoliberal privatisation of security in South Africa. Here, armed private security guards outnumber police by 5 to 1 in a multi-billion-dollar business. The play explores the question: What happens to ordinary people, hegemonic ideological constructs and societal perception of itself when policing is privatised? For these companies, no crime means no business, no profit. Crime does pay.

Although primarily written in English, the languages of a range of ethnic groups are crucial to the text, as are the rhythms of an emerging South African intertextuality of languages in contemporary discourse. This reflects the reality of current South Africa as, for the first time since apartheid, school pupils have to learn other African languages, histories and cultural notions.

This exposes the legacy of the arrangements of power and its attendant binaries, not just as resistance to that hegemony, but helps illustrate Foucault's knowledge-power-language paradigm which, when exposed, leads to an articulation of a counter-narrative. Implicit in this is the South African notion that protest is not only defined by Kershaw's notion of oppositional ideological transactions, but that, in this context, protest theatre always was, and continues to be, a profound combination

* Privatisation of security in the country and private security/policing is the second biggest industry in South Africa and employs over half a million armed guards, is a multi-billion dollar international business and part of the neoliberal, global development of privatisation. Given the paucity (and part corruption) of policing, individuals (who can afford it), businesses, schools, hospitals, malls, workplaces, factories and government buildings all have contracts.

of the way resistance and opposition to hegemony inform, frame and constitute a primary aspect in the creation of counter-narratives.

In this way, the play aligns itself with being a protest and counter-narrative to the legacy of apartheid and a critique of aspects of contemporary South African life.

Throughout the play's action, grotesque steel bars slowly rise and by the end of the play, the 'outsider' German character's home is surrounded by bars, suggestive of security from crime, apartheid prison memories, physical safety, fear, private/public spaces – ultimately an ironic and imagistic multiplicity of meanings are produced. This can be seen as a development of classic protest theatre in how it contributes to an ongoing and evolving satire of the grotesque being actioned by visual images, not only the social body.

In addition, whilst other images further complement the textually based narrative, the play also employs the notion of classic protest theatre, as outlined above, in its use of few props, actors performing numerous characters, sudden transformations in space and time, song, music, dance.

Classic Protest Theatre Aesthetics Today

The Fall by University of Cape Town students, staged at Cape Town in October 2016; the Royal Court Theatre in October 2017; and Edinburgh Festival Fringe 2017 – where it won prestigious awards (*Scotsman* five-star award, *Stage Edinburgh Award* for acting) – embodies this notion.

The play is about the controversial student movement and following discourse that centred around the removal of the colonialist Cecil Rhodes's statue from the University of Cape Town. It is based on the real events of the two movements in South Africa: the #RhodesMustFall and #FeesMustFall demonstrations in 2015–16. These movements led to the statue being removed from the university campus and the government 'reviewing' the rise in university tuition fees. As the students stated in their programme notes for the Cape Town production: 'We stand firm and resolute in our call for decolonisation in our country and across the world.'

As colonial and patriarchal icons are being challenged and dismantled as part of a global phenomenon, the production goes to the heart of the contemporary intersections of race, gender, power and histories being

positioned as counter-narratives. The play tells the stories of students caught up in the event and their personal response to it. It 'stands for student revolt around the world' as the critic, T. Dibdin, put it in *The Stage*.

The play is not only a protest in theme (collapsing the historical binary of a colonial icon which leads to a countering and decolonising of a singular colonial narrative – the cultural representation of Rhodes), but also employs the classical aesthetics of protest theatre. This illustrates how embedded the genre is in the mainstream of post-apartheid theatre.*

It further demonstrates how central, in aim and aesthetic, the great anti-apartheid protest theatre plays remain in South African theatre-making, as the country now focuses on countering the histories and memories of the past (colonial icons included) and critiquing current societal realities (for example, high student fees).

In *The Fall*, the dramaturgical structure sees the subjective represented in the group, and in the violated and violating black body, and, overall, reflects classical protest theatre aesthetics, as a way of critiquing current South African realities.

Conclusion

Thus, it can be observed that post-apartheid protest theatre (in its original format and as it evolves with new subject-matter and contemporary aesthetics) is more than a colloquial sense of the word 'protest'. Its aim is the interrogation of the binary, the counter to the inherited singular colonial/apartheid narratives, a challenge of aspects of post-apartheid society, and a decolonising of historical master narratives.

* It is interesting to note the beginning of a negotiated interaction between the classic *protest theatre* aesthetic of a grotesque/satirical/parody of the social body and an emerging, gritty realism. The play *Relativity: Township Stories* by Paul Grootboom and Presley Chweneyagae (first staged in Johannesburg, 2005) is about a serial killer on the loose in a township. The physicalised violence (rape, murder, assault) in the play is captured in a style that reflects this aesthetic negotiation. South Africa has become one of the most violent countries on earth (20,000 murders a year, 40,000 rapes including thousands of baby rapes, 150,000 assaults, rampant car hijacking, robbery, bombing of banks). 'Life is hard, death is easy' is the phrase from the play that expresses its central concern. Such extreme violence by poverty-stricken, township men with nothing to lose suggests a sense of an identity brutalised beyond humanity. The sense of abandonment through the lack of work (30 per cent youth unemployment), results in an identity abandoned by the new dispensation in the harsh Johannesburg streets.

In attempting to achieve this, it represents a rough, ongoing, partly shaped dramaturgical adventure, aiming to articulate a moment of the great post-colonial/apartheid story.

THE LOST ART OF AGITPROP AND
THE RETURN OF SOCIALIST PRAXIS
Rebecca Hillman

'If you believe in a fight for socialism then of course political theatre is relevant. And it is your job to make it so.' North West Spanner, 1978

'As the UK Labour Party aims to organise its forgotten heartlands, it can learn from a rich history of socialist culture in working-class communities.' RMT official and International Officer of Young Labour, 2018

Since 1968, the financial support, ideological frameworks, and industrial bases of theatre groups that routinely engage in specific political struggle have been eroded, and scholars have argued that 'we no longer live in the days when playwrights wanted to explain to their audience the truth of social relations and ways of struggling against capitalist domination.'[25] Nevertheless, I believe this volume is timely, not only in relation to the 50-year anniversary, but also to the present moment and what it tells us of the years immediately ahead.

I want to offer an argument for the value of past cultural forms for contemporary artists and activists today, building on a detailed defence of agitprop theatre that I made a few years ago.[26] Taking 1968 as my starting point I will examine two contrasting accounts of political theatre made in the UK between the late 1960s and early 1980s, and ask how the authors' perspectives map on to different approaches to theatre-making and political organisation at that time. I go on to focus specifically on Catherine Itzin's book *Stages of the Revolution: Political Theatre in Britain since 1968*, which provides a reference point for this publication as well as my analysis, but whose substance has been challenged by theatre scholars. I ask whether considering the book an 'activist text' might contextualise her approaches and encourage in the reader a proactive approach to the book and the work she focuses on. I go on to consider the relative obscurity of agitprop theatre history and the lingering unpopularity of the form, in relation to a burgeoning interest among young activists in

recalling ideas, aesthetics and methodologies that characterised socialist cultural activity in the twentieth century.

1968: Conflicting Accounts

1968 is a year referenced repeatedly in British theatre historiography as a watershed moment, when a generation of political artists were 'kicked awake' by activity on the continent.[27] Mass wildcat strikes, street battles and occupations of factories and universities in France, as well as of universities throughout Western Europe, were accompanied by radical artistic critiques. Meanwhile, in Britain, the abolition of the Lord Chamberlain's jurisdiction on the licensing and censoring of plays and the increase of funding for the fringe granted theatre-makers on the alternative circuit some creative and economic relief.[28] For scholar-activist Catherine Itzin, a combination of these factors, as well as the disjuncture between what a generation of young artists 'had been educated to expect, and the reality of the world around them', meant the year saw nothing less than the start of a socialist theatre movement in Britain, propelled by an 'unprecedented consciousness and activism'.[29]

Yet a tendency to over-emphasise the significance of 1968 for cultural shifts that were to occur over the next decade has been challenged, as has the sense of optimism that characterises the best part of Itzin's book, *Stages of the Revolution*. Theatre scholar John Bull claims, in *New British Political Dramatists*, that it is 'difficult to believe [Itzin] is prefacing a book on British drama'.[30] He objects to what he sees as a glossing over of the complexities of a range of factors towards the end of the 1960s, which, as he saw it, influenced the cynical and pessimistic tone of political theatre that would emerge over the next decade. While insurrectionary activity elsewhere provided the 'cutting edge' of inspiration for political dramatists in the UK at this time, for Bull it was 'primarily the experience of the immediate past and its lessons of failure and compromise' that influenced their work through the 1970s.[31]

In the UK, dwindling faith in the Labour Party's ability to implement radical reform grew at the end of the 1960s, feeding broader scepticism as to the progressive potential of parliamentary politics or traditional left organisations.[32] Meanwhile, although the new counterculture on the continent stemmed from the same Marxist analysis that informed orthodox modes of class struggle, it brought into question the fundamental binaries of work and leisure; conditions that underpin not only

the capitalist economy, but also the logic and demands of organised labour. The new radicals were thirsty for a fundamental uprooting of the capitalist system, which would not simply improve working conditions but would transform the life-world of the worker-consumer. Despite nurturing syndicalist perspectives and attempts to form alliances with workers, their approaches were not industrially based and their relationship with trade unions was underdeveloped. This fundamental disconnect meant that despite its initial force and the potent imagination of the movement, it struggled to make a sustained impact beyond the cultural realm.[33]

While philosophies and strategies of that movement continue to inspire activists and artists today, its legacy also speaks of a failure to implement integrated, pragmatic change. Business as usual was promptly resumed in France, with Charles de Gaulle winning the June 1968 election with new levels of popular support. This, Richard Nixon's comfortable victory in the US elections of 1969, and the re-election of a Conservative administration in Britain the following year were some of the factors that led Bull to claim that for those on the left 'the "swinging sixties" went out with more than a suspicion of a whimper.'[34]

An Activist Text and the Lost Art of Agitprop

Actually, while including political scenarios that Bull omits from his introduction,* Itzin's *Stages of the Revolution* betrays some of the same disillusionment, and a keen awareness of the anger that fuelled political work at the time. She speaks of an 'aggressive' generation of theatre-makers, the war babies of 1939–45 come of age, who, disenchanted with their lot, began to 'dismember [their] inheritance on stage'.[35] Nevertheless, it is fair to say that the tone of her book stands in sharp contrast to Bull's in foregrounding a sense of hope, strength and solidarity, rather than despair, confusion and fragmentation.

I do not believe that this emphasis is arbitrary, however, or naive, as Bull suggests. Rather, it seems to relate to the kind of practice that Itzin focuses on. Political theatre-making of the period has traditionally been split into two camps of avant-garde and agitprop approaches. While their

* See Itzin (1980). Events cited include among other things the Tet Offensive, the peak of the Chinese Cultural Revolution, anti-imperialist campaigns in Latin America, important shifts in the women's movement, and riots in Warsaw, Belgrade, Berlin, Tokyo, Mexico City and Milan.

mutual influence and the movement of practitioners between one 'camp' and another is acknowledged, avant-garde artists, inspired by new countercultural trends of the time, were often interested in 'bypassing the discourse of orthodox political debate'.[36] On the contrary, many of the practitioners Itzin focuses on were embroiled precisely in those debates as part of their routine engagement in collective struggle.

While *Stages of the Revolution* and *New Political Dramatists* have obvious connections and overlaps, they diverge fundamentally in content and form. The historical analysis offered by each author contextualises the practices they discuss, which, although happening across the same time period, occupied different political and theatrical landscapes. Bull offers a detailed analysis of plays of four major playwrights, who, more-or-less disillusioned with agitprop approaches, created the majority of their work in subsidised theatre venues. Itzin, on the other hand, provides space for 'theatre activists' who remained embedded in working-class communities and left organisations to discuss the explicitly agitational and participatory work they created for the shopfloor, picket line, rally or meeting room.[37]

How the books are written, as well as reflecting the nature of the work documented, presumably also relates to each author's intended readership, and the way in which they wanted those readers to engage. Itzin's use of the term 'theatre activist' is interesting, and it strikes me that her book not only documents very accessibly theatre practice that intervenes in real-world situations, but also that the perspective and tone of the book might instil in the reader essential qualities of the activist: a sense of injustice, and a sense of hope. I wonder what happens, then, if we consider her book as an activist text, written by and for political agitators and artists – or artists who would be agitators – who can gain insight for their own work, as well as a sense of why the approaches they are reading about are important? Viewing the book in this way means that the optimism that has undermined the value of Itzin's work for some scholars becomes vital. At least as vital as the branch social, or as singing on the picket line, or as the work of the theatre practitioners whose thoughts form the substance of her book, and whose practices tempered the trying conditions that often characterise sites of resistance. Hope is after all essential for transforming a sense of urgency into agency, and for making perseverance possible in the long haul of political struggle. In fact, in relation to activist practice, we might consider despair and optimism two sides of the same coin, remembering that the more

profoundly the former is experienced the deeper the activist must dig for the latter.

While I have focused on two particular books, the different approaches of these authors point to a broader issue, which is the scarcity of detailed analyses of agitprop theatre and, more generally, art in the service of political activism. There are a few reasons why I consider this a significant loss.

At a basic level, histories of struggle offer alternative perspectives to mainstream discourse, and allow us to imagine change in our own contexts. More specifically, as Larry Bogad suggests in his book *Tactical Performance: The Theory and Practice of Serious Play,* the absence of an archive of activist strategies, artistic or otherwise, prevents new generations from developing effective interventions rather than simply reinventing the wheel. For Bogad, this puts social movements at a serious disadvantage against opponents who can better afford to construct what he refers to as the 'institutional memory' of social conflict.[38] It is as a small attempt to illuminate a fragment of the *memory of social movements*, and to encourage a proactive reading of the rich history Itzin documents, that I offer, in this rather dusty corner of theatre studies, an alternative perspective on her work.

As for the merits of analysing agitprop specifically, you would be forgiven for asking what those are. Even where the enduring relevance of political theatre has been fought for, agitprop has been perceived as simplistic, hectoring and even 'suspect'.* Popular information sites describe agitprop as a term levelled accusatorily at socialist artists rather than one adopted willingly, which we are told reflects 'western distaste for the overt use of drama and other art forms to achieve political goals.'[†]

While theatre-makers in the UK at the start of the twenty-first century have produced politically-engaged work, this analysis rings true in terms of their tendency to be wary of being classified as a 'political' artist, or to be associated with agitprop theatre specifically.[‡] Activist playwright

* See, for example, Pearson (2001) p. 201; Howe-Kritzer (2008) p. 63; Botham (2009) p. 308.
NB: Botham is an unpublished PhD thesis, available from the University of Worcester library.
† See, for example, *The Encyclopedia Britannica Online*, or Wikipedia's page on agitprop.
‡ For playwrights wary of being associated with the term 'political' in the early 2000s, see Howe-Kritzer (2008) p. 7; or, by way of a very different example, see theatre company Take Back, who formed in 2015 to tackle austerity politics and whose company members self-identify as socialist, who are nonetheless praised for

Anders Lustgarten mentions agitprop in the preface to the script of his play *If You Don't Let Us Dream, We Won't Let You Sleep*. *If You Don't Let Us Dream*, which was staged at the Royal Court Theatre in London in 2013, debunked government and media spin around the necessity to cut services using short scenes, sparse staging, multi-rolling, and gags that relied on localised and popular knowledge. Characters were not developed in terms of their individual or psychological traits, but in terms of their social and political lives, and in just enough detail to construct an argument that austerity and debt amount to jargon designed to line the pockets of the rich after they receive their tax-breaks.

Given this detail, one can understand why, on seeing the show, critic Andrzej Lukowski was compelled to ask whether we were experiencing a resurgence of 'no frills agitprop theatre in the wake of the mounting ravages of austerity'.[39] I am reminded here of, for example, Kathleen McCreery's description of Broadside Mobile Workers' Theatre's 1976 show *Now You See It, Now You Don't*, which attempted, through a shrewd alternative analysis and accessible dramaturgy, to counter the government's 'tighten your belts' and 'get the country back on its feet' line, and the economic viewpoint being put across by the media that 'investment can be stimulated by the transference of funds from the public to the private sector'.[40] Yet for Lustgarten, while in 2013 it was time 'for the return of proper political theatre', this did not mean 'old-style agitprop'. Rather, he proposed that '*anti*-prop' would take on 'the overwhelming reality of 2013: the propaganda of markets that they're indispensable'.[41] While his play surely constituted a form of propaganda, he denied the legitimacy of undermining one form of propaganda with propaganda of one's own.

Journalist Paul Mason, who happened to see Lustgarten's play, pointed out that it's a shame 'stuff like this is not taken out and performed in aggressive theatre spaces, close to real life'. He went on to acknowledge that 'at least agitprop did relentlessly take this visceral theatre language to ordinary people.'[42] My sentiments resonate with Mason's here, except I don't see the commitment of agitprop practitioners to work in community contexts as somehow conciliatory, but, rather, as one strategic political approach among many.

not being 'bogged down' in 'old-fashioned agit-prop': www.takebacktheatre.com. I have found a similar tendency with new writers and members of traditionally radical groups, including Red Ladder and Mikron Theatre; see Hillman (2015).

As I mentioned in my introduction, I have published a detailed defence of agitprop theatre created in the UK in the 1970s (or, at least, theatre of that period that has been categorised as agitprop, even where its own practitioners resist the term). There is not room to repeat those arguments here, but suffice to say that accounts reveal the thoughtful approach of theatre-makers to political theory, their careful navigation of didacticism, and their commitment to producing work that can be defined by its dialogic and active relationship with audiences.* I also want to note that agitprop might be seen as inherently complex for its ability to decode representations of reality, identify points of change, and unpack the workings of political and economic systems, transforming them into comprehensible signs and metaphors with emotional currency, often in unpredictable working environments. Finally, I will say that there is evidence this work was received positively by its intended audiences and participants – including activists who commissioned the work in the first place – and that it compelled communities of workers or residents to engage, or to engage more fully, in ongoing campaigns.†

There are multiple reasons why I am interested in accounting for the complexities and achievements of this style of theatre, and in considering its contemporary relevance. As a director and activist, I have found combining agitprop forms with other theatrical approaches effective for mobilising people around current political issues, while my work has also been enriched through intellectual exchange with, and financial support and comradeship of, trade unions and trade councils. I am therefore keen that others interested in contributing creatively to specific political projects might gain insight from some of the formal and integrated approaches that characterised the work of many 1970s political theatre companies. I am also interested in what we might take from the openness of those companies to expressing a clearly rooted political and ideological stance, and how this resonates with a growing consciousness on the left.

The Return of Socialist Praxis

Over the past few years I have become aware of a number of instances where artists are using the word 'socialist' to define their practices,

* See, for example, Bowdler (1975) p. 5; Seyd (1975) p. 37; Itzin (1980) p. 325.
NB: The Bowdler interview and Seyd article are unavailable.
† See Itzin (1980) pp. 45–7 and 321–5.

which seek to galvanise action around political issues. Meanwhile, young activists have noted the importance of returning to cultures of the past to strengthen current campaigns. I offer just a few examples in the following paragraphs.

Salford Community Theatre are a socialist company who employ the community theatre model to encourage the involvement of local residents in their plays, and who draw historical parallels to agitate over issues such as welfare cuts, unemployment and gentrification. Their work has been produced with support from the local labour movement, and the company see their practice as part of a broad cultural and political turn whereby ideas of the radical left have re-entered mainstream discourse. In future projects they aim to contribute to the 'rebuilding of the left both locally and nationally' as part of the mass grassroots movement that has formed under Jeremy Corbyn's leadership of the Labour Party.[43]

Common Wealth Theatre are another working-class group who describe their work as 'rooted in socialist politics'. Their most recent production with the National Theatre of Wales, *We're Still Here,* told the story of the Save Our Steel Campaign at the Port Talbot steel works through the eyes of workers, local residents and union representatives. Despite the performance's site-specificity, the company view it as having international relevance in that it demonstrates 'how capitalism and globalization creates ghost towns with little thought for the people who live and work there', while it also 'speaks to the changing landscape of the UK, the people that get left behind and those that fight'.[44] Common Wealth consider their performances 'campaigns', and 'a way of bringing people together, and making change feel possible'.[45]

As well as new companies, theatre groups who made work in the 1970s but who had, to some extent, departed from their agitprop roots have gestured a return to the radical. Red Ladder, for example, has in recent years produced shows like *Big Society! A Music Hall Comedy* in 2013 or *We're Not Going Back,* a play about the 1984–5 miners' strike produced in collaboration with Unite the Union in 2015. Or there is Mikron Theatre, which has drawn parallels between the Luddite uprising, austerity Britain and the 2011 riots, and made agitational plays tackling NHS cuts. Banner Theatre, whose work always remained embedded in the trade union movement, has recently been involved in an initiative with the General Federation of Trade Unions and the University of Exeter to explore the full potential for the unions of 'the arts as a powerful yet under-utilised resource'.[46] This has brought activists and artists together

to question what practical steps might be taken to forge progressive partnerships in the current climate.[47]

We might view other projects in connection with this trend, albeit that they embrace different cultural approaches. For example, the organisation Momentum, which supports the left leadership of the Labour Party as well as running events locally, has developed the World Transformed event, which takes place annually alongside the Labour Party conference. The week-long programme has sold out two years in a row, and offers a rich mixture of discussions, workshops, performances, screenings and social events.

Unlikely art activists are also turning their focus towards a socialist politics. For example, Brandalism, an international network of graphic designers and graffiti artists who disseminate climate-conscious and anti-corporate 'subvertising' in stealth operations on billboards and bus stops, decorated the session spaces of the World Transformed in Brighton in 2017. It also produced pro-Corbyn street art in the run-up to the snap election in 2017, and has been approaching trade unions about possible collaborations on future projects.

Even the aesthetics of protests themselves mark a shift; for example, the 'red bloc', whose large crimson flags, disciplined marching and post-punk soundtrack have appeared over the last few years at various anti-Conservative Party or pro-Corbyn demonstrations. The bloc demonstrates a youthful reclamation of political identities associated with communism and socialism specifically, signalling that those 'grand narratives' of the early twentieth century, far from being obsolete, are being revivified.

It is against this backdrop that trade union officials, prominent Labour Party members, and activist authors have begun to address the importance of socialist cultural history in building a movement in the UK today, and it is the younger members of the movement who are leading the charge. Max Shanly, member of the Young Labour National Committee 2013–18, recently put forward a proposal for inclusion in Labour's Democracy Review, in which he acknowledged the loss of 'a once vibrant socialist culture that existed in [British] working-class communities'. Shanly points out that 'grounded sentiments of collective resistance were built up over generations by the labour movement' but claims that a retreat from this kind of day-to-day engagement has meant a critical detachment of party voters and potential activists.[48] He sees the current mass membership of Young Labour as an opportunity for

popular mobilisation, which might '[bridge] the gap between horizontalist networks and the labour movement's well-established traditional hierarchies and internal culture'.[49] Returning to 1968 for a moment, and the revolutionaries I discussed at the start of this chapter, I find this last point interesting in relation to the present day, where horizontalist networks like Brandalism, which takes influence from 1960s counter-culture, organise around the same manifesto as those who march in formation under red flags.

Building on Shanly's proposal, and inspired by the activities of Walter Greenwood, Ewan MacColl and other socialists based in Salford in the mid-1900s, International Officer for Young Labour and Regional Official for the RMT, Marcus Barnett, has made a case for rebuilding 'ecosystems of socialist culture', which would 'weave together youth culture with socialist organization'. For Barnett, today's 'red bases' include socialist food and clothing banks, sports and social clubs, and community theatre companies such as Salford Community Theatre. Barnett sees Labour's new community organising unit as having potential in relation to this activity. He suggests that it could be utilised to place 'popular left-wing politics ... convincingly in a local context', counteracting 'demoralization and far-right activism', and instrumentalising no less than 'the revival of British socialist politics'.[50]

As these exciting programmes unfold it is my concern that theatre's agency to play a part in them may be limited by a wariness of instrumental art in theatre and performance studies, and a neglect of theatre practice that seeks or has sought to rally people to a cause. Over the last decade I have repeatedly come across young, politicised artists who struggle to find an applied use for their work because their lack of political education is compounded by their lack of exposure to activist theatre companies, past or present. They are always enthusiastic when we talk about the possibility of the kind of collaborations fostered by such companies, and often ask how they might make the relevant connections. This enthusiasm is hardly surprising, given the context in which they have grown up.

Conclusion

Catherine Itzin notes that in the UK in the late-1960s young people could see clearly, often for the first time, the contradictions between what they had been educated to expect, and the world around them. We might say

the same of Britain's younger generations today, except that rather than acknowledging that we 'have it good compared to (our) parents and previous generations' in many ways, the opposite is true. The explosion of the 'materialist myth' Itzin discusses in the opening pages of *Stages of the Revolution* means that we not only understand our standard of living to be at 'the direct expense of the sub-standards of the imperialised third world', but that we are also increasingly in touch with the material effects of capitalism on our own lives, and the lives of our friends, relatives and workmates.[51] For young people in Britain today, precarity and debt are the overwhelming reality. Increasingly, it is understood that without a radical shift in political and economic policy, the security that would be provided by jobs for life – decent pensions, a benefit systems and public services that are properly invested in, or affordable housing – slip further from reach to become nothing more than nostalgic notions. At the end of 2017, one in every 200 people were estimated to be sleeping rough; over one million three-day emergency food supplies had been given to people in crisis; and a shocking report in the *British Medical Journal* estimated 21,000 deaths to have resulted from health and social-care spending cuts since 2010.*

As I prepare to submit this piece, students are occupying the university where I work, as well as universities up and down the country, in solidarity with staff, in opposition to the marketisation of education, and maybe because the prospect of our precarious future resonates with theirs. Their support has been overwhelming, while the resolute and vibrant atmosphere of picket lines has led to comparisons with other, especially politicised eras. But it is important to remember while we celebrate that this is also a unique moment, and it is ours. As is written across one of the banners of an hourly-paid lecturer with whom I've been out on strike: 'now is the winter of our discontent.' We are deeply politicised, and our anger holds as much potential for change as it ever did. This year and all the years contain their own set of events and circumstances, and will resonate with those events and circumstances to which we choose to connect them. I note here that new activists are reaching for a history many gave up for lost, and ask what might be done to help them find it.

NOTES

1. Catherine Itzin, *Stages in the Revolution: Political Theatre in Britain Since 1968* (London: Methuen Publishing, 1980) p. 2.

* See Butler (2017); Trussell Trust (2017); and Watkins et al. (2017), respectively.

2. *Ibid.*, p. 41.
3. *Ibid.*, p. 41.
4. *Ibid.*, p. 42.
5. Kathleen McCreery, 2017, phone call, 22 June.
6. Itzin, *Stages in the Revolution*, p. 238.
7. Kathleen McCreery, 2017, email, 30 July.
8. *Ibid.*
9. Chimamanda Ngozi Adichie, *The Danger of a Single Story*, online video recording, TED Talks, 2009, viewed 9 April 2018, from https://tinyurl.com/pmfqwzv
10. Temple Hauptfleisch and Ian Steadman, eds, *South African Theatre: Four Plays and an Introduction* (Netherlands: HAUM Educational Publishers, 1984) p. 5.
11. Mark Fleishman, 'Physical Images in the South African Theatre', *Theatre and Change in South Africa*, edited by Geoffrey V. Davis and Anne Fuchs (Netherlands: Harwood Academic Publishers, 1996) p. 177.
12. Jen Harvie, *Fair Play: Art, Performance and Neoliberalism* (UK: Palgrave Macmillan, 2013) p. 1.
13. *Ibid.*, p. 1.
14. *Ibid.*, p. 2.
15. *Ibid.*, p. 100.
16. Baz Kershaw, *The Politics of Performance: Radical Theatre as Culture Invention* (London: Routledge, 2001) p. 7.
17. *Ibid.*, p. 8.
18. Adichie, *The Danger of a Single Story*, TED Talks.
19. Kershaw, *The Politics of Performance*, pp. 72–3.
20. *Ibid.*, p. 248.
21. Ash Amin, *Conversations in Postcolonial Thought*, edited by Katy P. Sian (New York: Palgrave Macmillan, 2014) p. 98.
22. Mxolisi Norman, Unpublished Interview (Johannesburg, 2008).
23. Mxolisi Norman, Unpublished Interview (London, 2017).
24. Bonnie Marranca, ed., *The Theatre of Images* (New York: PAJ Books, 1996) p. 21.
25. Jaques Rancière, *The Emancipated Spectator* (London: Verso, 2009) p. 11.
26. Rebecca Hillman, '(Re)constructing Political Theatre: Discursive and Practical Frameworks for Theatre as an Agent for Change', *New Theatre Quarterly*, 31.4 (2015) pp. 380–96.
27. Howard Brenton, 'Petrol Bombs Through the Proscenium Arch', *Theatre Quarterly*, 5.17 (1975) p. 20.
28. Chris Megson, '"The Spectacle is Everywhere": Tracing the Situationist Legacy in British Playwriting Since 1968', *Contemporary Theatre Review*, 14.2 (2004), 17–20, p. 19.
29. Itzin, *Stages in the Revolution*, pp. 1–3.
30. John Bull, *New British Political Dramatists* (Basingstoke: Macmillan Education, 1984) p. 9.
31. *Ibid.*, pp. 7–9.
32. *Ibid.*, p. 5.
33. Sylvia Harvey, *May '68 and Film Culture* (UK: BFI Publishing, 1980) p. 12.

34. Bull, *New British Political Dramatists*, p. 10.
35. Itzin, *Stages in the Revolution*, blurb.
36. Bull, *New British Political Dramatists*, p. 25.
37. Itzin, *Stages of the Revolution,* blurb.
38. Larry Bogad, *Tactical Performance: The Theory and Practice of Serious Play* (London: Routledge, 2016).
39. Itzin, *Stage in the Revolution*, p. 239.
40. Andrzej Lukowski, 2013, 'If You Don't Let Us Dream, We Won't Let You Sleep', *Time Out*, viewed 9 April 2018, from https://tinyurl.com/y8xf9047
41. Anders Lustgarten, *If You Don't Let Us Dream, We Won't Let You Sleep* (London: Bloomsbury Methuen Drama, 2013) p. xix.
42. Paul Mason, 2013, 'Alcopops, racism and financial dystopia', *BBC News*, viewed 9 April 2018, from https://tinyurl.com/y84enb43
43. Sarah Weston, unpublished paper on Salford Community Theatre (2017) *Liberating Arts Festival.*
44. 'We're Still Here', 2017, *National Theatre Wales*, viewed 9 April 2018, from https://tinyurl.com/yahs6mqm
45. Common Wealth Theatre, *About Us*, viewed 9 April 2018, from https://tinyurl.com/ycbr70a8
46. Banner Theatre, *Origins and Practice*, viewed 9 April 2018, from https://tinyurl.com/ydgq3bl9
47. Dr Rebecca Hillman, 2017, 'Rebuilding Culture in the Labour Movement: Collaborations for the Future and Celebrations of the Past', *Culture Matters*, viewed 9 April 2018, from https://tinyurl.com/y6wpv3ek
48. Max Shanly, 2017, 'Towards a New Model Young Labour', *Medium*, viewed 9 April 2018, from https://tinyurl.com/y7xkzdgp
49. *Ibid.*
50. Marcus Barnett, 2018, 'The World Within a World', *Jacobin*, viewed 5 April 2018, from https://tinyurl.com/y9jsaue9
51. Itzin, *Stages in the Revolution*, p. 3.

Scene 2
Working-class Theatre

INTRODUCTION

Kim Wiltshire

Many of those who worked in agitprop theatre from the late 1960s onwards would say they were making working-class theatre, and they would be right. They were making theatre with the working classes and for the working classes. So, if that is the case, what distinction are we making here by having a separate section specifically called 'working-class theatre'?

Much of the agitprop theatre made during these early days had been subject specific, aimed at a particular group of people and forming part of a particular activist protest. In our definition, working-class theatre came later, in the mid-1970s and into the 1980s, during that troubled time politically when trade union power was curtailed by the Conservative government of the day and as the heavy industries declined, unemployment soared, and what it even meant to be working class was called into question. Agitprop during this time began to suffer, as explored in the previous section, and the form began to decline, often moving into work for schools and young people, as some of the work Red Ladder produced during this period did. However, this decline opened up a space for a new type of theatre to be made for working-class people, theatre that went to their places of leisure rather than their places of work.

This type of theatre is probably best exemplified by John McGrath and his work at both the Liverpool Everyman and with his company 7:84.* McGrath laid out his beliefs in a series of seminars on theatre at Cambridge University, which were brought together for the book, *A Good Night Out.*[1] He believed that to get the working classes into a theatre, you needed more than a message. You needed songs and music, a human story and something that the audience could feel a part of. This

* The company name referred to the fact that 84 per cent of the UK's wealth was held by 7 per cent of the population – in 2017 that ratio had worsened, and if McGrath was starting the theatre company now, it might be better called 5:95.

as an ethos is not so very far from some of the agitprop music-hall-style shows and cabarets, but McGrath aimed to tell the stories of people and to create a sense of empathy, rather than a Brechtian message-based style of theatre – although there were also times he employed these kinds of theatre techniques too.

Another difference between the agitprop style and the McGrath style was that the direct link to activism was not there for McGrath. He saw a wider injustice that he wanted to tackle. Agitprop plays made with factory-workers aimed for direct political activism, they were played at factory gates; McGrath went for working-men's clubs. But the political message was no less potent. As McGrath himself says:

> [O]urs is a class society, and notwithstanding the welfare state, nationalisation, the TUC and the Labour Party, the class which owns, controls or manages private capital and state capital is a coherent social entity with immense power; the British state and its institutions are organized in the interests of that ruling class … .[2]

The target was broader, and so the sense of inclusion was broader. The focus on process and discussion lessened, as the theatre-makers concentrated on the audience having a good time whilst they watched a show that highlighted particular issues the working class faced. McGrath wanted a sense of community with his theatre, not something entirely new: you can go back to Joan Littlewood, who created a theatre base for her community. But the key to McGrath's work was the wider political view and the basic idea of the 'good night out'.

In this section, one of the plays we focus on is McGrath's play *Blood Red Roses*. This play is perhaps not one of McGrath's best-known ones, but it is interesting because, as director Bob Eaton discusses in relation to his production of the play for the 1981–2 season at the Liverpool Everyman (a theatre to which McGrath had strong links), it was written for a Scottish audience but then re-shaped for a Liverpool audience. The play depicts working-class lives, but aims for a theatre audience, rather than that of a picket line or tenants' association, as agitprop did. As this short extract shows, the play touches on themes that were highly relevant for the working classes in the early 1980s – working, family and juggling commitments, especially for women, as unemployment began to rise. This extract looks at the differences between how the older and younger generations were dealing with these challenges:

ELLA: (*getting up*) Well, I'm not going to stay here to witness scenes like that one and then be told to shut up!

BESSIE: Well, shove off then.

ELLA: You're as hard and heartless as that mother of yours. And if you go off and desert your daughter, as your mother deserted you, that little girl will grow up as bad as both of you …

BESSIE: (*looks at her*) I am not deserting my daughter.

ELLA: Then where are you all day?

ALEX: (*reasonably*) Ella, listen, you've no right –

BESSIE: Keep out of this, Alex.

 (*To Ella*) I'll tell you where I am all day – I'm at work, I'm staying up late with grown-ups. OK? And when my daughter grows up she'll love me and respect me for it, just as I love and respect my mother for doing what she had to do.

ELLA: Well –

BESSIE: And if you say one more word, I'll do something I'm likely to regret, so don't. I'm off to get Jane … she's my daughter. My responsibility and she's going to be alright.

Bessie goes. Ella gets up with attempted dignity.

ELLA: Well, I suppose I'm just old fashioned … but if I had been that girl's father, I'd have put her across my knee. And if I'd behaved like that in front of my husband, I'd have had a few bruises before the morning – and no worse for it either –

ALEX: Is that a fact?

ELLA: Yes – there's still time to mend her ways. Cheerio.

Ella goes out. The men wave her off vaguely.

SANDY: I've got some moussaka in the oven – Greek.[3]

As this passage shows, unlike perhaps his most famous play, *The Cheviot, the Stag and the Black, Black Oil*, which spoke directly to the audience, this play has a more social realist feel, is less directly polemical and attempts to integrate the politics within a story. However, as this next extract reveals, McGrath still uses his characters as mouthpieces to get his point of view across; from later in Scene 9, the two men are left alone, and the conversation quickly turns to their ideas about war:

SANDY: The secret of health and happiness is to keep on winning: but even if your side is winning, you personally could well be dead. Or maimed for life. For a soldier, a military victory is an abstract thing, like pure mathematics – of interest to all, of benefit to none. Are you planning for a victory, in your class war?

ALEX: Victory? Don't frighten me. My father was a red, my mother was a red, my grandfather was put in prison in 1916 and then again in 1926; and I've been fighting the class war since the day I was born, it's my element, like the birds need the air and the fish need the sea … Christ knows what I'd do if we actually won. I'd be out of date, without the necessary skills … I think I'd suffer that, though – I've given up a lot of life for the day capitalism crumbles … everything I believe in follows from that …

SANDY: What do you think will happen on that day?

ALEX: Chaos. Confusion for years and years. But eventually … well, put it this way – with capitalism, we've no chance to go anywhere except backwards – back to the 1850s. With socialism, we might stagnate for a year or two – but at least we have the conditions for moving forward –

SANDY: Where's forward?

ALEX: Well – first things first: to a longer life and a healthier life and a more comfortable life: for everybody. After that – well – onwards to different ways of being better, eh? Our Janie – she'll see all that. I won't.

SANDY: And that's what you're fighting for?

ALEX: You've got it in one.[4]

The idea of daily life, the class struggle, as a war that equals that of an actual physical war is discussed by these two men, one older, who has actually seen action, and one younger, who is carrying on the political fight. This type of writing, for a playwright, falls into the polemical; the questions of whether two people would actually speak to each other like this, of who the message is for, of whether there is a sense of 'preaching' to the audience, are ones any good dramaturge would ask of the writer. And yet, the questions are important ones; as Rod Dixon explores in the section above on agitprop, a theatre piece still has to entertain, whatever the political message. In this section, playwright Lizzie Nunnery explores

Bob Eaton's 1982 production of *Blood Red Roses* and contrasts this to her own play, *The Sum,* which premiered at the Everyman in 2017. She explores her own artistic position in using theatre to explore politics with a capital 'P' and how this approach to political theatre has fallen in and out of theatrical fashion. The section is completed with Lindsay Rodden's consideration of McGrath's ethos of theatre-making, in 'Plugging into History: Time-travel with John McGrath and 7:84.'

But first, Bob Eaton recalls directing *Blood Red Roses* in 1982.

BLOOD RED ROSES AT THE LIVERPOOL EVERYMAN

Bob Eaton

I became Artistic Director of the Liverpool Everyman in the summer of 1981, for the first year of my time there sharing the job with Ken Campbell. This rather odd arrangement had come about because Ken, being the mad genius that he was, had spent the entire year's production budget on his first production, *The Warp*. The theatre board, somewhat alarmed by this, asked me if I would come in and, alongside Ken, come up with a programme that operated on a 'neutral budget'. In other words, I was to put on plays that were cheap to stage and would be sufficiently popular to generate enough box office income to balance the books.

As luck would have it, the first three shows I programmed were successful at the box office. The first was *Lennon*. John had been killed less than a year previously and I knew that the show would provoke interest, both locally and in the wider world, but I also knew that if I got it wrong and appeared to be cynically exploiting people's grief I would be in big trouble. Fortunately, the city took the show to its heart and we played to packed houses. The second show was *Old King Cole*, Ken's own anarchic kids' Christmas show, which Ken directed himself and which, while not being a massive hit at the box office, was at least cheap to produce, rehearsing and playing in the daytimes, while *Lennon* played in the evenings. The third show was *Brown Bitter, Wet Nellies and Scouse,* which Ken had commissioned from local writer Brian Jacques before my arrival. It wasn't a piece of great dramatic literature, but by the time we'd kicked it around, re-written it and put in a load of new songs, it was a thoroughly enjoyable show which celebrated the indomitable spirit of the city and proved enormously popular.

So far, so good. But what to programme next? I had, throughout the 1970s, been a great admirer of the Everyman's work, under the direction

of Alan Dossor and then Chris Bond. The idea of a theatre company rooted in its community, reflecting and exploring the social and political concerns of that community through entertaining, popular, accessible work appealed to me enormously. I looked back over the company's work to see which strands of which writer's work I could pick up and develop and found myself faced with a rather odd situation. At about the same time that I began work at the Everyman, the 'Gang of Four', namely Willy Russell, Bill Morrison, Chris Bond and Alan Bleasdale, all of whom had been central to the work of the Everyman, took over the direction of the Liverpool Playhouse. Of course, they did not sever all connection with the Everyman, but it did mean the Playhouse became their focus, and it led me to look at another writer who had been central to the Everyman's work. John McGrath's *Fish in the Sea* and *Soft or a Girl* had been two of the Everyman's greatest hits in the 1970s and, although I had not seen either show, from what I knew of them they seemed to embody the Everyman ethos as well as any. I had never met John. In fact, I don't think I had seen any of his work, apart from the film of *The Bofors Gun*. I was, however, very aware of, and admiring of, the work of 7:84. *One Big Blow*, the 7:84 show which John Burrows had put together with the lads who went on to become the Flying Pickets, had been one of my favourite shows of recent years. So, I gave John McGrath a call and asked him if he had any scripts that he felt I should consider. He said he would send me a script of *Blood Red Roses*.

I read the script and liked it immediately. I liked the story it told, I liked its politics and, constrained as I was by budgetary concerns, I liked the fact that it had a small cast. I decided I wanted to include it in the theatre's spring programme and prior to putting it to the theatre board, I discussed it with the board chairman, Alan Durband.

Now, Alan was that rare animal: a chair of a theatre board who actually understood what that theatre was about. His reaction took me completely by surprise. 'John McGrath? Oh no, too dry.' He had no problem with the politics of the play but he felt it would not draw a popular Everyman audience. I felt he was wrong. He wasn't.

An article appeared in the *Liverpool Daily Post* on 4 March 1982:

Riddle Of A Missing Audience: A real life mystery was puzzling bosses at a Liverpool theatre yesterday – the mystery of the disappearing audience. In recent weeks the Everyman has been playing to packed houses … And their newest musical, *Blood Red Roses*, was expected to

repeat the success with its script by Birkenhead writer John McGrath, whose shows used to pack the theatre in the early 1970s. But the show opened this week to an audience of just 70 people.

So why didn't it work? As I write this, I am looking at the poster for the show on the wall of my room. It's a beautiful poster, one of my favourites, designed by Everyman Theatre designer Sue Mayes and based on an old trades union banner. What strikes me is that the poster describes the show as 'a Liverpool Musical'. It was neither.

It's a Scottish story, not a Liverpool one. John had written it for a Scottish working-class audience, an audience he knew well. He felt that it would translate to a Liverpool setting if we maintained the Celtic connection by making Bessie's granddad Welsh and changed the family name from McGuigan to Griffiths, but it just never quite felt authentic. Scottish audiences had obviously found it authentic because in Scotland it was. Peter Cheeseman, Director of the Victoria Theatre, Stoke-on-Trent, and my mentor in the early 1970s, always maintained that you can create something universal out of something specifically local, but you cannot always successfully transplant local cultural specificity to another locality, just by altering a few names, and expect the new audience to buy it. The more a show is truly rooted in its local cultural 'soil' as it were, the more of an issue this tends to be. The meagre Liverpool audiences who did come to see it appreciated the characters, the story and the politics, but they never identified with it, never accepted it as a representation of their community, never took it to their hearts as 'theirs'. And, crucially, not many of them came.

Nor was it a 'musical'. That we felt the need to proclaim it as such only shows that at heart we knew it did not have the elements of popular entertainment that would attract a mass audience to the Everyman. The play was written for performance in Scottish clubs and pubs where the audience would be part of the performance. When John came to see the show in rehearsal at the Everyman his initial concern was that the actors wouldn't be able to grasp the necessity of a performance style that included genuine contact with the audience. He soon discovered he had no need to worry. The cast included Noreen Kershaw, the original Trafford Tanzi, as well as Graham Fellows and John McCardle, veterans of many of my non-theatre touring shows as well as *Lennon*. The cast were more than adequate to the challenge of relating to a mass popular theatre audience. Unfortunately, that audience just was not there. They

knew that *Blood Red Roses* as performed at the Everyman did not have the elements of popular entertainment that would give them 'a good night out'. I don't know how they knew, but they did, and they stayed away in their droves.

But if *Blood Red Roses* proved to be a bit of a damp squib at the Everyman in 1982, the production did prove to have a future legacy, at least as far as I was concerned. By the late 1980s I was Guest Associate Director of The New Victoria Theatre in Newcastle-under-Lyme, once more working for Peter Cheeseman, with whom I had begun my career. Peter's speciality was the creation of 'musical documentaries' telling local stories, often in the actual words of local people. I had used Peter's documentary technique in creating *Lennon* for the Everyman and he asked me to come up with something that, like *Lennon*, used rock and roll and told a story specific to the New Vic's locality and community. This led to *Good Golly, Miss Molly*, a musical telling the real-life story of the residents of a street in Stoke-on-Trent who were battling to save their houses from demolition. The central character was Molly Gordon, daughter of a Scottish miner, politicised by the 1984 miners' strike, who, I came to realise, owed a lot to Bessie McGuigan. As Graham Fellows, who was in both shows, said to me one day in rehearsal: 'this is just *Blood Red Roses* with rock and roll, in't it?' It turned out to be the most popular show the New Vic had ever produced.

WAYS OF SEEING: CLASS, GENDER AND THE UNIVERSAL FROM *BLOOD RED ROSES* TO *THE SUM*

Lizzie Nunnery

When John McGrath's play with songs, *Blood Red Roses*,[5] was presented at the Liverpool Everyman in 1982, the show's poster was of a grand gold and red design, showing a shoeless peasant woman holding up a giant wreath, and tied around the wreath an array of socialist banners: 'The Cause of Labour is the Hope of the World', 'Co-operation and Emulation not Competition', 'Production for Use not for Profit', 'Art and Enjoyment for All'.

Sitting in the McGrath archive in Liverpool John Moores University, slipping this neatly preserved poster from its crisp brown envelope, I felt an uneasy excitement. Here was political theatre at its most direct and unashamed. Here was the giddy paradox of a piece of marketing denying

the profit imperative. Here was a proposal of theatre not only as a forum for debate, but as a revolutionary force. The suggestion of the poster, and of John McGrath's work as a whole, was that politics could take place within the theatre, that a play could be action rather than merely reflection. As the playwright incisively declared to a group of Cambridge University students in 1979, it was '*mediation* of reality' not 'meditation of reality' with which he was concerned:

> I am trying to discuss a more active intervention by the theatre in forming contemporary life and contributing to the future of our society.[6]

McGrath's Cambridge lectures were published as *A Good Night Out*, almost a guidebook for theatre as activism. As a playwright and a socialist, I have time and again come back to those lectures, drawn to McGrath's conviction about the collision of political content and theatrical form; his brilliantly articulated confidence that one is not necessarily sacrificed to the other. In working on my most recent play with songs, *The Sum*,[7] his voice has never been louder in my ear. The play was produced by the Everyman in May 2017 and performed by the newly reformed Everyman Rep Company. It was intended as a dissection of the maths of austerity and featured characters singing about politics and even about politicians ('Forgive me if I smiled the day that Maggie Thatcher died'). In the final scene the central character, Eve, yells an anti-austerity speech in front of a banner reading 'Save the NHS'. This kind of direct, mediating writing had crept up on me. The form did not feel like a choice, but a demand of the subject-matter and the moment. During rehearsals for the play, Theresa May called a snap election, and before the run was over her majority was threadbare and socialism was back on our lips as a serious proposition. When the characters sang 'Watch out, the boat is a-rocking' in the final moments of the play, there was a renewed possibility that this might be true, and night after night members of the audience rose to their feet to express their willingness for that change. I had been lucky enough to hit a political and social moment in which my play could echo: never before have audiences responded so warmly to my work, with women hugging me (always women) in the bar afterwards, telling me: 'That's me. That's my life on that stage.' And yet amongst the artistic community I felt a more ambiguous and guarded response. As I saw political ideas painted in such broad strokes on stage (broader than I'd dared in any previous

work) I did find *myself* wondering 'Is it artful enough? Is it art?' And then another question: 'Does it have to be?'

I began to work with the Liverpool Everyman over 30 years after McGrath's time there. In 2004, fresh from an English degree, I joined the theatre's Young Writers Programme, and soon after also joined the staff as Literary Assistant, hungrily reading piles of unsolicited scripts, battling through endless admin, joyfully breathing in the atmosphere of a theatre regenerating itself as a vital space for new writing. In many ways the spirit of McGrath's days under Artistic Directors Bob Eaton and Ken Campbell was still evident. The publicity blurb accompanying *Blood Red Roses* described 'a show rooted in everyday life' and an 'absolute priority ... to give people ... some enjoyable music, a few laughs and a good night out ... '. These were still the values passionately discussed in meeting rooms and in the Everyman Bistro in the mid-2000s. We were telling stories to and for the working-class city of Liverpool. Literary Manager Suzanne Bell would speak evangelically of the need to hit 'head and heart'. A piece of theatre that only impacted on the former was not acceptable.

However, we also talked about 'politics with a small p, not a large one', careful that political ideas should not be too noisily or directly expressed, for fear that we would end up not making theatre at all but doctrine, or even worse, 'agitprop'. The British new writing culture of that moment was predominantly focused on naturalism (albeit often heightened or disrupted naturalism), and indeed on working-class or subculture stories. Plays such as Gregory Burke's *On Tour*[8] (which transferred from the London Royal Court to the Everyman in 2005) or Leo Butler's Royal Court success, *Lucky Dog*,[9] typified a style of new writing about contemporary Britain in which ideas about society were filtered through characters, not articulated by them. For a long time, this seemed to me the *only* engaging way to position social or political ideas for an audience. It also appeared somehow the most artistically dignified response. It was only in 2012 when Lindsay Rodden (then Literary Officer at the Everyman) introduced me to McGrath's work that I began to reconsider. Moreover, I began to make connections between McGrath's bold, interventionist style and the more stark and candid work of writers I already loved.

Brian Friel's *Translations*[10] is a tragic love story, but it's also a razor-sharp lament on the colonialisation of the Irish language, written for the people of Ireland in the midst of ongoing political violence. Timberlake Werten-

baker's *Our Country's Good*[11] (the first play I saw at the Everyman in 1999) features an Aboriginal Australian speaking directly to the audience about the disease and destruction that the British brought to that country. Dael Orlandersmith's monologue play *Yellowman*[12] (which received its UK premier in the Everyman in 2004) is a rasping howl against racial violence and unrest within the black community, the two characters pinning the audience with their stares and making them look. These plays, which I already knew inside out, were reawakened for me in their political motivations and were all the better for it. Their language was rich and beautiful, but their form deliberately simple. They didn't seek to meditate, but to mediate. Of course, by that time, the ground had shifted beneath us.

From 2008 onwards, we were negotiating a new political landscape, struggling to gain perspective on the crunch, the crash, the new reign of austerity. Post the 2010 general election, the emerging Conservative narrative of deprivation as a means towards progress spurred in me a desire to write more boldly, not to ponder but to *say* something. McGrath's work seemed strikingly of the moment: his damning articulation of the Highland Clearances in *The Cheviot, the Stag and the Black, Black Oil*,[13] or the oppressive rise of the conglomerate in *Blood Red Roses*. His definition of the struggle as a vertical class conflict incorporating oppressions traced to colonialism, and even feudalism, rang with a stark comprehensive truth. But the Tory landslide victory in the 2015 general election, and the subsequent Brexit vote, shook me. It shook up my notion of our national story. Was the struggle in fact a messy personal business? A horizontal negotiation with our neighbour for space and pay and a voice? Was it only the activity of patronising, disconnected middle-class liberals to believe in class war? I wrote *The Sum* out of these anxieties.

I wanted to test if socialist principles could still apply in specific modern contexts, could still resonate with an audience. I could not quite let the ember of belief die. So, I wrote with a clear agenda: to unpack the maths of austerity, particularly on women; to analyse the impact of living under it day to day at the bottom of the economic pile. Through Eve, I explored the effect of abandoning socialism, and abandoning herself to capitalist notions of worth. Perhaps I wrote in a more direct style than ever before because I was angry. I was reacting to the poverty I saw playing out all around me in my area of Liverpool. I wanted to galvanise anger, to share anger. I felt it was the best I could do. And given those

conditions and motivations of writing, 'politics with a small p' just was not going to cut it.

One reason John McGrath's work still feels radical today is his ambiguous relationship with so many of the supposed fundamentals of script-writing. In university tutorials and young writers' groups throughout the land, new playwrights are told emphatically 'show don't tell'. But the form of McGrath's plays suggests that sometimes showing can be telling: the message can be trumpeted, can be painted large, even spoken directly. Furthermore, his dissection of the notion of 'the universal' in play-writing carries with it a vital rethinking of the context and intention of much mainstream British theatre. As McGrath illuminates, that initially helpful mantra, 'the more universal it is, the better it is',[14] can become a damaging simplification:

> It is next to impossible to take the existence of various different audiences into account, to codify their possible reactions to a piece of theatre … So what do we do? Well, I'll tell you what most of us do – we take the point of view of a *normal* person – usually that of a well-fed, white middle-class, sensitive but sophisticated literary critic: and we universalise it as *the* response.[15]

The very sensible advice to any writer in any form is to go beyond the specific, to find the themes that chime with all of us, that unite and therefore humanise. So far, so socialist. But is it truly possible to write universally and with a political agenda? Is it disingenuous to suggest that the mostly left-leaning, liberal-minded plays on British stages today are really aimed at the widest possible human audience? As McGrath points out in that same lecture:

> What if we are black, say, and we go to see some splendidly effective, but completely racist theatre show? What if we are Jewish, and go to see some piece of anti-semitic drama such as one could easily see in Germany in the 1930s? … would we not feel demeaned, excluded from humanity, diminished in our possibilities … The meaning and value of theatre can clearly change from country to country, group to group, and – significantly – from class to class.[16]

If we accept this, then we simultaneously accept that any piece widely embraced by its audience is in some way skewed (for better or worse)

to that audience's particular cultural, social and/or political perspective. Knowingly or unknowingly, we are always choosing our audience, we are always writing with an agenda. Perhaps the only question is how far we go to veil and obscure this agenda through our choice of form, or, as McGrath would scathingly say, how far we go to clothe it in the 'all pervading air of mystery'.[17]

McGrath illuminates the risk of universalising 'white middle-class ... taste to the status of exclusive arbiter of a true art or culture'. I would add a word to that list: 'white, *male* middle-class ... taste'.[18] I am reminded of an experience I had at a feminist theatre conference around four years ago. The assembled feminist writers were divided into groups and asked to brainstorm ideas on how to counteract the gender imbalance on our stages and in our theatres. That all playwrights should be writing more female protagonists was wholly accepted. However, my tentative suggestion that there might be alternative female perspectives (that putting female stories on stage might mean altering approaches to play-writing) was met with unease by the group. I understood the drive behind this. The emphasis on difference between men and women can be problematic in a gender struggle that is by necessity focused on equality. I am of course aware how much damage has been done by male ideas of female difference. (I once was told by a young male playwright that there are fewer female protagonists because all the most dramatic things happen to men.) But what about female ideas of female difference? If we deny the potential for alternative narratives across the gender divide, are we not allowing reverence for 'the universal' to inhibit diverse views of society? In this way we can arrive at theatre in which male perspectives are (perhaps unwittingly) the norm, even if these roles are nominally gendered as female, and female actors placed within the shoes of men. Changing John to Jane in the character list is not enough. Casting a woman as King Lear or Othello is a vital step, but it is not enough. The same principle can of course be applied to race, ethnicity and disability. While we must always beware stereotype, a frightened or lazy adherence to the concept of the human 'universal' can in fact mean that we are not telling marginal stories at all, only giving the veneer of that. The significant shift towards gender or class equality in the theatre occurs when different ways of seeing are embraced, and those perspectives are allowed to shape form and content. The social and professional dominance of white, male, middle-class voices inhibits that. We arrive at a corresponding notion of what is universal, and risk

applying this to all work as an invisible standard. White, middle-class men in positions of power are understandably compelled by white, male, middle-class writers and plays. Who can blame them? So often there is a shared world-view. The fact that in 2017 less than a third of professionally-produced plays in the UK were written by women (the figures for main stage productions are wearyingly lower), shows that female voices are not being heard onstage and off. What is needed is a revolution in thought, in conversation. As long as we deny essential differences, as long as we speak only of the great artistic aspiration to 'the universal', the revolution will not come.

Time Out's review of the 1986 screen adaptation of *Blood Red Roses* describes it as a 'feminist saga'.[19] The press release for the Everyman's 1982 production says of character Bessie Griffiths: '*Blood Red Roses* is her story – the story of a woman trade-unionist and her battles, both local and multi-national.' In this play, as in *The Cheviot, the Stag and the Black, Black Oil,* and McGrath's 1975 Liverpool set piece, *Fish in the Sea,*[20] socialism and feminism intersect, with women depicted as the true warriors of our society. The episodic story of *Blood Red Roses* starts with Bessie's father Sandy returning from the Korean War, but quickly focuses in on his Glaswegian fist-fighter daughter and follows her journey from young rebel to politically aware, industrial militant and activist. Bessie is surprising, unconquerable, highly active in a physical sense, and in many respects resists cliché. Yet re-reading the script, I can't help but wonder if we are truly viewing this world or story through Bessie's eyes. Crucially, she never gets a monologue or piece of narration. These key points of story-telling and historic or social context are left to her husband Alex and her father. She is spoken about frequently, described often by the men of the play, and the effect is to mythologise her, to revere her, but frequently to translate her actions through a male gaze:

ALEX: Sandy – I admire your daughter -
SANDY: I should hope so. You married her.
ALEX: Aye, but … she scares the hell out of me … I'm no' sure I'm gonna stick the pace.
SANDY: No, maybe not. Her mother had the same effect on me.[21]

As they go on to discuss the place of the working class in international conflict, it is Sandy and Alex who are doing the seeing. In *The Sum* I was determined that the story should be channelled through Eve's perspec-

tive, and furthermore that she should be truly active: psychologically, emotionally, narratively. The challenge arose in doing this while simultaneously trying to express the masculine and capitalist forces acting to marginalise that character. Eve and Bessie are both working-class women buffeted by imperatives of profit and ownership. In Eve's case this extends to the ownership of her body, as she considers prostituting herself in a loveless relationship with her boss. Yet I wanted to ensure that Eve was not a passive victim of circumstance: that her actions had consequences, lined up the dominoes of cause and effect, and that ultimately, she regained some control of her journey. I had originally written *The Sum* as a play for BBC Radio 4, and in that process had pictured the piece primarily as a dark love triangle (Eve choosing between her hapless soul mate and her rich boss), but in reworking the story for the stage, I was struck by the necessity for Eve to go far beyond reliance on men, gaining freedom through connection with politics and community. In McGrath's characterisation of Bessie, I sense similar motivations. Her blazing trajectory as an activist brings with it a reordering of her family life, and an exciting abandonment of conventional roles. Bessie's father Sandy transforms from soldier to willing carer for his two granddaughters, with Bessie returning to work while her daughters are babies. The discussion of gender within working-class culture is skilfully handled in *Blood Red Roses* when Bessie's Aunt Ella rails at her niece for 'deserting' her baby in order to work. In response to Ella's criticism's Bessie rages: 'I'll tell you where I am all day – I'm at my work. I'm staying up till late with the grown ups, okay?'[22] Placed next to Ella's recommendation that a wild woman should be put across her father's knee (or indeed receive 'a few bruises' from her husband), it is clear that McGrath is highlighting the potential infantilisation of women within a traditional society. He is suggesting that socialist values lean and lead towards something more, something freer.

Yet the form of McGrath's story-telling doesn't entirely support this as it progresses. As Bessie finds the means and motivation to fight politically, somehow her husband Alex no longer can, somehow he's cowed. Alex represents infiltrated, corrupted, hamstrung unions, but his character also presents a male impotence alongside female fury and self-determination. Earlier in the play when their first daughter is born, Alex is seen prioritising politics over family, ranting at his exhausted wife in her hospital bed: 'Christ Bessie, what are we gonna do? Another *five* years of the Tories,'[23] too distracted to remember to kiss her. Yet from

here McGrath offers a journey almost of reversal for the pair, as over time Bessie's responsibility for her family extends to a political responsibility. For her, the battle is never theoretical, it's about meeting the needs of those in front of her (something I attempted to achieve in Eve's journey also). But for Alex the social power and freedom this gives Bessie is ultimately unacceptable. Late in the play he speaks direct to audience of his wife's political travels and exploits:

> I didnae find it easy either when she went waltzing off to Marseilles for the weekend wi' a bunch of handsome Spaniards – and me left doing the washing and the heavy father act ... I can't help it: politics has got to be a fight to overthrow the capitalist state ... And unfortunately, along with that attitude, there seems to go an old-fashioned need for the wife to look after the weans. Till after the revolution. I'm trying to be honest, and I think that's how it is.[24]

In this same monologue we learn that he has 'failed to overcome' his instincts, and has had an affair. And, of course, Bessie has no monologues in which to articulate her alternative view in such detail. In all John McGrath's overturning of expectation through *Blood Red Roses*, is it too much to imagine that Bessie and Alex might ultimately learn to fight alongside each other? Or indeed, that she might learn not to want or need him? Like the Dickensian heroine who sins against her marriage and so must die in the cold night, or Ibsen's Nora[25] fleeing her home into social oblivion, must Bessie lose so much? Could her strength ultimately represent something other than painful sacrifice? Here lies a difficult question about gender and approach to narrative form. Is it more important that McGrath demonstrates the truthful inequalities and contradictions occurring when the class and gender struggle collide, or might there have been more power in showing a woman ultimately overcoming these inequalities? Would this not be the really revolutionary and *mediating* approach to gender in a socialist narrative? Eve literally almost gives everything away in *The Sum*, in a different kind of fight. Indeed, at the end of the radio version she was a woman who had sacrificed her true love, longing for him back. But through the writing process for the stage, it became clear that she must be redeemed, not punished through her narrative: that she should journey back to a place of personal strength, conviction and at least partial victory. In the final moments of *Blood Red Roses*, Bessie announces she is pregnant by a

young activist who is now far away. She is in her living room with her two bright, forceful daughters, with the burning potential of her new child, poised against the world, independent. And yet, her final line is about the husband who betrayed and left her, how she would like him back 'but he won't come back now'. Strangely in this final moment, McGrath chooses to frame Bessie's journey as one of love and loss, giving loss the final word. For all the ways that Bessie challenges feminine expectation, this is at least in part a story of a woman who regretfully loses her man. To frame the previous question another way: when approaching female narratives, do we tell the tragic story because it is true (because history supports it time and again), or do we rewrite the story on stage in order to rewrite it in life? In passing into cliche, does the tragic female story become accepted, a mundane trope with little ability to enact change? Rather than revealing the victimisation of women, it becomes clear that the new revolution is about rewriting the possibilities. It is not enough to have content that points towards the need for change. The form itself needs to shift. At this point in my life as a writer, I find myself looking back critically on my past work through these new eyes, making new resolutions.

Reading *Blood Red Roses* now, there is horrible resonance in that final scene. Set in 1979, performed in Liverpool in February and March 1982, Bessie's line 'Now we've got the Tories there'll be no more jobs anyway', feels chilling. I imagine the words rolling round the dark dusty corners of the old Everyman theatre, spilling out down Hope Street and into the streets of Liverpool 8 like a lament. The previous summer those L8 streets had been alight with riot: a response to political abandonment and police oppression. When *Blood Red Roses* was performed in the Liverpool Everyman in 1982, the play brushed up against a painful moment. McGrath's ideas must have touched the skin of the audience with an electricity that almost hurt. There would be an erosion of employment and living standards in Liverpool in the decade that was to follow, there would be anger and injustice and so much need for voices like McGrath's to speak of revolution. Perhaps it is only a play with a direct expression (a theatrical form which rejects conventional ideas of 'mystery' and embraces an agenda) that can achieve this collision with the moment, this spark.

McGrath's theatre invited his audience not to get lost in another world, but to confront their own. He railed against playwrights writing with their eye on publication and posterity at the expense of 'the now', the

needs and desires of the audience in the room. If *The Sum* was more blunt, perhaps clumsier, than my previous plays, it was because it was spilling out of me in the moment, the characters reeling around in the empty space of the theatre, raw in their need to connect with a politics that might light up the dark. Surely, we are in another painful moment, straining to see ourselves: trying to work out, how (35 years after *Blood Red Roses*) we are still living in a society that punishes the poor for being poor, that allows institutional harassment and intimidation of women. Now is a time for playwrights to be bold, not contemplative. We are in need of an urgent reassessment, a reordering that takes place not just in our board rooms and meeting rooms, but on our stages, and in the fabric of our script-writing. If we are able to see it, the revolution is here.

PLUGGING INTO HISTORY: TIME-TRAVEL WITH JOHN MCGRATH AND 7:84

Lindsay Rodden

Theatre launches even the most private thought into a public world, and gives it a social, historical meaning and context as it passes through the eyes and minds of the audience. It is a place of recognition, of evaluation, of judgement. It shows the interaction of human beings and social forces. How could it remove itself from the other public acts of recognition, evaluation and judgement known as politics? How could it ignore the study of past interaction of human beings and social forces known as history?[26]

New Year's Eve, 2017: Outside, frozen in a brief window of light, the last hours of a disquieting year. I am ignoring the annual round-up of news and global events. I do not want to be reminded about who is bloated and drunk with power, who clings to it, who hungers for it. Who is failing us, and who is being failed. We are on the eve of something we cannot quite know, and perhaps we won't want to. I hardly dare to look.

Beside me, our new baby, asleep. So new she does not have a name yet. This feeling is familiar, but it is especially sharp today: fearful hope, hopeful fear – caught between the old year and the new, knowing and not knowing. Most days, hope bursts forward in colour and light. I felt it going nervously from door to door in the last days of the 2017 election. It is there, most days, hovering at my shoulder, looking down on the

boundless possibility of the clean blank page. Or when we brought the baby home from hospital, four of us now, at Christmas time, in the snow. But today is tired and dark. Fear wins out, and writing a play, of all ridiculous things, feels impossible. So, I stop writing, and stop time. I stop looking out to the future and look back to the past. I open a book.

1971: John McGrath has written his first show for the Liverpool Everyman, inspired by the inventive direction it is taking under Alan Dossor and his ensemble of actors. *Unruly Elements* is a series of short plays, bold with language, funny, strange, surprising, antagonistic and confronting, immediate, and messily human. Reading them now, I am struck by their directness, as if two hands have reached out into the audience, grabbed me by the collar and turned me around to look at what is happening outside the theatre building, right there on the street. And whoever is doing the grabbing is going to tell me just what he thinks about what we see there – and why not? This is not theatre that wastes time or minces its words. More often than not, while it might be the writer McGrath that has plenty to say about the world right now, it is women who are doing the talking. Here's Jenny, 16, asking her disillusioned dad to join her in a campaign to save the local pie shop:

JENNY: ... I made a speech. I said whatever we did, we weren't going to win, and the best way we could use the situation was as a graphic illustration to the people living around here of the way capitalism works. We don't want a twenty-storey hotel, we want Pelissier's pies, I said – but who consulted us on the subject – did *you* vote for it, did *you*? ... We know we're not going to change the hotel – but the hotel might just change the people ... For years, people will be gazing upon it and saying: look at it: symbol of exploitation. And when the time comes, they'll trust us. Join us. Guide us. Help us.[27]

The theatre is packed, the audience on creaking wooden benches, listening to a girl tell them how she thinks she could unite people to transform how their city works, damn it, how their world works. McGrath tells us in *A Good Night Out* that audiences were:

up to 75 per cent, and the audience responded to the jokes, the presence of recognizable local people and problems on the stage, and

the style ... full of verbal attack, not at all naturalistic ... encouraged by a determined publicity campaign, by the price of the tickets, by the informality, lack of middle-class bullshit about the theatre, and by the fact you could get a decent pint of ale before, during and after the show, young working-class blokes came with their wives for a night out. They enjoyed themselves and sent their friends ... The way was open to a new kind of theatre ...[28]

In the writing, the performance, in content, form and style, in the bar, in the auditorium, in the audience: McGrath is describing a united endeavour across every aspect of the theatre to make the art, the building and the experience something that a working-class audience feel is theirs. That theatre is not a rarefied form of culture, but a recognisable one, borne from and responding to our lives, our place, our time. The stage Jenny stands on is made of this collective effort, as much as wood and nails.

2017: I look up. It is dark now, the room reflected back at me in the mirror of the window. I think about teenage Jenny making her speech. I think of McGrath writing those words for the Everyman audience. Like McGrath, a large part of my growing-up was on Merseyside. Like him, I left and came back and left again, my family rooted in Scotland and Ireland, but the Everyman has always remained one of my most significant influences and favourite places – the theatre that made me feel I could roll up my sleeves and join in.

I re-set the time machine. It is 2014, and I have been working with Jeff Young on his play *Bright Phoenix* – one of my last dramaturge assignments for the Everyman, at least for now, and one of my favourites. The play is set in and around the soon-to-be-demolished Futurist Cinema. A gang of old friends have occupied the derelict building, sick of having no say in their city being taken out of their hands, hearts and memories, and given to developers. In the play and in real life, Lime Street is about to be demolished, to make way for (you guessed it) a hotel. A PR woman breathlessly talks about transformation and regeneration, all the while trying to ignore Spike, the wild street wanderer, who believes a far more radical transformation is just beginning.

SPIKE: ... And so everything has changed now. And everything will be changed forever. You talk about transformation. You talk

about the city changing? Well, I'll tell you this, mate, last night was just the start because you've never seen a change like the change that's gonna come ... The city ripped the length of Lime Street. Buildings fell. Drunks, dogs, mad bastards, taxis full of hen-nights, legless beggars ... fell between the cracks into the guts of Liverpool ... And I lay down in the gutter and cried, O earth why do you split open? And hurl into your gaping sewers great multitudes of men?[29]

Spike, Jenny, I want to believe you, but when will the time come? Maybe Jenny's dad is right, maybe we're coming at this all wrong. Because logically I know that nothing stays the same, that change is inevitable – this is how the natural world behaves, science tells us. Yet history keeps repeating itself. On and off the stage, the story sounds the same. I think of Kay, another character in *Unruly Elements*, who is not writing history, but is being consumed by it:

KAY: When I read my papers, I feel plugged into history. I feel the course of events coursing through my veins. I feel taken over, crushed, by many many men. I feel occupied, a house, squatted in, defiled. I feel like a deserted ball-room being defecated in by a halted army. I feel like South America after the Yankees have finished with it, like Dresden after the bombing. I feel like a shed full of cats. I feel like a midnight zoo. I feel like a clump of trees outside a barracks, full of soldiers in rough khaki having under-age village tarts. I feel like Pompeii the next morning. I become a human news-tape, mile after mile of me, torn out, pecked at by destiny's square lettering, ripped off, abandoned. Do you know why? Do you begin to? It's because I feel everything, all the way through me.[30]

Not for the first time, I am overwhelmed. I wonder if I am placing too much value on the role art could or should play in trying to shape a fairer, kinder, better society. If art can really change things. If theatre is really up to the task. In fact, the more I think about it, the more I wonder where I got this idea from in the first place? The answer is, of course, right in front of me.

1973: The year of *The Cheviot*. John McGrath, Elizabeth MacLennan and David MacLennan have set up their own theatre company, and this

year the company has split into two branches, English and Scottish, and the Scottish contingent are taking to the road with what would become 7:84's best-known play. Long before I watched the television recording, and even before I read the play for the first time, I held an admiring reverence for *The Cheviot, the Stag and the Black, Black Oil*. In form and intent it felt, and still feels, revolutionary. It is the perfect distillation of McGrath's ideas for what theatre should be – direct in style and address, full of wit and music, appealing to both hearts and minds, borrowing from the popular forms of music hall, variety and ceilidh. It looks back to the Highland Clearances and centuries of ordinary people coming second to big business, but ultimately illuminates the here and now. It tells us that history is repeating, but that it does not have to be that way. 7:84 took the show all over Scotland, especially to the communities of the Highlands and islands, and then Ireland, and then further afield, because the story resonated with working-class audiences everywhere. McGrath did not claim to be changing the world, but to be suggesting that it is ours for the claiming, and that change is possible if we want it:

> The theatre can never cause a social change. It can articulate the pressures towards one, help people celebrate their strengths, and maybe build their self-confidence. It can be a public emblem of inner and outer events and occasionally a reminder, an elbow jogger, a perspective bringer. Above all it can be the way people can find their voice, their solidarity and their collective determination.[31]

I love it for all this. But more than anything, I always just thought it sounded (as I might have put it then) pure dead brilliant – the kind of night where you and your fella sit and laugh your head off with the strangers next to you, where you discover that you share the same optimism, the same sorrows, and afterwards you feel that the world is your oyster, full of ridiculous hope, new ideas and the fresh night air, singing all the way home. Of course, I was not there, not having been born yet, and so it is as much a dream as reality. It remains an idea, a talisman: for me *The Cheviot* has entered the realm of myth. But the principles that this play and others demonstrated are not footnotes in fiction or history. They live on.

2000, or thereabouts: I'm 19 and in Glasgow, attending a debate about what the National Theatre of Scotland (NTS) could be. There is much talk

about not investing in a beautiful flagship building, but instead forging a company that is light on its feet, able to be at home in the Highlands, the Islands, on ferries and country roads, on hillsides, in kaleyards and shipyards, in pubs and clubs, community halls and, yes, theatres, all over the country. A theatre belonging to every village and town and city – belonging to everybody. I feel my heart leap, and the creased copy of *A Good Night Out*, recently bought in a second-hand bookshop on Otago Street, is burning a hole in my bag. Some 15 years later, the writer and academic Willy Maley would observe that the birth of NTS in 2006 coincided with the death of 7:84, when its funding was finally cut for good: 'The national theatre McGrath envisaged before his death, one with a roving commission rather than institutional anchorage, came into being, but without the radical, populist, working-class theatre of 7:84 or Wildcat.'[32] Still, the idea that the gigantic project of a national theatre, responding to and investigating a nation, could take as its genesis some of the founding principles of 7:84, was ground-breaking and thrilling to me then. That this was a genuinely popular idea is more thrilling still.

In 2010 the newly minted National Theatre of Wales (NTW) took as their stage, quite literally, the Welsh nation, sharing resources with Welsh companies and artists, and telling stories on people's doorsteps, in their workplaces, on beaches, in valleys, nightclubs and online. In 2017 NTW collaborated with the people of the steel-working community of Port Talbot to make *We Are Here*, a huge site-specific play made with Common Wealth, a young theatre company committed to working-class socialism, who believe that theatre has the power to imagine and ignite social change. I would like to set the time machine so that I could pick up McGrath and show him where his ideas are taking us. But there is more to the present than that, and I am not ready for it, not yet. First, I go back.

1979: the English faculty of Cambridge University. The world is about to change, in more ways than one. McGrath is giving one of the lectures that will form his seminal book *A Good Night Out*. He is describing theatre's extraordinary power to offer

> temporary, imaginative release from the chains of alienation and predictability ... It is this that can be ultimately the most subversive element in theatre, because it can create the appetite for throwing off those chains more frequently, for coming out of retreat and onto the offensive.[33]

That fighting spirit will be much in demand in 1979 and the coming years. McGrath knows this, after all he has read his history, and – in international solidarity – is aware of what happens when governments decide to undermine society, community and the working classes all over the world. The artist cannot – must not – close her eyes, stop up his ears. In fact, for McGrath, it is the transporting, transformative power of theatre that makes it, by its very nature, antagonistic to the status quo, and a force for change. Truly good, truly living theatre has to grapple with its times, forming a:

> questioning, critical relationship with their audience, based on trust, cultural identification and political solidarity ... The spectacle of the bourgeois artist desperately trying to curry favour with posterity by turning away from the present is a comic spectacle, and not one to produce either good theatre, or a better society.[34]

I take the hint, but I do not set the dial for 2018. Not yet. I keep turning.

1984, '85, '86: Something is wrong with the machine. Aspects feel horribly familiar. 7:84 are caught up in a cycle of endless reports, producing pages of figures, arguments and justifications, but the goalposts keep moving. Elizabeth MacLennan's memoir *The Moon Belongs to Everyone* reads like a chronicle of a heart-breaking game they never wanted to play yet can never really win, as she and McGrath and their fellow comrades fail to satisfy the demands of an enigmatic master who seems to hold all the cards and will not reveal all the rules. McGrath and MacLennan, with characteristic openness, put it all on the stage:

> People were amused. Highly. Then shocked. Can this be true? The centres of excellence theory – is it going to be at the expense of all this? Surely not. That is what the Arts Council is there for, they said. To bring 'art' to the 'regions'. Ah yes, but it depends what you consider to be art – and, incidentally, *which* regions. All arts are equal but some are more equal than others. And the same goes for 'regions'.[35]

Management consultants are on the march, sent to streamline subsidised theatre practice, slash budgets and jobs or pull the plug. How it is decided to cut the cake, with much the largest slices reserved for the biggest, wealthiest companies, overwhelmingly based in the south-east

of England, is not elaborated on. Not much has changed today, according to a report from independent researchers GPS Culture: 50 per cent of the current Arts Council budget is invested in London, including special resilience grants for major organisations,[36] whose work most of us will only get to see beamed into the cinema. Meanwhile 'austerity' continues to be the watchword for everyone else, and we are told we must choose between rubbish collection or libraries.

In 1984 it is hard not to feel that it is politically motivated, 'to stifle the dialectic of history', McGrath suggested later, 'in fact to bring about the ultimate wet dream of the politician in power with dictatorial tendencies, to bring about the end of history'.[37] It sounds melodramatic, now, and McGrath has every reason to want to damn the decision-makers, yet has a ring of truth. In 1984, the Arts Council's *The Glory of the Garden* plan did away with funding for the English branch of 7:84 and 32 other recipients, with still more companies, like left-wing touring company Red Ladder, being moved onto precarious local authority funding, while protecting so-called 'centres of excellence', no matter how inaccessible these were to the majority, and especially to the working class. McGrath suggests that:

> ... the real reason is political distaste. Distaste for class politics. Class, after all, has been proved, to the satisfaction of the south-east of England, not to exist. And theatre that supports working-class aspirations, and reminds people of their history and their human potential, is clearly a bit of a bore in 1984.[38]

Language, too, is subject to new codes, commoditised and co-opted to serve the Conservative government's project:

> Whereas 'rationalisation' had been seen through, 'restructuring' carried the Saatchi technique of emphasising the positive in essentially negative actions into the 1990s. It means the same – sacking people, providing worse services, or cheaper-to-make and nastier products, closing down whole communities. But it made the process sound as if there was a future.[39]

The slippery language trap will be familiar to any of the many theatres today under pressure to cut costs, going through the euphemistically named 'transformation' process. There is another uncomfortable echo

here too, because presiding over the English Arts Council, 'trot(ting) out the slippery words the Saatchi man had penned',[40] is William Rees-Mogg. Reading this now, the name provides an unwelcome jolt of recognition and the sickeningly familiar ring of inherited privilege, as Jacob Rees-Mogg, the son, waits with a project of ideological Conservatism of his own. Then, the father, with his hands on the Arts Council, squeezing the life out of it; now, the son, in Victorian costume, manners and morals, almost as if he is mocking the concept of history doomed to repeat itself, waiting in the wings, paring his nails, and fixing his gaze on a much larger prize. I am sick of reading. I start to write.

2023: Dawn Walton is hiking north, up the Pennine Bridleway towards 'the roof of England', Cross Fell. She is heading for Hartside Top Café, high on the hillside, head in the clouds, feet pounding the earth, for a cup of tea with Catrina McHugh. Here, after a glorious inaugural tenure as the custodian and curators of the New (Inter)national Theatre of England, Walton's team now hand over to McHugh. Walton's company Eclipse have been touring Black British stories all over the country, uncovering untold histories, and imagining a future written not just by a privileged few. Their Sheffield base has been the nerve centre of NINTE ('we need a better acronym' thinks Walton, as she puffs up the last stretch) for two years, though in practice they are always on the road and have many, many homes. Today, McHugh's women's theatre company Open Clasp will carry the flame back to Newcastle-upon-Tyne. But first there is so much to talk about: the ridiculously brilliant challenge of a national theatre project re-imagined as a grassroots movement, and how that project can hold hands with other movements all over the world, for a start. The two women sit at the window, talking, plotting, laughing, watching the clouds billow up the fell.

Stout boots and waterproof jackets are all the rage with theatre artists now, since Hartside has become a meeting point, even a pilgrimage, for writers and dramaturges, technicians and directors, performers and audiences, participants and makers. Ideas and inspiration are carried up and down the hill. Because national theatre (it resists capitalisation) is an idea, not a building. When it happens, it can happen anywhere, fleet of foot, forward-looking but not forgetful. It is a story about our time and place that you take part in. It comes to your school, to your library, your street. To your local theatre too, where the making happens as well (not everything happens outdoors – it still rains all the time in 2023).

This is where you learn that you might like to make national theatre too. Tickets cost whatever you can afford. Everyone is paid fairly. People are proud of living in a culture where national theatre is subsidised because they can see the money being invested all over the country, employing local people, in training and skills-sharing. It is an investment at local level that pays back locally too. In content, in ethos and in delivery, it is inclusive, inquisitive, embracing and bracing. It is about how we live and how we hope to live, and in that sense it is unashamedly political. But more than anything, it's about having 'A Good Night Out'.

The old National Theatre building on the Southbank in London is still there. Right now, it's in the hands of a group of school children, along with a copy of *Joan's Book* – Joan Littlewood's plan for theatres to be Fun Palaces, owned by their communities – and the Scottish writer Alasdair Gray's motto, 'work as if you live in the early days of a better nation.'[41] The children accepted these books, along with the keys, respectfully and with grace, but already they are plotting their own manifesto. Somewhere it will contain the word 'transformation', and they will mean it, because, they will argue, the world has got to change. The future is not yet written.

And what of the world beyond? Let's just say that the artistic revolution on and off our stages is only possible because it is mirroring the revolution on the streets.

2018: Head up. I have been reading and writing so long, here in the dark. Now weeks have passed. The days are getting longer and brighter. The baby is smiling, fat, happy. She finally has a name.

I think about the theatre I have experienced and loved in the past year or so. Open Clasp's *Key Change*, travelling to women all over the north-east, giving voice to women who have too often been silenced. Letting them sing. *Glasgow Girls* in the Citizens Theatre, packed to the rafters for the true, local story about teenagers standing up for their asylum-seeking neighbours. More singing. More unashamed hope and joy. Little John Nee performing songs and stories in a pub in Donegal, telling tales my granny would love, making us cry with laughter, and then breaking my heart with a song about a woman battered by her husband, and praying for revenge. McGrath would have liked it a lot, I think.

I think about every time I've gulped down a pint of soapy beer with a lump in my throat because that's a fiver or more I will never get back, never mind what the ticket cost, desperate to get out of the cold foyer and into the warm hug of the pub down the road. Every time I have looked

around me in dismay at an audience that appears to be exclusively white. When it feels like the middle classes laughing at (or sobbing feelingly, or nodding sagely, or shaking their heads at) the working classes, or worse, an impression of the working classes. That uncomfortable feeling when you feel like you are the only person not laughing. All this, too, is part of the picture.

I try to remember how I felt a year ago, back in the Everyman again, where I adapted Brian Patten's *The Story Giant*. The audience do not care what has gone before. These children from all over Liverpool only care about Rani on her balcony in India after a day's work; Betts in LA, waiting all night for her mom to come home; Hasan, the refugee trying to cross the border with his dad; and lonely Liam, on a boat in the south-west of England. And the Story Giant, who asks them to tell a new story, to make history. This audience has taught me something I knew deep down, but often forget. To write directly, with a joke on every page, not caring about critics or fashion, with my heart on my sleeve. To write without cynicism, without fear, but full of hope. To let audiences sigh, laugh, lean in and finish the story. And then – the theatre spins. There is a tear in the fabric of time. 'Be ingenious, cunning, and full of optimism,'[42] McGrath says. Say what you mean. Don't be cynical. Don't waste time. There is no time to waste.

Oxfam published a report, showing that in 2017, 'billionaires saw their wealth increase by $762bn in 12 months. This huge increase could have ended global extreme poverty seven times over. 82% of all wealth created in the last year went to the top 1%, while the bottom 50% saw no increase at all.'[43] 1:82. Yes, things change. Sometimes, just a little, and for the worse. Our new statistic.

It's time to stop reading. To plug into the world right now.

2018: The future is not yet written. But it is sketched on the back of a beer mat in a pub in Liverpool 8. Or on the back of a school book. Saved as a note on a phone. Dreamed, if not yet articulated. Perhaps with no means and little experience, but with the sure and steadfast idea that somehow, somewhere, this voice must be heard. That the way to do this is in our shared spaces, in our squares and schools and church halls and backroom bars and clubs and into people's living rooms if that's what it takes – the places where we talk and argue, eat and play and work. Where we feel alive.

I can travel there. Right now. If I can only write it, have faith in it, imagine. Let theatre be our time machine, and let us be the history-makers.

NOTES

1. John McGrath, *A Good Night Out – Popular Theatre: Audience, Class and Form* (London: Eyre Methuen, 1981).
2. *Ibid.*, p. 20.
3. McGrath, *Blood Red Roses* (1982) Prompt Copy for Everyman Production: Everyman Archive, Liverpool John Moores University, Act 1, Scene 9.
4. *Ibid.*, Act 1, Scene 9.
5. McGrath, *Six-Pack: Plays for Scotland, Blood Red Roses* (Edinburgh: Polygon, 1996).
6. McGrath, *A Good Night Out*, p. 1.
7. Lizzie Nunnery, *The Sum* (London: Faber & Faber, 2017).
8. Gregory Burke, *On Tour* (London: Faber & Faber, 2005).
9. Leo Butler, *Lucky Dog* (London: Methuen, 2004).
10. Brian Friel, *Translations* (London: Faber & Faber, 1981).
11. Timberlake Wertenbaker, *Our Country's Good* (London: Methuen, 1988).
12. Dael Orlandersmith, *Yellowman*, (London: Vintage, 2002).
13. McGrath, *Six-Pack: Plays for Scotland, The Cheviot, the Stag and the Black, Black Oil* (Edinburgh: Polygon, 1996).
14. McGrath, *A Good Night Out*, p. 3.
15. *Ibid.*, p. 2.
16. *Ibid.*, p. 2.
17. *Ibid.*, p. 3.
18. *Ibid.*, p. 3.
19. SGR, 'Blood Red Roses', *Time Out*, viewed 5 April 2018, from https://tinyurl.com/ydhtp3hr
20. McGrath, *Plays for England, Fish in the Sea* (Exeter: University of Exeter Press, 2005) p. 156.
21. McGrath, *Six-Pack: Plays for Scotland, Blood Red Roses*, p. 231.
22. *Ibid.*, p. 230.
23. *Ibid.*, p. 226.
24. *Ibid.*, p. 259.
25. Henrik Ibsen, *A Doll's House* (London: Bloomsbury, 2013).
26. McGrath, *A Good Night Out*, p. 83.
27. John McGrath, 'Unruly Elements/Plugged In: They're Knocking Down the Pie Shop' in *John McGrath: Plays for England*, edited by Nadine Holdsworth (Exeter: University of Exeter Press, 2005) p. 110.
28. McGrath, *A Good Night Out*, pp. 51–2.
29. Jeff Young, *Bright Phoenix* (London: Methuen Drama, 2014) pp. 6–7.
30. McGrath, 'Unruly Elements/Plugged In: Plugged Into History', *Plays for England*, p. 101.
31. McGrath, 'The Year of the Cheviot', Introduction to *The Cheviot, the Stag and the Black, Black Oil* (London: Methuen, 1981) p. xxvii.

32. Willy Maley, 2015, 'Why a Play Made in 1973 is Still Relevant to Scotland Today', *The National*, viewed 9 April 2018, from https://tinyurl.com/y8lp7ltk

33. McGrath, *A Good Night Out*, p. 91.

34. *Ibid.*, p. 99.

35. Elizabeth MacLennan, *The Moon Belongs to Everyone* (London: Methuen, 1990) p. 170.

36. Peter Stark, David Powell and Christopher Gordon, 2014, 'Hard Facts to Swallow', *GPS Culture*, viewed 5 April 2018, from https://tinyurl.com/ydzcaf6p

37. McGrath, 'Theatre and Democracy', *Naked Thoughts That Roam About*, edited by Nadine Holdsworth (London: Nick Hern, 2002) pp. 237–8.

38. McGrath, 'No Politics Please, We're British', *Naked Thoughts That Roam About*, p. 147.

39. McGrath, 'Democracy Consumed by Jargon', *Naked Thoughts That Roam About*, p. 183.

40. *Ibid.*, p. 182.

41. Alasdair Gray, *Poor Things* (London: Bloomsbury, 1992).

42. McGrath, *A Good Night Out,* p. xvi.

43. 'Reward Work, Not Wealth', January 2018, www.oxfam.org/en/research/reward-work-not-wealth, viewed 5 April, 2018.

Scene 3
Theatre in Education

INTRODUCTION
Anthony Jackson

As with many of the 'revolutionary' developments in British theatre in the 1960s, the movement known as 'Theatre in Education' (TIE) can trace its origins back to well before 1968. It arose from the mood of optimism that emerged after the end of World War Two and the determination among many, not least those in the cultural sector, to rebuild the country on more egalitarian principles. Ewan MacColl and Joan Littlewood had in 1945 re-launched their Manchester-based radical theatre group – Theatre Union, now re-named Theatre Workshop – to tour theatre-less communities in Wales and the North of England with plays that addressed topical issues (*Uranium 235*, 1946, on the emerging threat of nuclear war, for example). The Regional Repertory Theatre Movement gained a fresh lease of life as new Arts Council subsidies were directed to promoting theatre that served local communities in more direct ways than had hitherto been possible.* The Belgrade Theatre in Coventry was the first new, purpose-built theatre to benefit from public subsidy in 1958 – particularly significant, given that the Belgrade can legitimately claim to be the birthplace of TIE. Finally, new ideas were gaining ground in the education world – Peter Slade's work in Birmingham and his seminal book, *Child Drama* (published in 1954) contributed strongly to a widening acceptance of the need to move towards a more 'child-centred' curriculum.† The possibilities of drama as a means of learning 'soft skills' and of personal development and social awareness were beginning to be recognised, with Drama in Education (DIE) pioneers such as Brian Way and, later, Dorothy Heathcote and Gavin Bolton influencing those theatre workers who were searching for imaginative ways of reaching out to their communities and of engaging young people especially. Thus,

* See Rowell and Jackson (1984).
† See, for example, the Plowden and Newsom Reports prepared for government in the 1960s on primary and secondary education.

did the small outreach team based at the Belgrade, under the leadership of Gordon Vallins, begin in 1965 to take drama projects into Coventry schools, employing story-telling and participatory drama techniques to enliven the teaching of local history – which they labelled 'Theatre in Education'.*

TIE spread rapidly as theatres sought to extend their outreach programmes and develop a variety of ways of speaking to the community they served – to Bolton, Leeds, Peterborough, Nottingham, Greenwich and Edinburgh – all by 1973; and some Local Education Authorities (LEAs) formed their own TIE or DIE companies, most notably the Cockpit Theatre in London (1973). By 1980, there were over 20 fully-fledged TIE companies and a further 60 or so Young People's Theatre (YPT) companies that included TIE as part of their offer. Over the next few decades TIE practice also spread beyond Britain – to Ireland, the USA, Denmark, Norway, Nigeria, Australia and, later, South Africa and India – often taking on innovative forms and methods of approach in response to the current needs and cultural traditions of the host country. Wherever TIE sprang up, it did so, not in a vacuum but rather as part of a much wider concern among theatre practitioners in the latter decades of the twentieth century to search for new audiences and for new ways to speak to those audiences. By the early 1980s, then, TIE was no longer a primarily British phenomenon. Even now, TIE continues to evolve in many different cultures across the globe – sometimes directly influenced by British practice but in other countries emerging in forms that owe no particular debt to British TIE yet share common aims and stylistic approaches. The work of Augusto Boal is one particular example of theatre practice that developed first from cultural, political and educational imperatives in South America and then in turn had a profound influence on European practice, not least on British TIE and the subsequent development of 'applied theatre'.†

What was it then about the idea and form of TIE that captured the imagination and led to such rapid expansion between 1965 and the early 1980s? As a form, TIE has always been remarkably difficult to pin down: partly because it evolved rapidly and variously through many phases;‡

* For detailed accounts of the history and practice of TIE, see Jackson and Vine (2013); Redington (1983); and Wooster (2016); and for historical antecedents of TIE, see Jackson (2007).
† For examples, see Thompson (2014).
‡ See Jackson, 'Education or Theatre?' in Jackson and Vine (2013), for discussion of the main phases of TIE development between 1965 and the present.

partly because it always chose to adapt its approach according to the precise age group, circumstance and topic being addressed; and partly because it was unashamedly eclectic, drawing readily upon the work of theatre artists such as Brecht, Littlewood and Boal, and of DIE specialists such as Heathcote and Bolton. Hughes and Themen offer detailed and insightful definitions of their own later in this section. But, put simply, 'classic' TIE was the use of theatre by professional 'actor-teachers', mostly within school environments, to create learning experiences for children of a specific age group.* Those experiences sometimes looked like conventional play performances followed by workshops, sometimes they took shape as full-scale participatory events in which the children were actively involved from beginning to end (in or out of role), or often they were any one of an almost infinite number of permutations of the two. Always, however, there was some element of participation in the event appropriate to the age level and subject matter. Participation was there not to add spice to the entertainment (though it often did that as well) but to engage the children actively in the learning, indeed to stimulate, challenge and empower them rather than invite their passive looking-on. This was not a complete hand-over of the event to the children: the best and most effective pieces were always conceived as a shared theatrical whole in which – at least at key moments – genuine dialogue, negotiation, debate and collective activity were incorporated carefully into the script. The overall structure would be set in advance; the depth and quality and indeed the meaning of the experience itself however would be determined by the skill of the performers to motivate, to challenge, to listen, to respond, and to move the drama on not by diktat but by the willing agreement, indeed often the insistence, of the audience. The extract from *Farewell to Erin* (1979) reproduced below offers a good example of how this intricate balance between structure, script and participation was often set up, with an actor entering a classroom, in role, and skilfully beginning to situate the children in the world of the play. Without doubt, effective TIE demanded, and frequently got, an artistry and an educational *nous* from its actors of a very high order indeed.

But its viability and future survival were always fragile, committed as it was to providing the service free to schools and therefore dependent on public funding. Most companies used to receive the bulk of their financial support from a combination of sources: Arts Council funds

* The definition of TIE in this paragraph is adapted from Jackson, ' "I've never been in a story before!" ' in McCaslin (1999).

channelled through 'parent' theatres; LEA grants; and/or direct grants from regional arts boards. By the late 1980s, however, as recession bit and government reduced its state funding for the arts and promoted instead a shift towards a 'market economy', and as education funding was steadily devolved down to schools, companies were forced to augment their income by charging schools direct and (where possible) seeking commissions from agencies working in the public policy arena, even in some cases commercial sponsorship. Many companies closed in the process, because they found the financial and administrative demands overwhelming or because they refused to tailor their work to the new briefs being set. In the process, most of the companies that did survive found it impossible to continue employing permanent teams of actor-teachers. Ensemble work in the devising and acting domains therefore became increasingly constrained. On the plus side, new sources of funding opened up – e.g. commissions from regional health promotion agencies looking to enhance education about drug abuse or sexually transmitted disease; from the National Lottery for special one-off projects; and from the extra Arts Council money released for initiatives with young people. UK government policies to promote 'social inclusion' and the new 'citizenship' curriculum in schools did for a while expand the agendas to which TIE was able to contribute. And there were in turn some exciting new theatrical avenues of work explored. Innovative multilingual productions provided a significant response to the challenges of the multicultural society that Britain had increasingly become; TIE practice was fostered at other, non-school venues such as museums, as part of 'community outreach' programmes; while developments in 'physical theatre' progressively served to enrich the TIE repertoire, hitherto characterised by its mostly naturalistic orientation, in turn stimulating some energetic explorations of how live theatre could communicate with young people in ways fundamentally different from the dominant screen culture.

The Situation Now

It is, sadly, difficult to write about TIE now without using the past tense. Very little 'classic TIE' has survived the years of austerity and the marketisation of culture. But, as I have argued elsewhere,* and as two of the

* See Jackson and Vine (2013).

contributors to this book persuasively demonstrate, TIE is indeed – in many places and in one form or another – still alive and does still kick. Liverpool's 20 Stories High company highlights one of the significant changes that TIE has undergone since the heady days of the politically and educationally-driven work described by Tony Hughes and exemplified in the work both of M6 Theatre and the Belgrade Theatre in the 1980s. That is, the switch of emphasis from programmes initiated and performed by professional actor-teachers *for* young people to the more intensely participatory work of *I Told My Mum* ... in which young people themselves become pivotal in the creation and performance of the script. Interestingly, two of the TIE companies that managed to survive the huge changes in the cultural and economic climates of the 1990s and 2000s, if in different guises, the Belgrade and M6, have both given renewed emphasis to the youth theatre strands of their work and found various ways of integrating and indeed blurring the dividing lines between the 'amateur' and the 'professional'.

Another significant change has been the willingness to look again at the role that high-definition professional artistry can play in communicating with young people and stimulating a deeper engagement with their world and its issues. Thus, for example, M6's increased specialisation in theatre for the very young, particularly the four- to eight-year-old audience. What such work may lose in active, physical participation, it gains in emotional intensity and visual, aural and sometimes tactile stimulus. While at first sight such work might look like a flight from TIE to audience-focused children's theatre, at its best it can provide an engaging and empowering visceral experience that resonates as strongly for small children as 'classic TIE' did for older students, driven by the same belief that the child must be at the heart of the whole theatre process: from initial research to testing-out 'in the field' through to performance and follow-up with teachers, carers and the children themselves. The constant struggle to forge theatre experiences that integrate artistry with child-centred learning is as vital, and as needed, as ever it has been.

FAREWELL TO ERIN (EXTRACT)

The script was devised by Belgrade Theatre in Education Company in September 1979 for junior school pupils. This extract shows how the participation of the children is set up at the beginning of the play. As the drama progresses, the children are encouraged to become actively

involved in the dilemmas facing the characters, and at certain key moments, are asked to debate, solve problems and make decisions in role as Irish farmers. For example, there is one point in the play when the bailiff offers to pay the farmers their fares to America on the 'coffin ships' if they leave the land peacefully, and the children are asked to decide on whether to stay and fight or go to America. This type of interaction aids the children's imagination, emotional and social development, and improves their cognitive processing and analytical abilities.

Synopsis: nineteenth-century Ireland was a land ravaged by famine, feuds and fear. For some, especially those who were evicted from their farms by their English landowners, the only chance for a better life was to emigrate. For those who chose this path, however, their dreams of a new life ended in the workhouse or the 'coffin ships' to the New World. The play examines the story of a group of people who had to make that decision.

Scene 1

Mr McMann enters the classroom.

McMANN: Morning. Is this Mrs Wilson's class? Ah! My name's McMann, Mister McMann. Are youse the class expecting the talk on Ireland this morning? Oh thank goodness for that. Well now … I'm a farmer. What is it, do you think, that a farmer does? That's right and what is it that a farmer needs before he can do any of these things. That's right, land!

Now I own a good big bit of land near Carrickmacross in Ireland and I've brought with me a map of me farm. (*Puts map up on blackboard*) Can you all see that? Good. Well up here, I have some lovely pasture where there's a great herd of cattle grazing. Away over here on the hilly part, I have a few sheep. On this land I grow wheat, with just next door, a little barley. But away in the bottom fields, I grow potatoes or 'spuds' as we call them in the trade! Sure people have been growing spuds on this land for hundreds of years because at one time it was the only kind of food they had to eat. Up here, we have a very important part of the farm – the farmhouse. But this farm of mine you know there's always been some mystery surrounding it. I remember me

grandfather telling me that the first person in our family to own all this land was me great, great grandfather Paddy McMann.

No, I could never penetrate that mystery. Not that is until a couple of days ago. We had a terrible storm, and didn't the wind go and blow a chimney pot off – straight down through the roof. The wife was out of the way so I thought I'd go up and fix the hole before she got back, and not being one for the heights, I went to do it from the inside in the loft. I pushed up the trap-door in the ceiling and scrambled up. Now I'd never been up there before and it was really dark with just a ray of sunshine coming in through the hole in the roof. But that loft was not empty! Right in front of me was a great black shape and as I got closer, I could see it was an iron chest. I opened it and inside was this book, and this book was the key to the whole mystery. It's the old Accounts and Records book kept by Paddy McMann, my great, great grandfather himself and reading between the lines in here has told me everything.

A couple of hundred years ago, all this land and a lot more all round it, was owned by the Marquis of Bath, an Englishman. Now the Marquis of Bath was living in England so he didn't use the land. He rented it out to tenants and he had working for him a Land Agent and Bailiffs. Do you know what they are? That's right, they collect the rent and if anyone can't pay they have to 'evict' them. At that time, the land was all divided up into little plots of land. The only thing grown on that land was spuds – enough to sell and pay the rent and enough left over to feed them through the year. That was important 'cos it was the only kind of food they had, spuds. So they were very dependent on that crop of spuds.

But in 1845, the crop was infected with the potato blight. Do you know what that is? Aye, it's a disease – and what happened because of that blight – famine! No crop, no food, no rent money – hundreds and thousands starving to death and one of them was Paddy McMann. But instead of staying there, he set out to walk to County Monaghan on the other side of Ireland where he'd heard the blight wasn't so bad and

the land was good; and he joined up with a group of others doing the same thing. It became a race against time because they'd got just a little food left. They needed to find a bit of land to plant another crop for the Autumn or they would starve and the time for planting was almost past.

Now the story is all in bits and pieces in here so I can't read it out to you though I could show you – but I would need everyone's help. Would you all help me to show you what happened? Right! Well what'll we do is, we'll go back in time over 130 years ago and I'll be Paddy McMann my great great grandfather and youse all shall be the people that he was journeying with. Now all we have in the world is the clothes we stand up in but as Paddy I wouldn't look like this.

He removes his jacket, hat and glasses – puts on waistcoat, kerchief.

McMANN: I would have a neckerchief and an old waistcoat and a pack with just a couple of seed potatoes to give me a start on a new farm. To think our lives depended on a little thing like this. (*He shows seed potatoes*) Right friends, it's a long way we've come and still nothing to show for it but sore feet and half empty bellies. Let's go.

He takes the children into the Hall.

McMANN: We are just outside the village of Carrickmacross but Carrickmacross now, I've heard that some of the ribbonmen hang out there. Have you heard of them? Ah well, I've heard that they are a secret society who kill bailiffs and land agents and such-like, so we want to keep away from the likes of them. I suggest we all stick close together, do you agree?

Right! I know the way so stick close.

Are we all together now? Hey there's something going on here. Keep together and quiet in case it's trouble.

Scene 2

As the children enter the hall, led by McMann, Maggie enters, shouting and screaming from behind the cottage.

MAGGIE: No, no, no, no, no!

Kathleen enters. Maggie continues shouting and throwing off articles from the cottage.

KATHLEEN: Maggie, Maggie, what is it, what's the matter, what's happening?

MAGGIE: It's Trench. He's throwing me out of the cottage and off the land.

KATHLEEN: Where's Sean, where's your man?

MAGGIE: They took him.

KATHLEEN: Who?

MAGGIE: The Militia.

KATHLEEN: Come away now, tell me all about it.

Taking her on to the field.

MAGGIE: They came this morning. There were two of them with guns. One of them pointed his gun at Sean and they threw me down to the ground. I pleaded and pleaded with them not to take him but it was no good. They dragged him away and now Trench is turning me out. Sure if I had a gun I'd shoot him!

During this, shouting continues from the cottage.

KATHLEEN: Whist! Don't say such things. What have they against Sean?

MAGGIE: I can't say.

KATHLEEN: Come on now, tell me.

MAGGIE: He was a ribbonman.

KATHLEEN: Maggie! Do you know where they took him?

MAGGIE: Aye. To Dublin jail. I'll never see him again!

Enter Trench.

TRENCH: Now Mrs O' Rourke. We not only want you out of that cottage but we want you off the land as well.

KATHLEEN: You can't throw her off her land!

TRENCH: This has nothing to do with you Mrs O'Shea. Mrs O'Rourke, I have been authorized by the Court in Dublin to inform you that notice is hereby given this 24th day of April that Sean O'Rourke, being found to be a member of an illegal organization is now under arrest, all property confiscated and the tenancy hereby terminated. The Bailiff shall therefore effect entrance to the said property and take possessions thereof. Here's your Eviction Order, now take it.

MAGGIE: I don't want it!

TRENCH: I'm afraid Mrs O' Rourke you have no choice in the matter.

Hands eviction order to Maggie.

KATHLEEN: Don't take it Maggie!

She takes it.

TRENCH: There Mrs O' Rourke, you have been legally served notice, now be off the land.

Throws things and Maggie off the land.

KATHLEEN: No, don't. No!

TRENCH: Don't try to interfere Mrs O' Shea.

KATHLEEN: Are you all right Maggie? You'd best come home with me.

MAGGIE: No, I'll not do that, Kathleen. I'll not get you into trouble.

KATHLEEN: Have you tangled up with the ribbonmen yourself?

MAGGIE: I have.

KATHLEEN: What'll you do?

MAGGIE: I don't know. Don't worry, I'll be all right.

KATHLEEN: Come on, I'll give you a hand. (*Collecting things*) I'll come with you.

MAGGIE: No, I must go alone. Keep this safe for me.

She hands Kathleen a crucifix, and picks up the bundle.

KATHLEEN: I will surely. (*They embrace*) Goodbye. Take care.

Maggie goes.

INTERVIEW WITH TONY HUGHES (M6 THEATRE COMPANY)
AND JUSTINE THEMEN (BELGRADE TIE COMPANY)

Billy Cowan

Q: TIE seems to have metamorphosed into Theatre for Young audiences, and is sometimes conflated with youth, participatory and community theatre? Can you define TIE for me?

Tony Hughes: TIE is an integrated educational programme involving a mixture of classroom, performance, participation and workshop stimuli, using a combination of acting and teaching techniques, to engage small groups of pupils, through their emotions and critical thinking and thus stimulate their learning of universal, abstract, social, moral and ethical concepts around issues relevant to their lives.

Justine Themen: Tony gives a very clear definition, so I'd like to add just a few things that may be useful in understanding the depth of the impact of what he describes. First, TIE provides pupils with a 'window on the world' – it brings complex contexts and situations into the classroom that may otherwise be difficult to make real in a learning environment. This is powerful because the work can simultaneously be real (theatre is the only art form that can replicate human interaction in live space and time, enabling us to engage 'as if') and not real (the space of the school hall or classroom is the constant backdrop, creating a safe space to explore complex and unfamiliar situations). Secondly, drawing on Dorothy Heathcote's Drama in Education (DIE) work, good TIE also assumes that children already have skills, resources and knowledge within themselves that they can draw on to explore new situations and challenges. They learn through applying this internal resource to the new situation, articulating their thoughts, negotiating with the thoughts and ideas of others. It is a *child-centred approach*, rather than a top-down teaching method. Thirdly, there is an interesting incongruity in the need to create the concept of Theatre in Education – it always seemed to me that neither the job of theatre (to engage us with reflecting on and learning about the human condition), nor the job of education (to draw learning out from within) was being done properly. It is interesting that contemporary work such as Coney's *Early Days of a Better Nation* and the Young Vic's *World Factory* borrow from TIE practices in order to encourage more engagement from their audiences; whilst the education

sector is currently going in the other direction, wiping the arts from the curriculum, and reintroducing top-down teaching methods.

Q: Tony, what were M6's main objectives/ethos when you were there? Did TIE have collective objectives? Justine, what are your objectives today?

TH: M6 originally had a combined brief from its funders – children's theatre, community theatre and Theatre in Education (TIE). The TIE objectives were in line with the definition above: to employ actor-teachers (company members with a combination of acting, DIE and teaching skills); to establish a close working relationship with local teachers in order to develop an educational programme of work specific to each particular pupil age range; collectively to select existing TIE pieces or research and devise or commission new pieces of work relevant to pupils in those age ranges; to deliver these programmes of work to one or two classes at a time; and to organise teacher workshops, follow up and teacher-peer assessment.

If by 'collective' you mean across TIE companies – there was a well-developed national (and international) conversation about the differing types of young peoples' theatre including TIE, both through the actors' union, Equity, and the Standing Conference on Young People's Theatre. TIE companies regularly swapped programmes and were comfortable putting their work out for peer assessment. Equally, the educational world was developing a body of knowledge about Drama in Education (DIE) and the different roles of DIE and TIE. The concurrent publications by academic reviewers like Tony Jackson also added theoretical depth to the growing collective understanding.

It was a time when multi-skilling, such as the joining of education, drama and theatre techniques and practical skill, was more valued than today's focus on qualifications, segmentation and ultra-specialisation, where the experimental interaction of differing fields is lost to a concentration on specialist subjects. There was a widely-held belief that education should be primarily about the maximum development of each child's potential to understand themselves and their society, while at the same time providing tools and resources for them to shape both the self and the world. Today's belief that education should be utilitarian and vocational is the complete antithesis.

JT: As with M6 during Tony's time, the Belgrade's current remit delivers to a combined brief – across children's theatre, TIE, community theatre, youth theatre and talent development, even pushing now into digital practice, and also impacting the diversity of the theatre's 'professional' programme. Our objectives are to bear witness to the experiences of the diverse communities of the city and the UK, creating great theatre that encourages reflection on what it means to be human – whether putting on new writing in a school, on the Belgrade stages, or in a site-specific location. In the context of our TIE practice, we aim to ask questions that encourage the innate ability of most children to explore the complexity of their world, offering a small oasis in the qualification-focused curriculum of our schools. Whilst we would completely embrace the original Belgrade TIE company's objective to reach every child in the city at least twice during their school life, the disbandment of the Local Education Authority has made our relationships with schools fragmented and has drastically reduced funds available to deliver the work. As the birthplace of TIE, we now deliver only one TIE project per year, and the funding for that is expected to run out shortly.

Q: The beginnings of TIE were very much rooted in politics – socialist politics, where ideology was at its core. Tony, is this a fair assessment? Is the politics still central to Belgrade TIE, Justine? Has the politics changed?

TH: Certainly, in the 1970s and 1980s, Equity membership included a large contingent of supporters of far-left groups and it is true that most involved in TIE, certainly in the early years, shared left-of-centre political views. But then those were becoming the norm across the Western-educated 'elite' – there was a worldwide movement of protest, change and hope where all kinds of revolutions were forming. Both the education and TIE worlds then had a strong belief in challenging current orthodoxies and the 'fake news' of that time – the stereotyping, scapegoating and oppression which preserved the invisibility and powerlessness of sections of society.

The 1960s had seen a boom in child-centred educational philosophy (influenced by the pedagogies of Piaget, Montessori, Dewey with Slade, Way and Heathcote in the DIE area). Equally, education for social mobility had become an accepted aim. There was also a growth of liberal social values – in Britain the ending of capital punishment, legalising

of abortion and homosexuality and the Race Relations and Equal Pay legislation.

Following the inter-war agitprop movement, British theatre from the 1950s had a growing commitment to greater audience relevance; to telling the stories of ordinary people through new accessible techniques like informal language, in-the-round staging, non-theatre spaces and subjects focused on working-class experiences. The work of Augusto Boal and Paulo Freire was furthering the belief in education and theatre for the oppressed. So, theatre too had become a cauldron for challenging social and political norms and it was that which drove the early development of TIE as much as any political ideology – it is important to note that it was in the newly-built post 1960s repertory theatres that TIE was born.

JT: In as much as politics is about social relationships involving authority or power, politics is still central to Belgrade TIE and work with young people in general. The underpinning principle, however, is perhaps more implicit than explicit – the work aims to give voice to young people's thoughts and ideas, and in a system that would often seem to be designed to silence diversity of thought and opinion, this is inherently political.

Q: Tony, in what ways was the work political then? Justine, in what ways is it political now?

TH: It's fair to say our political analysis underpinned our work practices in TIE, but that was equally true then for many educationalists, youth and community workers, the community arts and theatre movements and theatre, film and TV dramatists. Equally, as I've argued earlier, the new educational and theatre pedagogies were as much the drivers as any 'socialist' manifesto. It wasn't just the work – even the structure of our working lives reflected our politics. M6 Theatre was a workers' cooperative with equal pay, equal numbers of male and female members, from different ethnicities, and decisions (including hire and fire) were taken by simple majority of all company members.

M6 programmes focused on political issues of the day like freedom-fighting, terrorism, nuclear disarmament, ecology, disability rights, police brutality and racism. Identity and gender politics came perhaps later to the party, but by the mid-1980s that was informing the work, although personal politics was still, sadly, less considered.

JT: Our current TIE project is about supporting young people in their transition from primary to secondary school – encouraging them to draw on earlier experiences of managing change and to build their resilience. Building this independence of thought and resilience is political in a system that in most other ways suppresses individuality. The children understand this implicitly – teachers report a build in confidence after just one intervention, a confidence that still manifests several weeks after the experience.

Q: Tony, can you remember one or two examples of the political work done then that perfectly illustrates the ideology and working methods of TIE? Justine, is there an example of work that has recently been done that you see as political?

TH: *Pow Wow* (1980) was devised by Belgrade Coventry TIE in the late 1960s and reworked by M6 (in its Bolton Octagon origin). A powerful theatrical characterisation for six- to seven-year-olds, it took the then universal, iconic, cultural stereotypes of the white, male, 'righteous, heroic cowboy' and the 'sneaky, dirty, native American Indian' chief. The cowboy has the chief imprisoned behind a wire fence. The cowboy 'sells' his truth about how the only place for such a person ('the other' in today's terms) is in a cage and gains the children's allegiance. He leaves and asks the children to make sure the chief doesn't escape. The chief then unveils his humanity and how his cultural values have been denied and cleansed, and over time builds trust so that the children (most times) do eventually let him out of the cage and are able to put a strong argument to the returning cowboy about why he was wrong in his treatment of the chief.

In Your Own Backyard (1982) was an M6 programme for upper secondary pupils responding to the decision over the preceding five years by IRA prisoners in Northern Ireland to go on hunger strike. The company undertook research, including visiting Northern Ireland, and devised a performance piece that attempted to explore the experiences in Northern Ireland that had led to those hunger strikes. Using a caged structure for the audience and hot seating of characters, it immersed the pupils in the concept of 'social being and consciousness' – how far does experience determine ideas and influence choices – to help the students assess the relationship between the external world and their own values and choices.

JT: *Rise* is a piece that I devised with a group of young women aged 13–23 and wordsmith Liz Mytton. It was based on the young women's own experiences of harassment, domestic violence, being underestimated in school and work, lacking positive role models, etc. They created a lively and moving story about a group of girls who go on a road trip to a Beyoncé concert to try to get some advice on how to deal with the challenges they are facing. Of course, they meet obstacles along the way that mean they miss the concert but find that dealing with the obstacles helps them to find resourcefulness in themselves and each other. The structure of the piece itself is quite conventional, but the politics lie in the personal exploration that the girls did to create the piece, their growing sense of their situation and how it shouldn't just be accepted. The work inspired other young women to speak out about the challenges they faced. It created a basis for parents to speak to their children about subjects they found difficult to address and challenged those working with young women to better support them.

Q: Baz Kershaw in his book *The Politics of Performance* highlights the danger of the political getting lost in the service of the art, but in TIE is there a danger that the 'art' gets lost in the service of the politics? Can this be considered a criticism of the work done in those early days – when there was more concern about the politics than the art?

TH: This was the widely argued dialectic of those days for the left-leaning theatre movement – including TIE and DIE. 'Political' theatre is a term equally applicable to the work of Brecht, Miller and Arden as to Joan Littlewood's Theatre Workshop but I would challenge anyone to dismiss their work as art getting lost in the service of politics. This 'political' approach also influenced repertory theatres like the Liverpool Everyman or Peter Cheeseman's Victoria Theatre, Stoke, so subjects with local working-class relevance began to grow – it still influences the films of Ken Loach or the plays of David Edgar.

However, by the late 1960s in Britain agitprop had become an often derogatory term for all left-wing theatre – especially for the work of companies like 7:84, Red Ladder and Belt and Braces. The work of these companies could be challenged for being one-sided polemic, simplistic, lacking in character depth or nuanced argument. As TIE also focused on relevant subject-matter and took place outside established theatre buildings, it also was sometimes deemed guilty of the same failings.

Of course, there were TIE programmes that didn't work, where it could be argued the piece of theatre failed to engage or explain, but presenting complex choices and resonating lived experiences with engaging characters were as important in TIE as in any other good theatre. Undoubtedly, agitprop shares the danger, with today's social media bubbles, of preaching to the converted and lacking the subtlety of challenging debate; but TIE didn't preach to the converted – the pupils weren't selected, and the 'Indian' wasn't always released. What mattered was if the art worked for the educational aim of the programme – if it didn't, if the politics overwhelmed, then neither the 'art', nor the 'politics' nor the 'education' would have been effective.

At that time, the art was as important as the educational aim. Undoubtedly, the work was emotionally 'weighted', rightly so as it was challenging supremely 'weighted' orthodoxies and class interests. If the criticism is that the students mostly adopted one viewpoint, perhaps that is because of the strength of that view and the power of that theatre.

JT: I agree with Tony that in the best theatre, the art and the politics are inseparable. I'd like to add that in times of austerity, like today, the other challenge is around the value placed on the work, and the resources available to deliver it. Because TIE is often perceived to be instrumental rather than intrinsically artistic, money to develop TIE shows to appropriate high-quality production standards is often the first budget to be cut, which leaves people delivering work on a shoestring. This affects quality, and the more quality suffers, the more the work is perceived to be instrumental rather than intrinsically artistic. It is a vicious circle. And so, the art and the politics of the work begin to separate out again.

Q: Is TIE always more concerned about the process than the end-product?

TH: I have two opposing thoughts here. The process versus product debate in community arts and community theatre has been around for decades. It centres on when a process activity – like a local community exploring their experiences through art form(s) – is translated into a performance/presentation of that exploration to an 'audience'. There is then the dilemma of whether that audience should respond to the process which the participants underwent or to the end-product – the participants aren't professional 'performers' so the 'performance' is unlikely to

meet 'professional' standards; but how else can the process be demonstrated, celebrated and evaluated?

This dilemma didn't happen in TIE – first, there was no 'audience' – visitors to programmes were discouraged, since that turned the pupils into 'performers' and secondly, where there was 'performing', it was by professional actor-teachers skilled in delivering an 'end-product'. For the pupils there was no separate 'performance' to be observed but a process to be experienced. Sadly, recording of the TIE process was rare and difficult because of its intrusive nature, although modern technology would make that easier.

But on the other hand, TIE programmes were principally about the process of education undergone by the pupils – a 'quality' performance of *In Your Own Backyard*, which resulted in every student believing that 'The Troubles' were purely the result of Catholic religious extremism, would have failed. So, the quality of the process is paramount, but equally the quality of the 'end-product' (whether workshop, participation or performance) is instrumental in the quality of the process – as with any stimulus to learning in any educational setting. 'Process' and 'product' were part of a virtuous circle.

JT: There are two things I'd like to add. First, in relation to the process versus product tension in youth/community theatre, I think this is another false dichotomy. There are different processes required in the making of this work that can lead to the creation of a quality performance, one that enables the power of the non-professional performer to shine through. If the roles are shaped with the participants in mind and pitched at the right level to suit ability, and the director supports the actor in selecting a clarity of intention, there is almost nothing more powerful than a non-professional actor playing a role with conviction, and one that is drawn in some way from their own experience. In such a context, 'professional' standards become irrelevant – the performance is successful *because* the actor brings *authenticity*. Furthermore, when the non-professional actor knows the show is good through the positive responses of audiences, s/he achieves a sense of pride that maximises all the benefits of the process. So, in this sense, the process and product are inseparable – once more it is a question of resource – get in good artists to work with the communities in a process that balances 'giving voice' with quality of product and the work is some of the most exciting work produced in theatre.

Similarly, there is a different craft required to make quality TIE from the craft required to make a well-made 'professional' play – the rules of the latter may be a useful reference point for shaping the drama and conflict for a TIE script, but we cannot judge the end script or show in the same way because space needs to be created for meaningful interactions with the young people.

Q: TIE theatre in the past was all about breaking the fourth wall, creating a more interactive experience for the participants. Do you think this is still the case? Should this still be an important part of TIE?

TH: I'm unable to comment on whether it is, but it certainly was and, I would argue, should be. Anything else confines the programme to 'theatre' or 'entertainment' and the pupils to being 'audience' – with all the inherent dangers of disconnection, misunderstanding and non-learning.

Breaking down the fourth wall was also an aim of that post-war movement to make theatre more relevant and accessible in content, staging and location. This philosophy was shared by TIE and the wider education world – a pupil-centred approach that believes the best learning occurs when pupils are engaged personally, emotionally, kinesthetically as well as intellectually. The six-year-old, faced with a 'threatening' Indian chief, taking the risk to open the cage to let him out, has learned at first-hand about the ethical concepts and politics of fear, scapegoats, injustice and oppression. Through interactive participation, the learning has been made concrete.

TIE utilised the power of theatre alongside the ability and pleasure children have in play to bring about 'suspension of disbelief', building upon the growing educational and DIE interest at that time in simulation games as a mechanism for learner engagement. Even when the TIE programme included a performance, techniques like 'hot-seating' or forum theatre enabled the pupils to test out their understanding face to face with the characters in the play – to become an integral part of the dialectic, to learn through doing.

JT: The 2015 Warwick Commission report showed that the wealthiest, better educated and least ethnically diverse 8 per cent of the population is the most culturally active. In other words, it is the most privileged, and arguably those least in need, who are gaining from the significant benefits of arts engagement. In Coventry, there is a 20 per cent dis-

crepancy in cultural attendance between the wealthiest and the poorest wards. As the city starts to prepare for its year as UK City of Culture in 2021, developing cultural products by, with and for its most disadvantaged communities remains a priority for the regeneration of the city. Making theatre more accessible, therefore, continues to be a priority and the TIE model is in hot discussion. In this context, and in the context of the decline of cultural provision in schools, the performance of TIE in a classroom is more radical than ever.

Q: What do you think the purpose of TIE is today? What should its purpose be? Should it still be political? What issues should TIE be looking at today?

TH: Arguably TIE today should have the same educational and ethical purpose as it did to begin with, but that is probably impossible. The cost-obsessed, neoliberalism begun under the Thatcher government, which starved TIE, forcing it to become mass entertainment and 'how-to-behave', still dominates government policy. One or two long-standing TIE companies (like Big Brum and Leeds TIE) might still try to maintain the early philosophy, but many went to the wall and most of the rest were forced to develop 'safe' performance work. Whatever has replaced TIE – whether children's, youth or community theatre – they all have value, but they aren't TIE.

It is difficult to see a relevance for TIE today without a more fundamental refocusing of education as a whole. Perhaps the growing mental distress which seems to be one of the consequences of today's pace and information overload, and of our digital world of insidious, 'fake-rage', moral and personal judgement, will encourage that over time.

I would still argue everything is political whether by intent or omission, so too TIE. The question is more how much its politics has been carefully chosen to resonate with the pupils' age range, develop their understanding, challenge ruling interests and help shape the world anew.

I would hope TIE today would still look at stereotypes, winners and losers, cooperation, ecology or the purpose of education, but equally I would hope it would also challenge new orthodoxies: globalisation; personal identity; the growing obsession that giving offence (as defined by any individual) whilst not illegal, should be prohibited; Brexit; or the oldest ones around change and redemption. In this time of 'fake news' and social media's 'filter-bubbles', there has never been a greater need

for the kind of critical thinking that TIE encourages – though perhaps today it should exploit contemporary technologies like virtual reality and gaming for its medium.

JT: I agree with Tony that it is almost impossible to practise TIE today, although I would argue that it is more relevant than ever, given the focus of the education system in the opposite direction. We try to carry the politics of the work in our youth theatre productions – much of which is devised using TIE techniques around complex social and moral dilemmas. For example, *The Impossible Language of the Time* [2015], created with writer Chris O'Connell and education practitioner Claire Procter, deals with the question of how to protest in a world that seems not to hear your voice. Or, *Somewhere to Belong* (2015) devised with Vamos Theatre and Youth Theatre practitioners Leon Philips and Reena Jaisiah, about how to find value in your own identity when the external world consistently interacts negatively with it. I would say that the same territories that we explore with our youth groups for their shows would hold good for contemporary TIE work.

Q: Do you have any advice on how to engage young people with politics?

TH: I find young people today are as much engaged in politics as ever – but it's not the politics of government or parties. Clearly many young people have been imbued with a sense of fairness and an experience of globalised inclusion, both of which will come to influence their future political choices.

On the other hand, perhaps our mass information and microscopic specialisation age has disempowered people; does it feel harder to bring about change from below – much social action has itself become 'professionalised' and top-down. The specialisation obsession has also limited the opportunities for experimentation – something attractive to young people. It was that encouragement of experimentation, which helped TIE to develop, and we need to regrow it.

Equally, TIE developed at a time when the new adult generation could not escape a sense of responsibility towards a world just emerging from a global war – a world that would need new moral and political ideals and a collective commitment to contribute. Today's focus on identity over community seems the obverse – we need to rebalance the pendulum. There is less experience today of collective action in social and working

lives; a sense of place is less prevalent and is often a source of conflict, especially between the generations. The success of social media and mass gatherings in engaging young people is well recognised, but maybe we also need to find more localised opportunities for young people to influence how their neighbourhood works and more opportunities to see inter-generational socialising and living.

JT: My inclination would be to go back to where we started this discussion, around why TIE is important. I feel that we shouldn't need to engage young people with politics per se; we should instead focus on developing young people's innate curiosity about their place in the world. The arts are a natural way in which children explore; through role-play, drawing, dancing, singing, creative writing. Removing these from the curriculum as learning methodologies restricts children's independent exploration of their world, reduces their curiosity, and limits their understanding. Reintroducing the arts later in the curriculum in a context in which they are taught as a set of skills to be mastered rather than as an innate manifestation of our humanity prioritises style over content and diminishes their power to engage children and young people with their world.

'EVERYONE'S GOT A STORY TO TELL ... AND THEIR OWN WAY OF TELLING IT'
Julia Samuels (20 Stories High)

In 2006, Keith Saha and I set up 20 Stories High (20SH), a Liverpool-based theatre company to create work with and for young people.

We had both spent the previous ten years working with, and being inspired by, some excellent political and artistically ambitious companies. Keith had worked as an actor, facilitator and musical director with companies such as Red Ladder, Theatre Centre, Contact, Cardboard Citizens and Graeae. I had started out in Theatre in Education and Community Arts, before moving into jobs in the education departments at Theatre Royal, Stratford East and the National Theatre. We had both collaborated with a wide range of artists, often those more experienced than we were, and I would say we very much felt part of a lineage of political and young people's theatre that grew from the 1970s and 1980s.

The vision for 20SH was simple: we wanted to take high-quality theatre, with cultural diversity and social inclusion at its heart, into

community spaces to reach young audiences. And crucially we wanted to collaborate with young people to develop both the form and content of the work. We came up with the tagline: 'Everybody's got a story to tell … and their own their own way of telling it …'

We started with two distinct but necessarily intertwined strands of work: professional touring shows and participatory activities.

Initially we focused mainly on the touring strand, involving young people in its development through workshops in schools and youth/ community settings on an ad hoc basis. We wanted to make shows that asked questions of the world around us in complex and challenging ways, and we were committed to creating work that had artistic integrity and high production values. The shows went into schools and community spaces in Merseyside, and increasingly into theatre venues nationally too. As well as reaching young people in their own environments, we were becoming interested in working with venues to develop new approaches to making their spaces accessible and appealing to young, culturally diverse audiences.

In terms of our participation strand, our dream was to develop our own youth theatre. We appreciated the one-off or short-term projects we were doing, but we knew that a youth theatre would allow us to have a much more meaningful creative collaboration with young people; it would deepen the conversation we were able to have in terms of both content and form. In our early touring projects, we were also struck with how hard it was to cast our productions: to reflect our audiences, to tell the stories that we wanted to tell. We knew that a 20SH Youth Theatre would also help develop a more culturally diverse pool of actors in Liverpool who would be relatable to our target audiences.

In 2008, as part of an Arts Council national initiative about inclusivity and diversity in youth theatre, we established our own Youth Theatre Group. We wanted to engage young people who might not have considered that theatre was 'for them'. Through workshops with local schools and youth clubs (including young people who had seen our first touring shows in those spaces) and local urban music organisation *Urbeatz*, we brought together a fabulous group of 13- to 25-year-olds. We were passionate about making the youth theatre as accessible as possible. There was no audition, there were no fees to pay and we would also support specific access needs when required, such as travel costs. The sessions would take place in a city-centre location, removing any tensions around postcode tribalism. We employed a pastoral member

of the team to support the young people both within and beyond our sessions. This has proved crucial in supporting long-term engagement for young people with often very complex lives.

A few months in, the youth theatre performed their first show, *Dark Star Rising*, co-directed by Keith and myself. The show was created out of a fierce debate the group had about whether or not people should feel responsible for making their communities better places. As with our touring work, we were not looking for something that offered the 'right answer'; we worked with the young people to explore the complexities around community engagement and disengagement, and sense of responsibility or lack of responsibility. The show was also made in parallel to Keith's professional touring show, *Babul and the Blue Bear*. As well as sharing territory in terms of subject-matter – both stories stemmed from the stabbing of a young man – the plays shared certain visual motifs, and they both experimented with similar art-form combinations; hip-hop theatre with masks/puppetry. It felt like both processes enriched the other. We were beginning to understand what the creative relationship between our youth theatre and touring work could be.

The youth theatre brought an incredible energy into play; we now had this group of dynamic, opinionated, creative young people as part of the company. They quickly became involved in much more than their weekly workshops and annual shows. They would drop into the office for help and advice, or even just to use a computer. We formed a Youth Advisory Group (now renamed Future Collective by its members) involved in decision-making across the organisation. We took them on theatre trips and residentials. They would explore embryonic ideas for projects through *Dinner & Debate* evenings. They would attend workshops and sharing throughout the development and rehearsal processes of our touring shows, offering ideas, opinions and insights. As we evolved as a company, they were involved in visioning, organisational development and recruitment processes. Two members joined our Board.

In 2010, we created a youth theatre show called *Rain*. It was a lovely piece about a friendship between a young woman who could not leave her house and her next-door neighbour, who could not bear to go into his. *Rain* was developed in collaboration with *84 Theater* in Iran as part of Manchester's Contact Theatre's Contacting the World festival. After enthusiastic audience feedback, Keith and I started to wonder whether we could adapt it to become a professional touring show. The response from the group was strong: it was *their show*, they had created it, it was not

ours to take and give to someone else to perform. We could not disagree. And while they were telling us how it was, some of them started asking the question: 'why can't we be in your professional shows, anyway?'

We mulled it over. We felt that our youth theatre was not quite ready to make that leap, but very *nearly*. We were also aware that there were multiple barriers to them going to drama school to train or university to study. For many of them it wasn't going to be either possible or appropriate. So, we asked ourselves, what were the other routes available to them becoming professional actors? They suggested we work towards creating a 'bridging project', which would help bridge the gap between what they'd been doing already and what would be expected of them in a professional rehearsal process and on tour.

In the meantime, some of the older members also said they needed a new challenge. Youth theatre was no longer stretching them. Together, we mapped out a plan for a Young Actors' Company (YAC), which would be a more challenging, focused group for older members. The first YAC show was *Tales from the MP3*, a verbatim play directed by myself and developed with the group. It was supported by artistic associate Philip Osment (whose long career had included working with companies such as Gay Sweatshop, Half Moon and Red Ladder, a good example of the continuing impact of the work of those key political/alternative companies on our processes).

We spent the first few weeks learning about verbatim theatre and the 'recorded delivery' technique (where the actors listen to the original interviews as they perform, copying the words they are hearing exactly as they are said). We all loved the technique and found it theatrically powerful, but we were struggling as a group to discover what the show should actually focus on, what sorts of people the young actors should interview. After one session where tensions were running high, the answer became clear. They should interview each other. Most of the group had known each other for years, but like most large groups, alliances and tensions had formed. So, we started a process where I interviewed them, and then they interviewed each other. They talked about the big stuff and the small stuff: what makes you happy and what makes you sad; home; your family; religion; racism. They asked questions about each other that they would never usually have asked and shared stories that they would not normally have shared.

Someone told a story about being bullied in school, a few of the group talked about their journeys from Africa to Liverpool, two of the group

talked about being the sibling responsible for caring for little brothers and sisters, a couple of people talked about their experience of having learning difficulties. They found they had things in common and other things that were incredibly different. There were things they agreed on and things they vehemently disagreed on. Together we created, in *Tales from the MP3*, a collage reflecting what it was like to be a young person in Liverpool today, and a story of a group of different people learning more about each other. In the performance, they played each other, mixing up gender and cultural heritage, which gave a playfulness and lightness to the piece, but also gave it a Brechtian estrangement, where the thoughts and experiences revealed insights and questions in new ways.

We received positive feedback on the show and decided to take it on a short national tour where we were able to pay our YAC members: our 'bridging project' was happening. The show felt different to the work we had been able to take on the road previously, which although *informed* by our young people, was not ultimately their work. *Tales from the MP3* felt as if it fully and authentically represented the creative encounter between the young people at 20SH and the artistic team.

The distinction between our professional touring strand and our participation strand, we realised, no longer felt useful. We no longer wanted our youth theatre and young actors to perform their own shows in the summer and then help to generate and develop ideas for plays that other people would make, perform and take on tour. We had become much more interested in the professional theatre we could make *with* the young people themselves, and so the way we make work has changed. That isn't to say that we never employ professional artists other than our pool of young actors and ex-members, but we are much more likely now to create theatre where both the form and content are performed by 20SH's young artists.

In 2014, Keith wrote *Headz* – a series of contemporary urban monologues for the young actors to perform as their annual summer show. The monologues capture the wit, the voices and the emotional intelligence of the young people we work with. We have subsequently toured a selection of the monologues to community spaces nationally. We pulled out a single monologue, *Black,* to go on a national tour. Riffing on the original *Headz* format, when asked to create a response to the Beatles' 'She's Leaving Home' as part of Liverpool's Sgt Pepper @ 50 festival, we created a site-specific piece performed in a local terraced house, centred on a monologue about a young carer. All of these shows

have been performed by young actors and ex-members providing them with their first professional jobs. The shows were supported with expertise from professional musicians and puppeteers.

This is not to say that everything we make at 20SH is completely democratic and originates with the youth theatre/YAC. Sometimes it is right for Keith and I to initiate ideas for projects ourselves, but we are finding ways to ensure that whatever we do involves the young people as meaningfully as possible.

In 2017, I created a play called *I Told My Mum I Was Going on an R.E. Trip*, which toured to theatres and community spaces in co-production with Contact in Manchester. It was another verbatim show, this time about young women and abortion. The idea had come from an informal conversation I'd had which made me realise that one's own experience of abortion wasn't something that was usually talked about. The conversation stuck with me: we are always interested in voices and experiences that are marginalised, and questions that might not have straightforward answers. To see if this was something the young people wanted to do a play about, we had one of our *Dinner & Debate* evenings. We sat around, ate good food, and discussed abortion passionately, honestly and expansively. As expected, there were very different opinions within the room. One young woman shared her experience of her own abortion and the group was very respectful of her doing so, whatever their stance on the issue.

A couple of days later, two young women from the group approached me with their own experiences of their unintended pregnancies. They had attended the *Dinner & Debate*, but understandably had not wanted to open up in such a large group. One of them talked about how she had been feeling so bad and guilty about her abortion for two years, and now, just talking about it, felt a little better: she was no longer burdened by the secret. Here was a play we needed to make; stories that needed sharing; conversations that needed to happen.

The play took a lot of research. There were many people to talk to and perspectives to take onboard: young women who had had abortions; those who had chosen to have babies when they had found themselves pregnant; partners; parents; sexual health professionals; campaigners. There were always ways to involve the 20SH young artists: they were interviewees and workshop participants; they suggested people they knew for us to speak to; some of them joined me as interviewers; we continued to talk about what we were discovering. Early in the script

development process, I led a few workshops with the YAC to explore the material we had gathered. We listened to some of the interviews, identified the most interesting themes and ideas, and the areas that were challenging and difficult. In the workshops, we made recordings of the group responding to our research. We also played around with how we might stage the final production. One key moment for me, which made clear to me how invested everyone was in the development of the work, was when two of our members sent me a recording they'd made of themselves late one night having a conversation about abortion. They had been debating a couple of areas that they had found trickiest in our conversations; whether male partners should have a say at all, and what was an appropriate gestational limit for abortion. They realised their conversation could be beneficial to the play, so they recorded it on their phones and sent it to me. That conversation ended up as a key scene in the final script.

The play centred on four young women's stories: Paige from Liverpool; Tanaya, a young Muslim Mancunian; Leah who had travelled to Liverpool from Northern Ireland for her abortion; and a character we called Cousin, who was a Zimbabwean relative of Paige's sister's boyfriend. We needed four actors to play these parts and multi-role as the various other characters: doctors, partners, parents, other young people who were trying to work out what to make of it all. When we held the auditions, we were delighted we were able to cast two of our YAC members as Paige and Cousin.

As always, our wider group of young people continued to be involved, attending sharings at the end of R&D processes, coming into rehearsals and giving their honest feedback. Throughout the couple of years, I was working on the show, I received many links on social media from group members who had come across something they found interesting and relevant that they thought I ought to know about.

The play had a successful tour of theatres and community spaces. It did not prove possible to get it into schools as the subject-matter was too challenging. However, a few schools were able to bring groups to see performances in theatre venues. We also adapted it for television and it was originally shown on BBC2 as part of their *Performance Live* strand. We are now exploring how to get the film into schools, as this will be easier than bringing in the live production. We have had feedback, particularly from RE teachers, that it would be a useful learning resource. They report that their students would find it relatable and engaging,

as it reflects a wide range of viewpoints respectfully, while advocating for fundamental women's rights. We have the involvement of our 20SH young artists to thank for that.

One of the questions we now face is that, as some of our young people develop into artists in their own right, and grow out of the youth theatre and YAC, what happens next for them? As you would imagine, many ex-members have gone off to do different things outside the arts, but lots of them have become enthused by the idea of having a career as theatre-makers: actors, writers, workshop leaders, directors, producers. 20SH only has a limited amount of paid work to offer, and it is important that we continue to extend these opportunities to the next generation of young people coming through.

Some of them are already finding exciting projects, jobs and commissions, outside of 20SH, and some are even starting their own companies. However, in a competitive industry, where careers are often forged through a combination of networks, luck and talent, many of them still need support. Various studies* back up the easily perceived situation that people of colour and/or those from working-class backgrounds are massively under-represented in arts employment.

We are now devising a Professional Development Programme. It is in its planning stages, but we envisage it will be a rolling year-long programme, which offers professional life skills workshops, paid trainee roles, mini-commissions for emerging artists and companies to create socially-engaged projects, coaching and mentoring, and networking opportunities.

We see our work at 20SH as political in many ways. We are political about its content: making theatre which asks challenging questions; exploring themes and stories relevant to young, diverse, working-class audiences. We are political about its form: embracing art forms beyond traditional theatre; collaborating with artists and young people to find the right ways to tell stories in a way that feels contemporary, authentic and relatable. We are political about our process: we want young people's voices, concerns and questions to be at the heart of the work. We are political about its context: working in schools, youth clubs and community spaces or in traditional theatre buildings in ways that challenge them to become much more accessible.

Ultimately, we are political about sharing practice. Keith and I were influenced by earlier Theatre in Education and Community Theatre

* See https://tinyurl.com/ybzbkpnn and https://tinyurl.com/ybllr9bvv

practitioners who always offered their ideas in a spirit of generosity, inquiry and collaboration. In turn, we are encouraging, enabling and challenging a new generation of theatre-makers, supporting them to develop their craft, their ideas and their voices.

As an example, we have just supported one of our young people to write her first play. Part of the funding that enabled us to do this came from the inaugural Jenny Harris Award. I first came across Jenny when I read an article she had written about setting up the ground-breaking 1960s community theatre, The Combination. That was a key moment that inspired me into a community/young people's theatre career. I later worked with Jenny at the National Theatre where she ran the Education Department. Jenny died in 2012: the NT Foundation created the award in her name to support companies or individuals working with young people from marginalised or under-represented communities in theatre – the work about which she had been so passionate.

The play is based on the writer's own experience of a very challenging mother-daughter relationship in the context of domestic abuse. The writing is distinctive, sharp, witty and very moving. Together with another ex-member, the young writer is in the process of setting up her own company to tour the show into schools and domestic violence units. It is this type of work that makes me feel 20SH is making an exciting contribution to the future of young people's theatre.

Thanks to Keith Saha and the 20 Stories High team.

Scene 4
Women's Theatre

INTRODUCTION

Kim Wiltshire

The movement that is referred to as second-wave feminism began its rise during the late 1960s with the work of feminist writers, academics and activists such as Betty Friedan with the 1963 book *The Feminine Mystique*[1] (influenced by Simone De Beauvoir's *The Second Sex*[2] from the late 1940s), Gloria Steinem, Kate Millett, Germaine Greer and Andrea Dworkin, to name just a few. Whereas the main aims of the first wave of feminism, in the late 1800s into the early twentieth century, had been suffrage and the right to vote, second wave feminism fought for equality, in terms of pay and working conditions, reproductive rights and affordable childcare, as well as consciousness-raising around domestic abuse and sexual assault.

In the climate of the late 1960s and early 1970s, it was unsurprising that women-centred theatre groups began to flourish.

Of course, many women worked in other areas of political theatre, but the feminist cause encouraged women to come together to discuss the issues they faced on a daily basis, whether that be the roles assigned to women in the workplace, the social constraints they faced, or the gender inequality that affected all aspects of their lives. As time went on, this work split into two definitive areas: work aimed at women, especially younger women, that explored issues they faced on a daily basis, and work that promoted women's place in the theatre world generally. Both areas produced work written by women, produced by women, directed by women and aimed at women, but with slightly different agendas.

This section will explore one of those early companies, the Women's Theatre Group (WTG), which was re-named Sphinx in 1991 when current Artistic Director Sue Parrish took over. There were of course other theatre groups that were women-centred, such as Monstrous Regiment, but the Women's Theatre Group was one of the earliest, and, as

Sphinx, it is still creating work that is by, for and about women.* But also, as a company, it went through two phases, as WTG and Sphinx, which highlights how the split into what might be termed political activist work as opposed to exploring women's roles in the world of theatre changed over the decades.

The Women's Theatre Group/Sphinx

In 1973, a Women's Festival of Theatre was held at the Almost Free Theatre, where a group of female theatre-makers and political activists came together to discuss and make work. From this catalyst, two women's theatre companies or cooperatives emerged: the Women's Company and The Women's Theatre Group.

The Women's Company was relatively short-lived as a theatre company, although they did produce Pam Gems' play, *Go West Young Woman*, at the Roundhouse in London in 1974. The group mostly comprised women already working in theatre, who were interested in finding ways to break through the 'glass ceiling', with the aim of creating shows that played traditional theatre venues but centred on women as actors, writers, directors, designers and technicians.

The Women's Theatre Group, on the other hand, was considered to be the 'amateur' group, as many members had no theatre background at all: they were creatives who were also political activists. They were interested in using theatre to disseminate feminist issues more widely, to work on political issues and, close to an agitprop style, raise awareness of those issues through theatre and performance.

In 1975, both groups applied for Arts Council funding – the Women's Theatre Group got the funding, the Women's Company did not, and sadly did not survive much longer.

The Women's Theatre Group's (WTG) first production with an Arts Council grant was *Fantasia*, followed the next year by *My Mother Says*, a play about contraception and sexual awareness for young women, which was later filmed by the Inner London Education Authority. This was a kind of theatre in education, but it was also about raising awareness with young women about the realities of the world around them, in a way that traditional education failed to do. Although *My Mother Says* caused

* For more information on women's theatre groups, and the theatre-makers involved, please visit the Unfinished Histories website at: www.unfinishedhistories.com

some controversy, in the film version perhaps more than the theatre version,* it crystallised the group's ethos. *Work to Role* followed, again aimed at young women and exploring the issues around what type of jobs female school-leavers might expect.

The fourth show, *Out! On the Costa Del Trico*, was much more explicitly political, focusing on equal pay. In a similar method to companies like Broadside Mobile Workers' Theatre, the group wrote this play in collaboration with striking women from the Trico windscreen-wiper factory in Brentford. The show was produced at the Bush in 1976, and received a mixed response. Catherine Itzin explains:

> (T)he women loved it, but the union officials (men) objected, 'said the feminist consciousness had been imposed where there was none, that the WTG didn't know anything about working-class women.' … They had deliberately avoided emphasising a feminist consciousness that wasn't really there (there was in fact only one feminist on the picket line), but they did want to show the solidarity that had developed. But the play had a feminist perspective if not a feminist bias, if only because the WTG was constituted entirely of women and never used men.[3]

Through these early productions the group worked as a team, exploring different ways to make theatre, and similarly to many agitprop companies, the discussions before and after the performances were as important to the group as the shows themselves. They wanted the shows to move things forward politically and used a variety of theatre-making techniques to find the best way of working creatively. One example of this is that, inspired by the People Show, the group made an early decision to dispense with directors and writers, working collectively on their first productions.

However, after *Trico* there was a change in personnel, and with *Pretty Ugly*, in 1977, the group used a freelance director for the first time. As the 1970s came to an end, the group saw multiple changes in membership and ways of working. Ironically, when Thatcher came to power, theatre companies who made work by women for women about women began to struggle. During the 1980s there was of course a sense of change across the arts as a whole, including theatre, in terms of funding, structure and even the 'point' of art. As Peacock, in *Thatcher's Theatre*, explains:

* See Itzin (1980) pp. 228–9, for more on this.

Even in the first year of the Conservative parliament, the cuts imposed unexpectedly by the Arts Council made it manifestly apparent that Margaret Thatcher's economic policies would inevitably have a detrimental effect on the subsidised theatre. What theatre workers did not expect was that, particularly in her second term after 1983, Thatcher would systematically attempt to eliminate the social structures underpinning many areas of British society. In doing so she would initiate a wider cultural shift ...[4]

This cultural shift saw a move away from many of the basic foundational beliefs of the alternative theatre companies that had emerged in the late 1960s and 1970s. Collectives were out, professionalism and corporate-speak were in. Art had to aspire to excellence, whoever it was made by or for, but 'excellence' was never clearly defined, and often seemed to suggest that only mainstream art, old art, art by dead people, could in fact be 'excellent' at all.

During the 1980s, WTG tried to continue as a collective, but with a shifting membership throughout the decade, there was no sense of continuity. During this time, Saunders notes that:

Commissions fell through or departed from the brief, work was rushed into production before it was ready in order to fulfil touring commitments and was poorly reviewed as a result. The company had no signature style or preferred mode, although it generally included music and song in its shows and employed imaginative designers.[5]

There is also the sense that theatre companies who wore their political heart on their sleeve were somehow old-fashioned, perhaps even a bit embarrassing. However, during this decade the company worked with playwrights such as Timberlake Wertenbaker (*New Anatomies* 1981), Bryony Lavery (*Witchcraze*, 1985) and Elaine Feinstein (*Lear's Daughters*, 1987) moving away from producing work mostly aimed at young women, and appealing to a wider audience. But funding and annual battles with the Arts Council were still a problem. Saunders explains that there was some pressure from the Arts Council to rebrand and professionalise:

The key point about the new name, however, is that by the 1990s it was unusual for companies to have names that overtly advertised their

politics. But it was not unusual for the Arts Council to be encouraging companies to use consultants and corporate language.[6]

This highlights the changes that were happening with political theatre companies during this time. Successive Thatcher governments dismantled those socialist structures, and the Arts Council, as the holder of the purse strings, was in a position to persuade the companies they funded that more professionalism and less idealism were the order of the day. As Peacock says:

Post-feminism, extreme individualism and the emergence of successful career women who were keen to deny any association with feminism, left little room for the claims of sisterhood and solidarity.[7]

Times had moved on. In 1990, Sue Parrish took over as Artistic Director, moving the company from a collective to a hierarchical structure and changing the name from Women's Theatre Group to Sphinx.

Parrish took on a company that had some financial issues, although it had continued to get Arts Council support (and did until 2007, when it finally lost its regular funding). Parrish's aim was to get women's theatre up on the 'main stage' and she decided she had, in her own words, to 'clear the decks'[8] and find a new direction for the company. The theatre work concentrated on female themes still, with women centre-stage as writers, actors and artists, but socialist or left-leaning politics were no longer at the heart of the company, as it aimed to find a wider audience for its work. With this in mind, Parrish created 'The Sphinx Test' (inspired by the Bechdel Test) which asks:

Protagonist: is there a woman centre stage? Does she interact with other women?

Driver: is there a woman driving the action? Is she active rather than reactive?

Star: does the character avoid stereotype? Is the character compelling and complex?

Power: is the story essential? Does the story have an impact on a wide audience?[9]

These questions are ones that the early founders might recognise, even if that socialist political urgency has now left the political theatre-making of Sphinx. Times change and missions develop over time, but the theatre company has been going since 1974, and still champions women-centred theatre.

Following this introduction, there is an interview with the Artistic Director of Sphinx, Sue Parrish, and a founding member of the Women's Theatre Group, Mica Nava. This is followed by an extract from *Work to Role* by the Women's Theatre Group.

Catrina McHugh and Jill Heslop write on why women-centred theatre is still relevant today, in relation to the work they do with Open Clasp Theatre Company, and Anna Hermann from Clean Break explores the work that that company does with women prisoners and offenders.

In compiling this section of the book, it became clear that women theatre-makers like to collaborate and work with other women theatre-makers. During 2017, a range of historic sexual assault allegations hit the headlines, many concerning so-called Hollywood players, but some focused on the British theatre world, going back decades. In October 2017, I met with Mighty Heart, a women-centred theatre company, based in Manchester. We discussed how theatre groups that are focused on women and women's issues are still relevant in the light of those historic allegations, and this section ends with an edited version of that conversation, highlighting why women making theatre with and for other women is still so important today.

INTERVIEW WITH SUE PARRISH (SPHINX) AND MICA NAVA (WOMEN'S THEATRE GROUP)

Kim Wiltshire

Q: Why did you first want to work in women-centred theatre?

Mica Nava: When we first started the Women's Theatre Group in 1974, our goal was to disseminate feminist ideas to new audiences. Even though some of us were professional actors, we saw ourselves as part of women's liberation and the socialist theatre movement, as political activists, rather than aspiring actors or theatre directors. We met at the Almost Free

women's theatre season in the autumn of 1973. One of the organisers of the season was Michelene Wandor, who later wrote a number of books about alternative theatre. She was in my women's group, so I went along with her. The initial WTG was quite large but fairly soon split into two smaller groups with different objectives – the Women's Theatre Group (WTG) and the Women's Company (WC). Members of the Women's Company tended to be 'professionals' and were more interested in breaking into mainstream theatre and creating bigger roles for women in the theatre world. The WTG at the time consisted of Anne Engel, Clair Chapwell (then Chapman), Julia Meadows, Sue Eatwell, Lynne Ashley, Frankie Armstrong and me. We were more interested in the political project and what was often called 'theatre in education'. It was for our work in that field that we were awarded Arts Council funding which enabled us to work consistently for several years.

Sue Parrish: As a female theatre-maker, I had no choice but to work in this area. I have had an experience similar to many other women of my generation: I did well at school, I did well at university, I trained to work in theatre and then I hit a brick wall with my career. I realised that someone had to do something about this, and so I began that work myself – not just for me, but for other women writers, directors and artists. It was not just about advancing in my theatre career, though, it was very much about putting the stories and experiences of women centre-stage by using female artists. I was fascinated and compelled.

Q: Can you tell me about some of your early work?

MN: The alternative theatre world in the 1970s was a very exciting space, politically and artistically. Those of us in WTG identified with agitprop groups like Red Ladder. In my case, I was also close to the world of 1970s experimental theatre; my then-husband, José Nava, was in the People Show. Emil Wolk, who lived in our house during those years, performed with a number of alternative theatre groups. The People Show worked collectively, without directors or hierarchy, and the WTG attempted a similar theatrical process and structure.

In the early 1960s, I lived in New York and directed a play with a teenage cast, *Spring Awakening* by Frank Wedekind, about young people and sexuality. That experience and those themes fed into WTG's first collectively-written play, *My Mother Says I Never Should*, which was

designed to challenge different social expectations about boys' and girls' sexuality and to provide information about sex and contraception in an engaging and witty way specifically for young audiences.* It was first performed at the Oval House Theatre in 1975 and toured widely thereafter to dozens of schools, youth clubs, universities and small theatres in London and around the country. We went abroad with it as well. Each performance was followed by a discussion between members of the cast and the audience, usually in small groups. Most teachers and youth workers were very supportive and the Arts Council, the Inner London Education Authority and the Greater London Arts Association were all willing to subsidise us during that period, presumably because they recognised the social value of our intervention. But it was not without problems. The ILEA video of our performance, regarded as a teaching resource for schools, was used extensively for a few years until discontinued because of complaints by some parents and teachers. In 1978 the *Evening Standard* published a four-column letter from a London teacher headlined 'Incitement to Sex in a Film for Schools', blaming the play for encouraging girls to get contraceptives as well as, contradictorily, for the growing number of teenage pregnancies in London.

The other significant play of the mid-1970s was *Work to Role*,† about women in the workplace, which we also toured widely. I remember that we were also involved with the Association of Community Theatres (TACT) which provided a political meeting space for theatre groups like our own and a chance to organise.

SP: In 1979 the Conference of Women Theatre Directors and Administrators was formed by a group of female theatre-makers, who included Sue Dunderdale, Clare Venables, Jude Kelly and Carol Woddis, to name but a few. The main aim of the women involved was to explore why there were barriers in the theatre world that we could not breach. Many of the women, myself included, could not understand why the theatre world was so resistant to women who worked as creative artists. At that time, there were very few female artistic directors of theatres, although there were many more female assistant directors; what we found was that women could not get beyond that 'assistant' role. The conference was

* See Wandor (1980); the introduction describes in more detail the aims and processes of working.
† See Unfinished Histories' website for more information about the early days of the Women's Theatre Group productions: www.unfinishedhistories.com

a true network of support and further emancipation; out of that group, many female theatre-makers gained the confidence and knowledge to push through those barriers.

When you are at the start of your theatre career, as a woman, you do not know why you are seen as a second-class citizen – but you are. Through the conference, I became, if I wasn't already born one, a Fury. And I met fellow Furies, chief of whom was Pam Gems. I worked often with Pam, who was a co-founder with Sue Dunderdale of the Women's Playhouse Trust. Pam to her dying day was a Fury. She stayed very angry about the discrimination and the barriers that she as a woman artist faced during her career.

MN: I left the Women's Theatre Group in 1977 and went back to academia to do a PhD. The three or four years of my life as a member of WTG were productive and influential but the work was very intense and also very demanding in terms of time. When people really identify with a project, conflict is more likely. And so it was. The 1970s was a very political decade – especially for women who had been less involved in the 1968 upheavals. The women's movement took off in 1969 in the UK and the following years were incredibly exciting but also often painfully turbulent. In addition to my work with the WTG, I was teaching part-time at Birmingham School of Art and had three kids to look after. So it was very full on. It was a relief to start the PhD.

Q: Do you think women-centred theatre is still relevant as we move through the twenty-first century?

SP: Men are still the dominant gender, whether as writers, directors, actors or board members. Some male artistic directors are trying to bring more female artists into their theatres, but very often this is done by focusing on a female protagonist in a well-known play, for example an Ibsen or Shakespeare. Whilst this may shine a spotlight on that one woman playing that one female character, it still doesn't do anything for emancipation, and it doesn't shake male entitlement. There is a sense that feminism happened and we are post-feminist now, so everything is OK now. But theatres and theatre-makers are still producing stereo-typical characterisations of women which continue to support cultural assumptions about women. And if young people are seeing these pro-ductions, then the cycle just continues, unfortunately.

MN: I'm preparing a short article on the #MeToo movement and comparing it with the politics and ideas of second-wave feminism. There's been an eruption of opposition to sexual harassment, but it's been relatively narrow in its focus. Second-wave feminism was a broader, more progressive movement in many ways, but the new post-Weinstein feminism is certainly more extensive. It has become a mass global movement and is to be celebrated. I look forward to seeing where it goes. Feminist theatre is most certainly still relevant now.

SP: I can accept that I am narrowly focused on women-centred theatre, but I aim always to work with writers who are going to write about women as people who are core to the story they are aiming to tell. I am not interested in that story from the male point of view. I am interested in exploring the female point of view, expanding what can be done with those stories to make them really count.

The Sphinx recently held two events: Women Centre Stage, the first in 2015 at the National Theatre and the second at Hampstead Theatre in 2016. They were immersive events, full of women theatre-makers, but we did not stereotype, we looked for stories about women forging new lives or creating new worlds. And this doesn't have to mean the story is 'heroic', it can be a small domestic story, but it is about finding and showing new directions for women-centred theatre. These events were hugely successful, with both women and men, and there were no adverse comments about the focus on women, that men were not the protagonists, or centre-stage.

I love the classics, but sometimes I wonder what doing production after production or entire seasons with them is actually putting back into our culture. We need new work, new stories and new voices. And I think there should be many more female voices in there. People often see me as some type of thought police, because I will point out, over and over again, that productions are staged, still, with no women involved. Sometimes I do resent having to be that person, but sadly it is still a necessary part of my role. So yes, women-centred theatre is still very relevant in the twenty-first century.

WORK TO ROLE (EXTRACT)

A play written by the Women's Theatre Group.

THE WELFARE SCENE

Characters:

Liz: Age 19, unmarried mum on Social Security and waitress.

Jackie: Also a waitress; fairly political.

Social Security (SS) Officer

Rosie: Age 17, just leaving school.

Liz and Jackie walk to SS Officer's booth. Liz sits.

SS OFFICER:	Well, I have your name on my list but I don't seem to have a file on you.
LIZ:	I just moved and they told me to come here.
SS OFFICER:	In that case I'll have to take your details again. Full name.
LIZ:	Elizabeth Johnson.
SS OFFICER:	Address?
LIZ:	51 Leyburne Road, N18.
SS OFFICER:	Date and place of birth.
LIZ:	4th of the 4th, 1957, Ohio, USA.
SS OFFICER:	(*Peering at her suspiciously*) Are you British?
LIZ:	Oh, yes! I came to England with my mother when I was twelve.
SS OFFICER:	Married or single.
LIZ:	Single.
SS OFFICER:	Any dependants?
LIZ:	I've got a little girl, Tracy, she's just 4 months.
SS OFFICER:	In that case I shall have to fill in a form for single parents. Child's date of birth.
LIZ:	The 18th of March of this year.
SS OFFICER:	Name and address of father.
LIZ:	Oh – I haven't told him – he doesn't know.
SS OFFICER:	He doesn't know what?
LIZ:	About the baby.
SS OFFICER:	Do you expect me to believe that? What's his name?
JACKIE:	You don't have to tell her, Liz.
LIZ:	I told my other officer already.
SS OFFICER:	Father's name.
LIZ:	(*Resigned*) Roger Mitchell.
SS OFFICER:	Address?

LIZ:	I don't know.
SS OFFICER:	Is he sending you any money?
LIZ:	No, of course not, I haven't seen him!
SS OFFICER:	Did your previous officer try to trace him?
LIZ:	I don't know.
SS OFFICER:	Was an affiliation order taken out against him?
LIZ:	I don't know.
SS OFFICER:	We must contact him. He must be made to support his own child. There's no reason why the taxpayer should do the job, is there?
JACKIE:	It's our money you're paying out; we all pay contributions.
SS OFFICER:	Be quiet please. When did you last see the father?
LIZ:	About a year ago, but he never even knew I was pregnant.
SS OFFICER:	Didn't you feel it was your duty to inform him?
LIZ:	No, it was my decision. I don't want him to know and I don't want him to pay.
SS OFFICER:	You don't want him to know? Isn't that rather irresponsible of you?
JACKIE:	That's none of your business.
SS OFFICER:	Keep out of this. (*To Liz*) Why did he leave you?
LIZ:	He didn't leave *me*. I left him, even before I knew I was pregnant.
SS OFFICER:	If you're going to lead that kind of life, I'm surprised you don't take more care.
JACKIE:	We don't need the morality, thank you.
SS OFFICER:	He must be found and taken to court.
LIZ:	Jackie – he hasn't got any money!
JACKIE:	Even if they get money out of him it doesn't make any difference to what you get. (*To SS*) You know men can deny it in court and say it was someone else. You'd just be humiliating her in public.
SS OFFICER:	(*Ignoring Jackie*) Can I see your allowance book, please.
LIZ:	Here it is – I'm not getting any rent allowance now, but I need it because I'm paying £6 a week rent now and electricity as well.
SS OFFICER:	Why did you move?

LIZ: Tracy and me was sleeping on the sitting room floor at my uncle's.

SS OFFICER: Rent book. (*Liz hands it to her*) Your landlord, Mr Perkins – does he live on the premises?

LIZ: Yes, downstairs.

SS OFFICER: Is he married?

LIZ: I don't know – I think he was, years ago, yes.

SS OFFICER: Are you co-habiting with this Mr Perkins? (*Liz breaks up laughing*) We have the authority to investigate, you know.

LIZ: We only share the bathroom. (*Jackie groans*)

SS OFFICER: I see. (*Writes*) Shared facilities. I'm afraid I shall have to keep your allowance book until an inspector can call.

LIZ: You can't do that – What'll I live on?

JACKIE: Give her a receipt.

SS OFFICER: Stay out of this, you're not helping your friend.

JACKIE: You're not allowed to take her book without giving her a receipt.

SS OFFICER: Alright, you'll get a receipt, young woman.

LIZ: But what am I supposed to live on?

SS OFFICER: You should get a giro sometime this week.

LIZ: With the rent money?

SS OFFICER: Most of it, I expect.

LIZ & JACKIE: How much?

SS OFFICER: I said *most*. The exact amount is not under my control. Besides, if you're co-habiting with Mr Perkins, the State expects him to support you and your child.

JACKIE: You expect us to be prostitutes then? If we sleep with a bloke he's got to pay us for it.

SS OFFICER: You are sleeping with him!

LIZ: (*In amazement*) Mr Perkins must be at least 70! He can't even climb the stairs to the bathroom. (*To Jackie*) I think he pees in a bottle in his room.

JACKIE: It's not *what* you do – it's what they think you do that matters. They only have to see a double bed and they wonder who's keeping you warm.

LIZ: I wouldn't mind someone keeping me warm!

SS OFFICER: Now, Miss Johnson, have you any monies coming in? From parents, grandparents? Any savings? (Liz shakes head) Any other source of income?
LIZ: No – (*Urgently*) when will I get my giro?
SS OFFICER: Sometime later this week. Thank you, that'll be all, here's your rent book.

Liz and Jackie go to where Rosie is sitting.

ROSIE: I heard her. What a place!
JACKIE: Isn't it typical how she assumed Roger walked out on you.
ROSIE: That's funny – that's just what Marilyn thought. She couldn't believe you didn't want to marry him.
LIZ: Marilyn! I wouldn't be in her shoes!

Music.
Exit all except Liz.

THE WELFARE SONG

I'd rather have my freedom than a freezer,
I'd rather be on Welfare than be wed.
For though it's true
There's a lot I've been through
I don't take the Welfare to bed

I don't cook meals for the Welfare.
I don't clean the Welfare's shoes
I don't do the Welfare's washing up.
Or get the kitchen sink blues because of the Welfare …

True, sometimes I get lonely in my one room.
It's hard for me to see the way ahead
But there are men in my life
And I'm no one's wife –
And I don't take the Welfare to bed!

Exit Liz.

THE WORK OF OPEN CLASP AND WHY WOMEN-CENTRED THEATRE IS STILL RELEVANT TODAY

Catrina McHugh (MBE) and Jill Heslop

In this section we consider the reasons why women-centred theatre is still relevant in the UK today. To do this, we will explore the work of our theatre company, Open Clasp, through the exploration of three short case-studies that lead to a consideration of why this work still needs to be made, and still needs to be seen.

Changing the World One Play at a Time: A Background to Open Clasp Theatre Company

Open Clasp is a women's theatre company founded in 1998 and based in the north-east of England with a national and international reach. Driven by a passion for unheard voices and working in partnership with community and youth organisations and prisons, we create theatre that is embedded in the experiences of marginalised women and young women in the North of England. Our work resonates deep into the communities in which it is created and performed, but also speaks outside these communities, encouraging audiences to walk in the shoes of the women, make space for debate and ultimately advocate for change.

Our methodology to create theatre is unique and no company works the way we do: collaborating with marginalised women to draw out their collective voices, voices that through a devising process become powerful professional theatre productions. Using drama techniques to create a safe space for discussion and debate, groups work creatively, taking ownership and control. The process is democratic and we collaborate as equals; each woman in the room is an expert in her own experience.

We work with a diverse range of women, often groups that other organisations find hard to reach, including women from minority communities, Travellers who experience discrimination, women seeking asylum and those refused asylum. We have worked with the LGBTQ+ community, women who have lost their children to adoption, those who identify as sex workers and young women who find themselves homeless, women who have experienced childhood sexual abuse and exploitation, women who have been raped and those who self-medicate and have a dependency on drugs and alcohol.

The plays that are created are deeply driven and directly informed by the lives of the women we work with and, as such, are truthful, hard-hitting,

warm and often funny. We perform to a diverse range of audiences and aim to use the theatre created to impact change on multiple levels. Our work is performed in theatres, prisons, schools and community centres, at conferences, the Houses of Parliament, the Edinburgh Fringe Festival and off-Broadway, New York, to national and international acclaim; our performances get people talking and contribute to social change.

Using theatre as a vehicle, we aim to create a world that can safely place audiences in the shoes of others, give them an opportunity to feel empathy, understanding and compassion with the women and issues portrayed on stage, and feel anger and injustice. We work in direct partnership with community and youth organisations and service providers; people who are grounded in their communities and have the expertise and understanding to use our work to support real, on-the-ground change. We also regularly collaborate with researchers and leading policy experts to contribute to regional and national discourse.

The following case-studies illustrate our methodology through projects carried out between 2014 and 2017.

Key Change

This piece began its life in 2014 when Dilly Arts* devised the *Women's Voices from Low Newton Prison* project and raised the funds for Open Clasp to work with women in HMP Low Newton prison, County Durham. The brief was to support the women to create and perform a new piece of theatre, and then for this work to be taken out and performed in male prisons in the north-east of England.

Over a period of six months, Open Clasp's creative team met with a group of women every Friday in the prison chapel. The first phase saw the company introduce its methodology to create a safe space for discussion and debate. Drawing on their own experiences, the women created a character, Lucy, and decided on significant turning-points in her story; that she was kicked out of the family home at 16, following a relationship with an older man, that she suffered with postnatal depression and had experienced domestic violence. It soon became clear that Lucy could not hold all the experiences of the women in the room, after a scene had been created based on a shared experience of heroin, in which Lucy, living in a refuge, using heroin, invited another woman to

* Dilly Arts is the only arts development company in the north-east of England specialising in working with people in prison.

use. A big debate took place, with those who had and those who had not used heroin, all claiming ownership and truth of Lucy's story. In order to hold both stories, we introduced another character, Angie. Not unlike Lucy in her experience of domestic violence, we learnt that Angie had been given heroin at the age of 17, had multiple partners who treated her violently, and turned to sex work to support her drug use and that of her multiple partners.

> The reality is that they were all women who didn't know each other in the prison – all with different experiences. Our process enabled them to think about the character first, to provide them with that safety, so they could [eventually] get to their own stories. It helped to build trust and forced them to rely on each other for support and in the end, creating a theatre piece helped to make the solidarity happen. We all laughed about things, and cried about things. We structured it so everyone could genuinely trust each other, and creating a show united the women, the whole process enabled them to be themselves.[10]

Drawing on the characters that the women had created and further conversations in the room, the first draft of the play *Key Change* was written over one week. The script was given back to the women and, as agreed, also presented to the Governor of HMP Low Newton for his consideration and endorsement, leading into phase two, in which the women performed the piece to their prison peers.

> Whilst the women stepped up and into rehearsals led by our Associate Director, Laura Lindow, I sat in the Governor's office, defending the script and the women's viewpoint of life in prison. And it was in this moment that I learnt the art of negotiation and the need for compromise when working within a prison setting. Compromises were made, and an invitation was extended to the Governor to come and see for himself what the women were doing. We thought if he could only just see the truth and power of their performances, then ... maybe he could feel reassured.
>
> He came into the rehearsal room (the prison chapel) and sat with us and the women All of us, the creative team, officers and the Governor, watched the women not only tell the story of life before prison but also what happens inside the prison. The story took us from the prison van into reception, induction and the first night on

the wing. It showed drug use, time in segregation and the frustration when trying to communicate with loved ones on the outside. It also showed the characters' determination to change – 'this is my last time' – and what is needed to support that change, for themselves and within the Criminal Justice System.

It was without doubt an extremely challenging time for everyone. The Governor [risked] public backlash and bad publicity. We had been brought in to deliver on the project and we needed the Governor's endorsement to enable us to take the play out of the prison and tour to men's prisons. To his credit the Governor did take that risk and endorsed *Key Change*, inviting the whole prison to the performance. The women, now theatre-makers, supported by Open Clasp actors, performed *Key Change* to their peers, with the empathy and solidarity for the characters and women on stage palpable.*

Phase three saw *Key Change* taken out of the women's prison, and performed by professional actors who had worked alongside the women in the prison, and toured to men in HMP Frankland, HMP Durham and Deerbolt Young Offenders Institute. The audiences were wide-ranging and made up of men serving life and those on remand. The impact was tangible; many said they could see themselves as children, could see their mothers being hurt, or that they could see the man (the perpetrator) they once were, and the man they are now. The project ended with a public performance at Live Theatre, Newcastle.

It was clear from the impact on audiences that this play could, and should, contribute to an understanding of the experiences of women, and to the debate around alternatives for women in prison. The following three years saw the play tour to sell-out audiences at the Edinburgh Fringe Festival, winning the Carol Tambor Best of Edinburgh Award 2015 and leading to a 3½ week run off-Broadway in New York, where it received a *New York Times* Critics' Pick. During a national tour in 2016, we were invited to perform *Key Change* in the Houses of Parliament, contributing to the debate about alternatives to prison for women, sharing a post-show panel discussion with Clean Break Theatre Company and Baroness Corston, author of the ground-breaking Corston Report.†

* Catrina McHugh, Artistic Director of Open Clasp Theatre Company and author of *Key Change*.
† See Corston (2007), which outlined the need for a distinct, radically different, visibly-led, strategic, proportionate, holistic, woman-centred and integrated approach.

Despite national and international mainstream success, we continued to tour the play to non-mainstream audiences in prisons and communities impacted by the issues in the play. While in New York, we performed to a group of women in York Correctional Institution, Connecticut, to a standing ovation (the women were not allowed to stand) and a woman shouting, 'This shit's global!' Voices were reaching out across the miles, connecting the north-east to Scotland and the US, with a shared recognition that gender violence and childhood sexual abuse plays its part in the story that leads to life in prison.

Key Change continues to have a life; in 2017 we were commissioned by The Space, a partnership between BBC Arts and Arts Council England to film *Key Change* and stream globally as part of the UN campaign to end violence against women and girls. The play continues to reverberate over the razor wire and out into the general public consciousness. Our goal is to continue to use this piece of theatre to inspire a transformation of the prison system and to provide alternatives for women.

Rattle Snake

Rattle Snake was created by Open Clasp to train frontline police officers in County Durham in better responding to sexual and domestic abuse, coinciding with the change in UK law in 2015 which made coercive control in relationships a crime. Based on research that identified gaps in police understanding of coercive control by Professor Nicole Westmarland and Kate Butterworth of Durham University, and the impact of arts-based research interventions by Professor Maggie O'Neill, it was funded by Durham Police and Crime Commissioner and the Arts and Humanities Research Council.

In *Rattle Snake* we meet two women both involved with the same perpetrator, James, whose coercive controlling behaviour affects their ability to think, feel and escape; both women are trapped, not only by the perpetrator but by the state. We see the impact of domestic abuse on their mental health, how this can be used against victims/survivors, to threaten and control, and how the state views mental health and the stigma and discrimination that are James's weapons.

To create the piece, I interviewed women who had phoned the police for help; spoke with academics that had commissioned the project, with women's organisations and with Professor Evan Stark who coined

the term coercive control. I wrote *Rattle Snake* and designed an interactive drama workshop and over 12 days, we trained just under 400 officers in bullet-proof vests who dared us to make an impact and we did.

During the first leg of the tour I met a young man/boy in a referral unit. He watched *Rattle Snake*, and then asked to speak with me afterwards. With his teacher present, he told me about how his real dad had been like the man in the play, how his dad, like the man in the play, had moved on to other women, had more children and how his mother and the other women are now free. However, though he is safe, this child is also triggered when the 'real father' tries to get in contact with him.

I am especially proud of the children's voices in the play: they are being heard and they need to be, as we know their mental health is also being affected and they are also in need of services and support.*

Rattle Snake continues to be performed nationally to diverse audiences and highlights the role that theatre can play in ensuring that vital academic research has a wide reach on-the-ground.

Sugar

During 2016 we worked with three groups of women, returning to work in HMP Low Newton, alongside those on probation in Newcastle upon Tyne and a hostel providing emergency accommodation for homeless women in Manchester. We identified common themes in all three groups: childhood sexual abuse, domestic violence, drug and alcohol abuse, homelessness, along with a lack of provision to support women with complex needs.

In response to each group, the resulting piece *Sugar* consists of three monologues, which speak directly to the audience, filling the space that separates the actor and audience with voices asking to be heard. It was previewed in the north-east in 2017 and included a performance to an invited audience within the prison. This performance was without doubt one of the hardest we have performed and, for some, it was too hard to watch, listen and relate to: a small number of the audience members left. We asked the women who remained whether it was too much, but

* Catrina McHugh, Artistic Director of Open Clasp Theatre Company and writer of *Rattle Snake*.

their response was that it was not and that it was real and powerful and needed.

For those who have not seen the show, I have been asked 'is there any hope?' I have hesitated in my response as, at the time, all I could see were the issues and lived experiences that the women had shared; of childhood stolen, a mother lifting her daughter and placing her in her father's bed, rape, women being beaten, wires wrapped around their legs and electrocuted, homeless women raped again. So hope was not the first thing on my mind. But this play is about hope; I see it as I saw it in workshops with the women. We cannot airbrush the reality of crimes committed against the women we worked with, who are victims before they are offenders, but we had the privilege to witness and celebrate the resilience of these women and their ability to survive. I read a quote, when working with the women, which said: 'we don't walk between raindrops, we have the scars to show for our experiences.'[11] It is that strength and resilience that gives the women hope: knowing that you got through it, not as a victim but as a survivor, gives you hope in your darkest moments; when you think there is no hope, no end, there is. You cannot take the past or the reality away but you can know there is a change; that you can, and do, survive, live, laugh and love.

Sugar does not let perpetrators hide in the silence of society; touring in 2019, it's a call for change, in attitudes and culture, and a call for action.

Why is Women's Theatre Still Relevant?

The context in which we work is a global epidemic of misogyny, control and violence against women and girls, which is not yet treated as a human rights issue, a crisis or even a pattern. According to the organisation Refuge,[12] in the UK two women every week are killed by a violent male partner and one in four women in the UK are affected by domestic violence, including so-called 'honour' crimes and forced marriages. Rape impacts nearly one in five women directly, and as a threat, virtually all women. 98 per cent of rapists are men. Sexual harassment and intimidation are widespread.

Theatre by and with marginalised women has the capacity to act as a truth commission; to hold a mirror up to experiences of violence, abuse and poverty and the injustices in our society which are multiple and intersectional. We need women's theatre that breaks the silence on this deep, pervading gender violence, because it affects us all. Open Clasp's

plays are not about others; these issues are present in all of our lives. We all know someone in this situation.

This theatre matters because we find ourselves living in a world where others still feel entitled to take away another person's liberty, to control, threaten and annihilate. Women are living this life every day and the women who collaborated with us are often still living the reality of what audiences see on stage. Life and art collides. That this is still incomprehensible to the mainstream is exactly why we need this kind of theatre, shining a light on the marginalised and the voiceless.

The women we collaborate with trust Open Clasp and invest their time, take risks and stand tall. They are heroes, they survive experiences that no one should ever have to and many would not be able to. Open Clasp meets these women as equals, standing in solidarity, and together we make change happen.

Art makes the world, it matters, it makes us. Stories and narrative matter. We need to notice who speaks and who is heard, and listen particularly to those who have been silenced. Our collaborations with women ensure theatre is made through their lens; that the theatre created reflects the society we live in, though hidden from sight, and through this reflection we can learn, feel empathy and advocate for change.

FORTY YEARS OF WOMEN-CENTRED THEATRE-MAKING
Anna Hermann with Kim Wiltshire

What is Clean Break?

Clean Break has been around for nearly 40 years, and I have been working here for 16. As with many theatre companies, the nature of the theatre made in the very early days was very transient: created, performed, gone. It was not published, so we have been going through the process of archiving our work to ensure that the early days and the rich body of work from that time is neither lost nor forgotten. We hope to make this archive accessible to others in the future ...

The initial drive for establishing the company was to create theatre directly born out of the experiences of women who founded the company; Jacqui Holborough and Jenny Hicks founded Clean Break whilst they were in prison at HMP Askham Grange (they originally met in HMP Durham in 1977), and they formed the company when they left in 1979. In the early days they (and other women who joined them)

worked as a collective, writing and performing their own plays, and touring locally, nationally and internationally, reaching a wide range of audiences across small-scale theatre venues, and as part of community events, conferences and education provision.

The founders moved on in the mid-late 1980s. Since that time, the company has grown and evolved but stayed true to its original mission to open up a dialogue with audiences about the hidden stories of women in the criminal justice system. To secure Arts Council and other core funding, it moved away from the collective nature of the early days to a more traditional company structure, and as it grew, two complementary but different strands of work emerged. These two strands were the artistic work, commissioning exciting and diverse female playwrights, immersing them in the life of the company and then producing their plays on the national stage; and the education programme, reaching out to women with experience of the criminal justice system and offering theatre education and training opportunities and support in a women-only space. In 1995 the company bought and carried out capital works on its own building in Kentish Town, funded through a range of sources, including trusts and foundations and the Lottery Award through the Arts Council. At this point, with its own purposely-designed women's centre for the arts, it was able to become a serious provider of theatre education, exclusively for women with experience of the criminal justice system, and women at risk of offending with drug and alcohol and/or mental health needs. That's been a major piece of the company's work over the last 20-plus years – working with women across London and beyond in prisons, and using theatre as a tool to develop skills, overcome challenges and grow in confidence, building pathways to future education, volunteering and employment. To create a safe space where women can be heard, be creative and receive holistic support, and where all the barriers to participation (including lack of education, childcare needs, low self-confidence, mental distress, drug and alcohol use, and unhealthy relationships) are taken into account, has been a major achievement. And this work has an impact that academic studies have endorsed and that we witness anecdotally every day from the women we work with, both in our London studios and in prisons across the country.

Hundreds of women have studied with us, learning skills, gaining qualifications, getting support, building confidence and self-belief and transforming their lives in significant ways. Many have gone on to study

at degree level, and we have very strong partnerships with universities, particularly the Royal Central School of Speech and Drama, with whom we have partnered for almost 18 years to widen participation at HE level. Other women have gone on to enter the theatre industry and work professionally there, but for those women who have not, there has been a considerable impact on their life chances and their self-confidence, having developed transferable skills to take into the workplace, and on their ways of thinking and behaving, their stability and well-being.

These two strands have not been mutually exclusive. Over the past ten years women who have been through the education programme have also worked professionally with the company in our public work, performing plays in a range of settings including universities, conferences and for criminal justice audiences such as the Parole Board, to increase understanding and improve policy and practice in the criminal justice sector. This work has been well received, and we have recognised the significant impact on audiences that comes from women with 'lived experience' telling the stories – further reconnecting the company in the present day to its origins. We have also developed practice in other areas – training professionals in the criminal justice system in the multiple and complex needs of women, and training emerging artists in using theatre in criminal justice settings. We also partner with other women's sector organisations to drive through change for women in the criminal justice system, working closely with Women in Prison amongst others.

Clean Break is now completing an exciting period of change. Companies with the longevity of Clean Break have to re-imagine themselves, look at how and why we are still relevant, especially in the unsettled and changing world in which we live.

We have made the choice to integrate those different strands of the company's work: the artistic work, which the public sees and knows about from our theatre productions, and the educational work, which has often been delivered more privately in our own space. This is a women-only safe space – developing skills and aspirations and making theatre with women: our 'members'. We are integrating all our work into a new artistic voice for the company that feels relevant, important to our ethos and values, and our new aesthetic. Our public work will see our members actively involved at the heart of our productions – either in the cast alongside professional actors or in other ways, to ensure their voices and their experiences are integral to the audience experience. We will

remain largely writer-led, so it is about the voice of the female writer and her truthful articulation of the experiences of the women she has learnt about through her time with the company.

We have worked with some amazing writers, including Rebecca Prichard, Lucy Kirkwood, Chloë Moss, Winsome Pinnock, Vivienne Franzmann, all communicating different stories of women's experiences. There is a naturalistic thread running through much of what we have produced. The company has created heartfelt, emotional stories of women's experiences, but along with the pain there is often a huge amount of humour, strength, resilience and hope, which is really important – and reflects real life. Women bring both suffering and laughter to the space.

Moving forward, we are interested in experimenting more with form and with diversity of scale. And we are also interested in embracing the digital world and looking at different ways of reaching audiences, and having sustained conversations with new audiences, about the issues and experiences facing the women, to impact more and create change both for marginalised women and in society.

Women-centred Theatre

For me, women-centred theatre is theatre that explores themes relevant specifically to women and from a female perspective, for example themes of motherhood, body image, gender-based violence; as well as potentially being theatre that is made exclusively by women – so women-only theatre, where women carry out all the roles involved in theatre-making.

Women-centred theatre might involve mixed-gender casting and creative teams, but women-only theatre is theatre made only by women. But not only for women! So, at Clean Break our theatre is made exclusively by women but it is about telling the hidden stories of women in the criminal justice system to mixed audiences. Part of its impact is reaching audiences of both genders who might not know, understand or empathise with the stories we are sharing. But we also aim to impact on those who have power and influence in society. We want to play to mixed audiences, and change hearts and minds in the process. However, we also want to take our plays to women who have lived experience of the themes, so we tour women's prisons where our work is about validation and empowerment, not necessarily about insight into new worlds, but possibly about new or different choices.

Women and Political Theatre

By its very nature, by making women-only theatre we are making a statement about the need for that, and we are also using legislative power (for example Equality Action 2010) to employ women only, so it has to be 'political' with a small 'p'.

You can have theatre made by women that is not political in its desire to challenge the status quo, but the process of making theatre exclusively by women is, of itself, political. And I would say that it has to be political now; we are still living with gender inequality. And so, just by creating safe spaces and by ensuring women in theatre are employed in non-traditional roles and have new opportunities within the industry, with women playwrights at the forefront, all those things are, in and of themselves, political. We are telling hidden stories of marginalised women who are not on main stages, so that is, again, a political act. And our playwrights often acknowledge that their work for Clean Break and their meetings with the women in prisons and in our studios had a significant impact on their political education, and an impact on their subsequent work.

Then there is the political act of wanting to change the world we live in through the theatre we make and to have a lasting impact on audiences. With this intent, we have commissioned specific plays promoting alternatives to imprisonment. We have brought these plays to magistrates, to the House of Lords, the Parole Board, to the Ministry of Justice, to places where people have power and influence, and where hearing directly from the lived experiences of the women we are working with, who are sharing their stories through theatre, has really opened ideas and changed minds. Of course, it is very difficult to measure the success of this work in bringing about change, and this is something we want to pay more attention to, as we move into the next stage of the company's life. How do we capitalise on an audience's new understanding and transform it into action and meaningful change?

Is Women-centred Theatre Still Relevant Today?

I would not be working in this sector if I did not believe women-centred theatre was relevant.

Gender inequality still exists: the issues of sexual harassment in the theatre industry itself that directly emerged early in 2018, gendered

violence, the gender pay gap; this is what the second-wave women's movement, and within that, the women's theatre movement were fighting against. The sexual exploitation of young women remains an issue, and particularly in the criminal justice system; women being criminalised for their class, poverty, race and gender. Over 100 years ago, women over 30 won the right to vote, and yet women and men in prison still have no right to vote. So, there are a huge number of themes, stories and female perspectives that need to be told on mainstream stages as well as non-traditional, community and alternative spaces. I want to see a burgeoning of the voices of women from all backgrounds, until we are in a position of equality. Equality has to sit alongside diversity, and diversity has to nurture our desire to hear different stories, so I do not see women-centred theatre as ever being irrelevant. It will always be relevant to me – and it will always be relevant to 50 per cent of the population.

At Clean Break, the importance of women-centred theatre is also about having women-only spaces. Every day I see how important those spaces are to the women who come here, many of whom are survivors of male violence, who need to be in an environment in which they feel they can really belong and where they can build confidence, feel safe and heal – an environment they can inhabit with other women with shared experiences, different stories, but a mutual understanding of exclusion and trauma.

In a way, we take for granted the rights we have now. I think it is vital to understand the history that has come before us – the women's theatre movement of the 1970s.

At Clean Break, we are thinking a lot about collaborative styles of leadership and collaborative processes of theatre-making. We are a hierarchical company, we do not operate as a cooperative, but there is a huge amount of collaboration – on decision-making, ensuring that we include different voices and respect the diversity of the women involved, and the women who bring lived experience of the criminal justice system. I think all that is building on what has come before, and then finding new ways of working.

To young, female theatre-makers I would say: be brave, be confident, know that your voice is unique, do not wait for others to give you permission, and go for it. It is not easy. It is a hard environment in which to form new women-only theatre companies, but I think there is a lot of entrepreneurialism in companies emerging now, and a lot of companies finding interesting ways of developing work and becoming viable. It is

important to see what is out there, to look at where there are gaps and look at where you can find a particular niche. Certainly, for myself as a young woman in the 1980s, the companies that I saw, the women's theatre companies that were in existence, had an impact on me as an artist and wanting to believe that there was a place for me in the industry where I could make the work that I wanted to, and had a right to have my voice heard in the sector. So, I hope there's a sense of stability and confidence that having a company that has been in existence throughout the past 40 years can provide for other companies and younger women theatre-makers.

We are saying 'it is possible, you can do it and you have a right to do it and be there.' I would encourage others to believe that and feel the same.

A CONVERSATION ON SEXUAL ASSAULT IN THEATRE
Mighty Heart and Kim Wiltshire

KW: I know we live in a culture where women's bodies have been objectified for centuries – probably since time began – but now it is not just the objectification, not just the justification by men of that objectification, but the ownership men feel they have over women's bodies. I've never been able to understand it, and with the #MeToo movement it feels like the moment has come when women can suddenly talk about this situation. Have you both noticed that, especially as women in theatre?

Lisa: I don't know how to describe what's happening at the moment. Because I love theatre. I didn't grow up with any money, we were just normal working class. So theatre has transformed me. My love for theatre is so rich and deep, and rooted in how transformative it can be. But I feel physically sick at the theatre industry at the moment, at the way women are treated.

It is not just the lack of representation on stage. It is a total lack of diversity. The fact is that most decision-making bodies are run by white men. I believe in the power of stories; I believe in how transformative stories can be. But the people running the industry … I feel so alienated from them.

Sam: It's insidious. Normalised. Here's an example: the other night I had the telly on in the background, and it was a programme about the Royals, and this line caught me totally off guard. The presenter actually

said something like: Royalty are known for going out with and having relationships with actresses. This is prime-time TV normalising the objectification of women in the arts. And it is that deep-rooted, so the work to untangle it all is huge. Because if you've got people sat on the settee watching TV, hearing that, well very few people are going to question what that TV presenter is telling them. This is why it is so important to be telling the stories of women, by women, for women, about women.

L: Our first show is called *When I Feel Like Crap I Can Call Kim Kardashian Fat*. We Interviewed 200 self-identified women about being raised in a culture that completely objectifies and places value on your body. You are valued on whatever your BMI is. How much weight you are, how much you put on while having a baby, how quickly you lose your baby weight. I guess that's the politics we are drawn to, that theatre reflects. Stories we feel angry about. For us, these are the politics and important issues we are investigating through our work.

The piece of work we are currently making is called *Binge* – it's about the way women and eating is policed by the media. For example, the way chocolate is sold on TV. Any woman eating on TV is sold as a blow-job or an orgasm. We've been investigating how we reclaim the notion of women eating, women taking up space, of celebrating the bodies we have. The only place I ever see body diversity is in devised theatre, as if the theatre-makers say: you say I'm too fat to be in your industry, then we'll make our own theatre.

Now this is only from my lived experience as an actor, but you can either be the thin actress or you have to be the overweight actress, no middle ground. I would say I've got a pretty average sized body, size 12 to 14. I'm classed as overweight on the BMI, and I never see my body on stage when I go to the theatre. I only ever see actresses who are cast as the larger funny one or the larger matriarch. Or I see the thin, vulnerable, white, middle-class, waifish.

S: But even with our company, the way we're treated is very interesting. I wonder if it is because we're two young women? We've had people going behind our backs and not being above board with information. I wonder if we were two older white blokes, or even two older men, regardless of colour, whether theatre companies would be treating us this way. Because it always feels like we're babied.

L: Babied, that's exactly right. We've been running a theatre company for three years now, and we're babied all the time because we're women. Also, people mistake our kindness and warmth for naiveté and dizziness. It is very rare that we feel really empowered; we empower people, but we don't feel empowered.

KW: Empowerment is a major part of this. With the #MeToo movement, a lot of people have reported on how they said no and were subsequently assaulted or raped, awful stories. But what I wondered about was all the women who said 'yes' and potentially did get on with their careers. Where is their story? Is there shame in saying, 'yes, I did do that'? In our society we still can't deal with having empathy or sympathy for the women who said 'yes' to sexual exploitation to improve their career prospects because that's the way they believed the world works. There are no stories coming out from this point of view, because society wouldn't feel sorry for those women, it would blame those women. But that is still a bloody awful story, horrendous.

L: I imagine the way it's framed is that in some way they have gone against the sisterhood for doing that. That's not what I believe. I believe the very problem is that women think they have to do that to get the part. But certainly, I'm sure there would be a feeling of: maybe I've let the sisterhood down.

S: There's this thing in our culture of girl-on-girl hate, fed by a magazine culture that tells us women 'gossip' and judge other women.

L: Do men have to be that ruthless and cut-throat? Do men sit there and feel like that? No, they don't. It is really very frustrating. That's why we, as women, have to keep making work.

S: We talk a lot about being paid artists, professionalising our work. Lisa and I will not work for no money and we won't employ anybody for no money. We all work in the arts, we know and appreciate that sometimes there is no money, but unless we are all making a stand, we are not going to make a change. As women in theatre, we can go down the route of conforming, doing the whole Botox thing, looking a certain acceptable way that the media and magazine culture have told us is the way to look, but then you're normalising it for everyone. Or you can be a professional theatre-maker who tells actual women's stories.

L: One area of concern as well is social media. This links into the normalising of women looking a certain way. Young women are being taught that the number of likes they get equates to self-worth and self-esteem. If they do the pouty face, they get more likes. They learn that this kind of behaviour is attracting more likes, which makes their self-worth grow.

We're completely raised to pit our bodies against all other women's bodies, but sometimes I think a lot of it is fuelled by fear. There must be so many scared men in our profession. How scary to think that women might be on an equal footing. How scary for those who are used to women being this objectified thing that they are always a cut above – to think that might end must be so terrifying for them. We could feel depressed about it, but I don't because of the work we make. We make women-centred work, self-identifying women-centred work. For our last project we've just worked with nine female artists. I think we have, probably consciously, tried to take ourselves out of some of those spaces and cultivate a culture of our own, so I don't recognise that world of men making decisions over me, my body or my work any more.

KW: Do we have to think about removing ourselves from a male-dominated culture? It seems to me that, in the 50-year history of women-centred work that I've been looking at, what we've ended up with is women in a few positions of power, but they're inculcated with the same values as the men who dominate the business. Because that's what we can't eradicate. How can we? Regardless of gender, an artistic director will tell you that they've got to make theatre that sells. So, that world actually does impact on our work because we're not being commissioned for any of the main houses in theatres. The world of men, sometimes disseminated through women in power, still gives us the narratives we are used to, which feeds into the narratives that we'll make the effort to go and see at the theatre, which then has a female artistic director who says: but this is what sells.

L: In the end, that is what is radical about it, isn't it? Women's theatre? Because it won't be, can't be, commissioned or programmed in those spaces. But there is still the need to make it.

S: It's that fear … of other women doing well and that we can't all do well together. We're trying to break that culture, but it is hard …

NOTES

1. Betty Friedan, *The Feminine Mystique* (NY: W. W. Norton and Co, 1963).

2. Simone de Beauvoir, *The Second Sex* (London: Vintage Classics, 1997).

3. Catherine Itzin, *Stages in the Revolution: Political Theatre in Britain Since 1968* (London: Methuen Publishing,1980) pp. 232–3.

4. D. Keith Peacock, *Thatcher's Theatre: British Theatre and Drama in the Eighties* (London: Greenwood Press, 1999) p. 1.

5. Graham Saunders, *British Theatre Companies 1980-1994* (London: Bloomsbury, 2015) p. 215.

6. *Ibid.*, pp. 231–2.

7. Peacock, *Thatcher's Theatre*, p. 168.

8. Interview with Kim Wiltshire for this book.

9. Sphinx Theatre Company, *The Sphinx Test*, viewed 17 December 2017, from https://tinyurl.com/ydxbbofp

10. Courtney Marie, 2016, 'Interview: Playwright Catrina McHugh on "Key Change", Women's Prisons, and Using Theater as a Vehicle of Social Change', *StageBuddy: The Insider Guide to Theatre*, viewed 5 April 2018, from https://tinyurl.com/y7p6deoa

11. Hara Estroff Marano, 2016, 'The Art of Resilience', *Psychology Today*, viewed 5 April 2018, from https://tinyurl.com/ycq3yg27

12. 'Tech abuse', *Refuge*, viewed 23 January 2018, from https://tinyurl.com/yc7bbywp

Scene 5
Queer Theatre

INTRODUCTION

Billy Cowan

'If anyone questioned what we were doing, we'd say, "Get a frock on dear, go out in the street, then you'll understand."'[1]

For many people, the history of gay political theatre in the UK, and by this I mean work that was specifically made by an organised group of gay people (gay writers, performers and producers), about gay people and for gay people, starts with Gay Sweatshop. For the purposes of this Introduction, however, I would like to start with, not Sweatshop, but the playwright, director, actor and political activist, Noël Greig, and his involvement with General Will in Bradford.

Formed in 1971, General Will, according to Catherine Itzin, was 'one of the early, seminal political theatre companies'[2] whose original policy was: 'To perform shows about contemporary political issues in both theatre and non-theatre environments with a belief that theatre had an important role to play in radical political propaganda.'[3] From 1970–74, their plays were mainly socialist and all written by David Edgar who said they were 'pure unadulterated agitprop'[4] aimed mainly at a working-class audience. After 1974 their focus changed to more community-based work where their process shifted from making plays 'for the people' to 'with the people'.[5] Noël Greig joined the company around this point and helped script *The Prison Show* (1973–4) with ex-prisoners and a prisoners' rights organisation. He also performed as an actor and, during a play called *Dunkirk Spirit* (1974– 5), went on strike mid-performance saying, while holding up his Equity card, 'as the only homosexual member of the General Will, I am, at the moment, being subjected to a campaign of harassment and discrimination by my co-workers, therefore … I am withdrawing my labour.'[6] Dissatisfied with 'the company's domination of class politics over other oppressions'[7] and, according to David Edgar, as 'a protest against a left that dismissed gay liberation as unserious'[8] Greig forced the company to re-think its policies.

Hence, between 1975 and 1977, the company was reconstituted with a deliberate predominance of gay and lesbian personnel.[9] Although it remained an organisation committed to working with all sections of the community, lesbian and gay issues became one of the main areas of focus, and were explored in plays like *Les Be Friends*, *Present Your Briefs* by Bradford Gay Theatre, *All Worked Up*, *All Het Up* (about gays and the psychiatric services) and *I Just Don't Like Apples*. These plays were celebrated at a General Will festival in Bradford at the Library Theatre in 1976. During this time, Noël was involved with, and recruited the help of, Bradford Gay Liberation Front (GLF). It was here that he met Don Milligan, who became a co-writer on the play, *Men*. Don confirms how they met:

> I became friends with Noël in the course of his involvement in GLF … Noël was experiencing difficulties regarding his political relations with General Will as the only gay man in the troupe. Consequently, he enlisted the intervention, support, and participation of Bradford GLF activists in agitprop theatre events in the city and the West Riding.[10]

An extract from *Men*, a play about masculinity and trade unionism, by Greig and Milligan, is published in this section because it seems to encapsulate not only the type of overtly political play of the time, one that according to Milligan 'surrenders nuance and development to its didactic purpose'[11] but also because it reflects the problems Greig was having in General Will itself. It is also interesting because it reminds us that the left was also, at this point in time, uncomfortable with homosexuality. Milligan explains:

> The atmosphere on the left reflected that of wider society and was particularly sharp in working-class communities where a traditional culture of solidarity and community resulted in deep suspicion and distrust of difference of any kind. This was particularly true of communities centred around engineering, mining and heavy industry. The parties and groupuscules of the left reflected this outlook and presented no challenge whatsoever to the hostility routinely expressed towards homosexuality and homosexuals in the movement and in the wider community.
>
> Consequently, when I came out I found myself sandwiched between the deep suspicion of communist and socialist organisations, common

among the more anarchic life-stylist gay and lesbian activists, on the one hand, and the conventional repressive outlook of the left and the labour movement's narrow focus, on the other.

This is where the themes explored in *Men* came from – the tension between the emancipation of homosexuals and the more traditional concerns of the labour movement.[12]

At around the same time that General Will was doing gay and lesbian work in Bradford, Gay Sweatshop in London had formed. Although Noël Greig was not one of the founders of Sweatshop, he went on to play a major part in its evolution and development. Sara Freeman in her chapter on Gay Sweatshop in *British Theatre Companies: 1980–94* states that Greig 'may well have been the most remarkable dramaturge and visionary of Sweatshop's history – the company's most productive years, from 1977–87, came during his tenure.'[13] In an interview for Unfinished Histories, Greig explains how his relationship with Sweatshop started:

> When I'd gone on strike, and had all that ... on the front page of the *Gay News*, they wrote me this lovely letter going, 'Noël we are full of support for you. If we can do anything for you ... '.[14]

However, later, when Sweatshop were touring *Mister X* (one of their first plays) and contacted Noël and General Will for help in finding an audience and accommodation in Bradford, things between the companies didn't go well, as Noël explains:

> They brought *Mister X* up around about the time we'd just done *All Het Up* and everyone in Bradford was 'hmm'... Fay Williams phoning me up and saying, 'Oh Gay Sweatshop are coming up. Can you make sure you bring all the GLF people to it?' ... And it was sort of like, because Gay Sweatshop were this professional group and we were this rabble that somehow their only interest in us was ... (this was our perception of it – not necessarily reality) ... to get an audience and to find places for them to stay, and they didn't seem very interested in what we were doing ... anyway, we took them all out to the local Shebeen in Manningham. But we were horrible to them, because I think we thought we were the bees knees.[15]

Although, according to Greig, Jill Posener (one of the first women members of Sweatshop) did not want anything more to do with him after this, he explains what happened next:

> Then Drew Griffiths rang me up because actually Drew had seen *All Het Up* and he thought it was fantastic and, even though we shouted at them, he still thought I was an interesting person and actually if I was around in London that Gay Sweatshop might be interested in talking to me.[16]

The next thing Greig did was to go down to London and join the most significant gay theatre company of the last 50 years.

Helped in no small part by the decriminalisation of homosexuality in 1967, the Gay Liberation Movement and the Theatre Act 1968 that abolished stage censorship, Gay Sweatshop was formed in 1974 by Roger Baker, Lawrence Collinson, Alan Wakeman, Drew Griffiths, Gordon MacDonald, Gerald Chapman and John Roman Baker. For about 23 years, until it folded in 1997, the company was at the forefront of gay political theatre in the UK. In that time, it helped establish the careers of many now well-known and successful gay writers including Philip Osment, Jackie Kay, Byrony Lavery, Martin Sherman and Phyllis Nagy.

The company's original objectives were about raising visibility and counteracting 'the prevailing perception in mainstream theatre of what homosexuals were like, therefore providing a more realistic image for the public'.[17] Much of the early work consisted of cabarets and simple stories about characters coming to terms with their sexuality; 'coming-out' to themselves as well as to society in general. The company's creative methods were focused on 'modes of workshopping, collaborative writing, and author-led devising'.[18] *Mister X*, one of its first devised plays was, according to Drew Griffiths, 'a simple agitprop show about a boy who becomes aware of his sexuality, and aware that it's different ... It was about getting rid of self-oppression so you can start fighting society's oppression.'[19] To prevent a bias towards gay male narratives and a gay male agenda, lesbians were invited to join the company in 1976 and stories that gave the lesbian experience a voice were also created; shows such as Jill Posener's *Any Woman Can*, based on her experiences of 'coming-out'. Although the content of these early 'coming-out' stories may seem political with a small 'p' now, Simon Callow, in an interview for

Unfinished Histories about his involvement in Sweatshop's production of *Passing By*, explains why they were so important:

> *Passing By* was my first experience of political theatre. Though in essence a very sweet account of a passing love affair between two young men, it was utterly radical in offering no apology or explanation for the affair – it was just an affair, like any other. The effect on the predominantly gay audience was sensational – they wept, not because it was sad, but because it was the first time they'd seen their own lives represented on stage without inverted commas, with neither remorse nor disgust.[20]

What made these plays political with a capital 'P', however, were the public protests and demonstrations they provoked in the places to which they toured, and the subsequent backlash and media coverage that often resulted. As Philip Osment makes clear, when talking about the protests that interrupted a performance of *Mister X* in 1975 at the Golders Green Unitarian Church, these protests often led to positive outcomes:

> It was obviously a frightening experience for the actors and the show suffered that night. The effect of the demonstration though was that the Unitarian Church congregation, who might have been quite shocked by some aspects of the play, were totally won over by it because they had been given such a blatant example of the persecution of homosexuality by bigots.[21]

It was also the awareness-raising activities surrounding the touring that made Sweatshop's work a significant weapon for the gay liberation movement:

> Through travelling around the country with the play, holding the discussion and providing *Gay News* and gay publications on the bookstall, the company became part of a network of information. They were spreading ideas which were censored by the press and the media and were forging links with people all over the country. Sometimes the performance provided the first impetus for the setting up of a local gay group because it brought people together, or it helped local groups to gain new members and to consolidate their activities. Often campaigns against the company would backfire ... and people who

might otherwise have sat on the fence would be politicized by seeing intolerance and prejudice masquerading as morality and decency.[22]

Other significant plays of this period include: Michelene Wandor's *Care and Control*, which used documentary evidence and interviews to tell the story of how lesbians had been deprived of the custody of their children;[23] Greig's first play for Sweatshop, *As Time Goes By*, co-written with Drew Griffiths, about gay lives caught up in three crucial moments in history (late-Victorian England and the trial of Oscar Wilde; Berlin in the early 1930s and the rise of fascism; and the Stonewall Riots of 1969); and *Age of Consent*, devised by the company to challenge the legal age of consent for gay people, which was 21 at the time. These shows, especially *As Time Goes By*, started to cement Sweatshop's reputation for producing high-quality theatre.

The late 1970s was a positive and productive time for Sweatshop. In the same year as *As Time Goes By*, the women members of the company were involved in setting up a Women's Festival at Action Space's Drill Hall, after which, the men staged the Gay Times Festival. Both events were highly successful and, with many gay artists and groups taking part such as the Brixton Faeries and Bloolips (of which more later), they helped create a sense of the 'collective' and galvanised the movement. Peter Robins for *Gay News* stated that Sweatshop had organised a 'three week happening that should be remembered as a landmark in the progress of gay awareness in England'.[24]

The festivals also cemented the relationship between the Drill Hall and the gay rights movement, eventually leading to it becoming one of the most important venues in the country committed, though not exclusively, to producing a queer, gay and lesbian programme. Below, we interview Julie Parker, Artistic Director of the Drill Hall (1981–2011) who discusses in more detail the work of Sweatshop and the Drill Hall during this time.

Before I move onto Sweatshop's work in the 1980s and gay theatre beyond this, it is worth looking at some of the other significant gay theatre companies that arose around this time. In South London there was the South London Gay Liberation Theatre Group, founded in 1974, which later became known as the Brixton Faeries. According to Terry Stewart, one of the original members, the group formed after being inspired by the production *The Divas of Sheridan Square* by Hot Peaches, an American theatre group who were touring England at the time.[25] The

Faeries were a group of gay men who met (many of them squatted) at the South London Gay Community Centre. They used pantomime, agitprop and street theatre, radical and traditional drag to portray, according to founding member Ian Townson, 'the homophobic forces active at the time in a humorous style, rejecting a homosexual integration at the border of society in favour of radical self-identity'.[26]

Another important company, Bloolips, was founded in 1977 by the actor Bette Bourne.* The company used radical drag to attack the far right and the religious far right and to search, in Bourne's words, 'for a new kind of gay man'.[27] Interestingly, Bourne started his gay theatrical 'career' with the same company that had inspired the Faeries, New York-based Hot Peaches. For a company that only received one Arts Council grant, the reach of Bloolips was incredible. It toured to Germany, Holland, Denmark, Italy, Belgium, San Francisco, Toronto, Vancouver, and its show *Lust in Space* won an Obie after a nine-month run in New York.[†]

Finally, there is Hormone Imbalance, a lesbian, feminist theatre group whose first revue was at the Gay Sweatshop Times Twelve Festival at Oval House. The group, which first met and discussed the idea of a lesbian company at the Gay Times Festival, worked as a collective, and many of the members had already been involved with Sweatshop's women's group, including Sara Hardy and Jill Posener. The company's policy, although not formalised, was to create 'an exciting theatrical venture within a surrealist form designed to make visible our invisibility'.[28] According to an interview in *Performance* magazine, the group formed because it felt 'the established gay mode of agit-prop presentation' was in a rut.[29] The first show, therefore, used parody to 'shoo lesbian theatre out of the closet of cosy naturalism and smug agitprop where gays are heroines and hets are beasts'.[30] It was a great success and the company was asked to tour the show to other venues. Although the company was short-lived and only performed one more show, *Ophelia*, a lesbian, feminist re-working of *Hamlet* where Ophelia does not kill herself but runs away with her lesbian lover. It is worth mentioning here because of its connections to other political theatre companies. Melissa Murray, the main creative force behind the company's shows, went on to work with Monstrous Regiment, while Sandy Lester went on to work with the 1980s lesbian theatre company, Hard Corps. Sara Hardy moved to Australia and

* See Senelick (2000), and Bourne and Ravenhill (2009) for more information about Bette Bourne and Bloolips.

† Off-Broadway Theatre Award given by the *Village Voice* newspaper.

continued to create alternative theatre, becoming a founding member of Radclyffe Theatre Productions (1985–2000).[31]

By the end of the 1970s, these gay theatre companies had all contributed enormously to the gay liberation movement. When the 1980s arrived, Brixton Faeries and Hormone Imbalance were no more, and things did not start off well for Sweatshop. In 1981, under Thatcher's government, funding to the company was cut and it was forced to close for two years. It was resurrected in 1983 with a focus on encouraging new writers and producing new writing, first of which was Greig's play *Poppies*, set against the threat of nuclear war and inspired by the peace movement, CND and the Greenham Common protesters. The play was another success and helped solidify and enhance the company's artistic reputation, especially in the eyes of the Arts Council, who in an internal memo stated that the play 'was one of the more interesting and artistically adventurous projects of 1983/84: it took artistic risks of a kind that unfortunately is quite rare nowadays.'[32]

Nuclear disarmament may seem an unusual topic for a gay theatre company concerned with gay rights and visibility, but Greig explains why he thought it important: 'Men kill each other because they do not know how to love each other.'[33] The idea of a story that placed gay men at the heart of the narrative, but had a universal subject matter, was typical of Greig's work. In the years that followed *Poppies*, however, the company had to address some very serious issues that would specifically affect the gay community: AIDS and Section 28 of the Local Government Act which attempted to criminalise the promotion of homosexuality and prevent local authorities from funding gay and lesbian organisations. A couple of Sweatshop's most successful and important plays came during this turbulent period: *Compromised Immunity* by Andy Kirby and *This Island's Mine* by Philip Osment.

Written in 1986, *Compromised Immunity* was developed for the Gay Sweatshop Times Ten festival. As *Time Out* stated in its review, it was 'the first British play about Aids'.[34] It received many positive reviews, with the *Time Out* reviewer preferring it to Larry Kramer's seminal AIDS play, *The Normal Heart*:

It bypasses the bluster, polemic and manipulation of 'The Normal Heart' to present a vividly human story where the medical condition of the title takes on complex nuances of meaning which affect everyone on and off stage.[35]

At a time when headlines about the 'gay plague' were fuelling homophobia and bigotry, and setting back the gay liberation movement 20 years, the play, like most of Sweatshop's plays, generated hostile reactions. The Tory-controlled Devon county council cut a £10,000 subsidy to the Exeter and Devon Arts Centre where the play was to be performed. This, again, caused a huge political debate with lots of media attention, which probably helped to politicise sections of the community. This resulted in the Arts Centre having to hire a bigger venue to house the over 200 people who wanted to see the play on the eve of the general election.[36]

Philip Osment's *This Island's Mine*, which explores the 'idea of families and how we create alternative families for ourselves based not on blood ties but on a community of interest and ideas'[37] was not a direct response to Section 28, but it was held up as an example of the kind of initiative the government was trying to censor through the clause.[38] In this way, it was important in calling attention to the government's heavy-handed agenda. Kate Owen, who designed the play, remembers how Sweatshop and the play were mentioned in the House of Commons' debate, and how Neil Kinnock's office wanted him photographed on the set.[39] The play was also interesting because, unlike many of its predecessors, it won over audiences and critics alike with its artistic qualities, not its provocative nature:

> With Clause 28 lumbering towards the statute book, Gay Sweatshop find themselves at the very front of the frontline ... So you might have expected the group's latest show to adopt an introspective, angry or didactic stance ... But *This Island's Mine* ... is the most warm-hearted and sagely contemplative new play I've seen in months. ... And far from blindly thumping a militant tub, the play poses awkward questions about the loyalties of the oppressed.[40]

At the time the play was being developed, Sweatshop was instrumental in setting up an arts lobby to oppose the clause. The lobby drew many influential and well-known figures such as Ian McKellen into the campaign, becoming an effective weapon in the fight against the legislation.

The 1980s continued to be a productive time for Sweatshop, and under Greig's leadership the company became, according to Sara Freeman, 'a dramaturgical force' that continued to develop new writing, not just from a gay perspective, but also from black, Asian and disabled perspectives.[41] A lot of the work during this period consisted of readings of plays

in development, and there were two important anniversary festivals (Gay Sweatshop Times Ten and Times Twelve) that showcased this new work – significantly Jackie Kay's *Twice Over*, the company's first play by a black writer, about a teenage black girl who discovers her grandmother was a lesbian.

When the 1990s arrived, Sweatshop was in a very good place artistically, and in terms of its national reputation the company was well established. When Lois Weaver and James Neale-Kennedy took over as joint artistic directors in 1992, things continued to move in the right direction. Artistically, it was buoyed by the success of *Kitchen Matters* (1991) by Byrony Lavery and Carl Miller's *The Last Enemy* (1991) and, in terms of funding, it received for the first time in its history three years' worth of revenue funding from the Arts Council. However, there were serious problems ahead with what seemed to be a clash between Sweatshop's pre-1990s identity and how Lois Weaver wanted to take the company forward into the new millennium.

Considering Weaver's background with American experimental theatre group Split Britches, it is not surprising that she wanted to 'radicalise the company into the realm of queer performance'.[42] With the dawn of queer theory, which resisted fixed categories of identity, gender and sexuality, it seems inevitable that the company became less focused on 'traditional' plays written by gay writers, about the gay experience, and began to concentrate on more experimental pieces such as *The Hand* (1995), a lesbian horror ballet written by Stella Duffy, as well as solo performances and performance art. However, considering how successful the old Sweatshop had been, it was not easy for the company to let go of this writer-centred approach, and a tension emerged between wanting to maintain aspects of this old Sweatshop and the desire to create new 'queer' performance art. This tension would weaken the company's identity and eventually contribute to its demise in 1997.

Gay Sweatshop was probably the last significant gay theatre company in the UK dedicated to producing LGBTQ+ specific work for and by LGBTQ+ individuals. Others followed, and some still exist today: Arcola Queer Collective, a community theatre company which creates 'punchy, radical and riotous re-imaginings of classics';[43] Hope Theatre Company, Manchester, which produces work that 'promotes equality and celebrates diversity';[44] Outbox, which produces devised theatre with a company of LGBTQ+ performers, focusing on unheard stories of their community;[45] TheatreofplucK, Belfast, which was the first publicly-funded queer

theatre company in Ireland;[46] and Truant Company, set up in 2004 by myself and director Natalie Wilson after my play *Smilin' Through* won the 2002 Writing Out Award for Best Gay Play.[47] These companies, however, are small entities and only produce, at most, one or two productions a year. None of them, at this point in time, is part of the Arts Council's national portfolio of companies receiving revenue funding, although most have received project funding.

When we consider all the rights that the gay community have won in the first decades of the twenty-first century – the homosexual ban lifted from the Armed Forces (2000); age of consent equalised in Great Britain (2001) and Northern Ireland (2009); transgender people given the right to change their legal gender (2005); civil partnerships (2005); the right to adopt (2009); same-sex marriage (2014) – it is not surprising that the idea of a dedicated gay theatre company that produces work all year round seems anachronistic. However, there are still battles to be won, with the war now being fought mainly by the many queer arts festivals and individual queer artists that have emerged since the demise of Sweatshop.

Significant organisations, venues and festivals that have produced and/ or curated LGBTQ+ specific work while Sweatshop existed, or since its demise, include: the Drill Hall (London, 1984–2007); Queer Up North (Manchester, 1992–2007); Glasgay (Glasgow, 1993-present); Duckie @ Royal Vauxhall Tavern (London, 1995-present); Homotopia (Liverpool, 2004-present); Outburst (Belfast 2006-present); Queer Contact (Manchester 2008-present); Shout (Birmingham, 2009-present); Above the Stag Theatre (London 2008-present). The King's Head Theatre in London, under the artistic direction of Adam Spreadbury-Maher, should also be mentioned for producing new gay plays, reviving some forgotten plays such as Colin Spencer's *Spitting Image* (first produced in 1968) and developing new gay writers through their annual queer season. Commendably, Oval House in London has continued to develop, produce and showcase gay-specific work – including work by many of the pioneering companies mentioned.

These organisations would be nothing without the many queer performance artists to whom they give, or have given, a platform over the years. Many of these artists come from 'the most continuous and the richest theatrical tradition' of drag artists – too many to mention here – who have been the 'least honoured and the least documented'.[48] What follows is a list of some of the most significant of these individual performers, as

well as gay playwrights, who have written politically relevant work since 1968. The list is not exhaustive and I can only apologise now for leaving someone out:

The queer force of nature that is Neil Bartlett, who has been making queer-significant work as a performer, playwright, director and novelist since the early 1980s; Peggy Shaw of Split Britches (1980–present); Lily Savage, aka Paul O'Grady (1978–2004); actor, director, screenwriter and playwright Rikki Beadle-Blair (1979–present); David Hoyle (1990–present), who performs his anarchic work at queer arts festivals up and down the country; Chris Goode (1999–present); outspoken socialist and performance poet Gerry Potter (1999–present), who also created and then destroyed his alter-ego Chloe Poems; writer and performer Julie McNamara (2002–present); trans-performer/activist and artistic director of TransCreativeUK, Kate O'Donnell; Tina C, aka Christopher Green (1997–present); and queer performer Dickie Beau (2011–present), who has transformed the art of lip-synching. Finally, we have playwrights Mark Ravenhill and Sarah Kane, whose works are more concerned with universal themes than queer-specific, yet are very much political, and Jonathan Harvey, author of probably the most famous gay British play of the last 40 years, *Beautiful Thing*.

This section concludes with an interview with Ruth McCarthy, Artistic Director of Outburst, the first queer arts festival in Northern Ireland, and a contribution from Chris Goode, 'We Who are Here Together: (Re-) making Queer Theatre'. Both discuss the political nature of their work and what queer theatre/performance means to them as we move into the third decade of the twenty-first century.

The final scene of *Men*, a play written during Noël Greig's time with General Will, follows. It was first produced in 1976 at the Bradford Library Theatre. As far as we're aware the play has never been published. A copy of the play can be found, however, in the Noël Greig archive held at Rose Bruford College. Rights to publish here have been obtained from Don Milligan and Noël Greig's agent, Alan Brodie Representatives.

MEN (EXTRACT)

A play by Don Milligan and Noël Greig.

Synopsis: Richard, a closeted homosexual, works for a factory in Bradford and is the deputy convenor for the factory's union members.

He has ambitions to become the official full-time convenor. When there are rumours of redundancies, Richard arranges a secret combined committee with union representatives from the factory's other branch. As this is not an official meeting, there is no budget to put them up in a hotel, so Richard agrees that the union representatives stay at his house where his camp, gay lover, Gene, also lives. In this final scene, Richard confronts Gene for effectively 'outing' him to his heterosexual union pals.

Act 2, Scene 2
The Bedroom

Lights up. Gene is discovered sitting on the end of the bed, smoking a cigarette. He finishes the cigarette and stubs it out in an ashtray balanced precariously on the edge of the bed. Gene takes off his shoes and stands. Takes off his trousers and carefully folds them over the back of an upright chair. He crosses to mirror and starts to clean face with cleansing cream and cotton wool tissues.
Richard enters. He takes off his jacket and tie and hangs them up.
A silence as they go about their tasks.

RICHARD: Nice sort of bloke, Syd, don't you think?

Gene does not reply.

RICHARD: (*Obviously uneasy but trying to make normal conversation*) What time did he arrive?
GENE: Oh, he was here quite a long time. I liked him.
RICHARD: I suppose he's not a bad old stick.

Gene turns, about to say something. He decides not to and goes back to cleansing his face.

RICHARD: What was he talking about?
GENE: Who?
RICHARD: Syd.
GENE: When?
RICHARD: Oh, just as he was leaving.
GENE: Can't remember.

RICHARD: He said something about you not forgetting what he'd said.
GENE: You obviously don't need reminding.
RICHARD: I just wondered what he's said that was so important.
GENE: Why? Doesn't he say important things very often? Anyway, it wasn't anything.
RICHARD: Why are you being so bloody mysterious then?

Gene turns to face Richard.

GENE: It was about me going to art college, or night classes. He seemed interested.

Richard sneers.

RICHARD: Ah, self-improvement. Syd's into that …
GENE: And you're not, of course!
RICHARD: Bitch!
GENE: Well I don't think I could teach you much on that score, Dickie dear.
RICHARD: You've been giving a good few lessons in it this evening.
GENE: Sorry I spoilt the party.
RICHARD: Don't worry, dear, I'm used to it. But there was no need to make Eddy and Pat feel like dirt.
GENE: They didn't make me feel at home exactly. Which is rather odd, since this *is* my home. Besides, why should I help with your nasty little conspiracies?
RICHARD: A combine committee is not a conspiracy …
GENE: (*Blazing*) That's not what I was referring to. I was referring to *you*, dear …

Gene advances on Richard, taps him on the chest with index finger.

GENE: … I was referring to your little *secret*, which isn't a secret any longer. I don't care if they *do* see it, why should I? Underneath that working-class hero is a screaming queen trying to get out. No, that's wrong. Not trying to get out, *just screaming.*
RICHARD: (*Smiles patronisingly*) Oh, it's onto that one again, is it? And I suppose you felt pleased that you laid it all over Eddy and Pat. Eddy's just ignorant.

GENE: And I was educating him. I won't be called *queer* in my own house …

RICHARD: He didn't call you queer …

GENE: 'Queer Groups', he said it. 'There's even a queer group in Leicester.' You heard him. Or are you busy re-writing history again. You lot are certainly very well trained in that …

Gene turns away and gets nail varnish remover and sits on the bed with cotton wool buds and starts to clean his nails.

RICHARD: That's different …

GENE: (*Smiling through his teeth*) … from *what*, love?

RICHARD: Eddy was talking about the labour movement … he didn't realise you'd be annoyed …

GENE: And he didn't realise we were gay, because you'd spent most of the evening making sure he didn't …

RICHARD: You certainly took care of that …

GENE: And you've spent most of your life making sure no one else knows. (*Quickly and viciously*) Why didn't you bring them to the Junction?

RICHARD: Because I wanted to talk to them seriously.

GENE: You what?

RICHARD: I said …

GENE: I heard.

A pause. They are standing very close. Gene slaps Richard's face. Richard pushes Gene, who falls back onto the bed, awkwardly Richard turns away.

RICHARD: You took care of things all right. Tomorrow it'll be all around the meeting, and by Monday everybody in the fucking factory'll know …

GENE: Gossip? How dreadful. I didn't realise that shop stewards gossiped. Such sensible men, too.

RICHARD: They'll all know. They're *worse* than a gaggle of women.

Richard speaks directly to Gene.

RICHARD: Why did you have to do it?

GENE: 'Cos I'm pissed off.

RICHARD: (*Doggedly, beginning to break down*) But you love me.

GENE: (*Ignoring that*) I'm pissed off at being the skeleton in your closet. I'm pissed off at having to go down the bar myself. I'm *not* your guilty secret, I'm your affair. I'm your *lover*. That's important.

RICHARD: Well of course it is.

GENE: How well do you know it? I mean it's politically important. Does that make it easier for you to grasp? Does it?

Richard sits on a chair.

RICHARD: Christ! That's a new one!

Richard turns quickly and looks at Gene.

RICHARD: Since when were you interested in politics! What do you ever think about? Bloody make-up, camping around ... it's all your bloody self. It's vanity, that's all. Fucking vanity and camping around. Nothing. There's no ... substance ... it's all ... insubstantial. No wonder working men hate us.

GENE: You hate us. You hate yourself. Probably more than they could ever do. And if they hate us it's because they're afraid of something in themselves.

RICHARD: (*Viciously*) Been reading our Wilhelm Reich, have we?

GENE: (*Continuing*) And *you* imagine that you'll be acceptable if you're correctly packaged; all suits and backslapping with the *lads*! I don't love you!

RICHARD: You do. You must do.

GENE: Must I? How can I love someone who's in love with power? You want to be a powerful man, don't you? Don't you?

RICHARD: I want to ... I want to change this fucking rotten system ... I want to do something with my life ... I want to do something, not sit around on my arse discussing the latest eyeliner or the price of carrots.

GENE: Well then, *come out.*

RICHARD: (*With emphasis*) It's – not – necessary!

GENE: Because if you do, you won't have your power any longer. As a man. You've got to keep your self-hatred so that you

can be powerful. The reality never lives up to the image, and you'd rather have the image wouldn't you? Wouldn't you? Why do you think Hitler could never admit that he needed glasses?

RICHARD: So now I'm a four-eyed fascist!

GENE: (*Laughs*) I didn't say that. Look at you … pretending to be things you're not. Pretending you're confident, in control. Well, you're not. There's two people downstairs who are going to spill the beans. Just think of it! Two het men … two breeders … and they don't admire you any more. And you have to be admired, don't you?

RICHARD: That's enough …

GENE: But you don't admire yourself do you? Because you hate yourself …

RICHARD: All right, leave it there …

GENE: So you have to be admired for being somebody else …

RICHARD: (*Shouting*) I said, just leave it there …

GENE: Are you threatening me? Well threaten away, because we know the territory, don't we? I wonder what they'd make of *that*. Their good old solid Dickie going in for a spot of queer bashing? You're a closet queen, Dickie; all leading men are closet queens, whether they're homosexual or not. They are just cardboard cut-outs.

RICHARD: You're hysterical.

GENE: (*Points to himself – shouts*) Socialism is about *me*. Not about your neurosis. Socialism is in the gift of the powerless. It's got nothing to do with powerful men.

RICHARD: (*Sneering*) The meek shall inherit the earth!

GENE: On cue, duckie! You control the tongues in our heads too, do you?

RICHARD: Wrap up, will you?

GENE: Why should I?

RICHARD: I want to go to bed …

GENE: Do you indeed?

RICHARD: Stop it!

GENE: Why should I?

Richard throws his arms around Gene, although it's like he's trying to put a fire out.

RICHARD: Because I don't want it to carry on. Because I just want to go to bed and for it to be all right …

GENE: That's right, a quick fuck'll quieten her down! I wonder how many het households this little scene's being played out in tonight. Perhaps you and Eddy can swap notes tomorrow.

RICHARD: Jesus! Leave it off. Leave me alone.

Richard punches Gene.

RICHARD: You're not being fair, I … you just don't understand …

Gene recovers. Speaks to the audience.

GENE: Now we have the appeal to the sympathies. Surrounded on all sides by hostile forces. The *Man* must have somebody that knows the truth to lick all his wounds. Behind every throne there's a woman, a lover, some convenience, repairing the image of the man yet never part of the picture. Propping up the man, but never of course pulling the strings.

RICHARD: You've got your claws out tonight, haven't you?

GENE: And they'll stay out. You've kept me hidden for long enough. Well the cat's out of the bag now. You're going to have to decide what's more important … Union career or yourself. Commanding, powerful, resourceful Dick, or nervous, effeminate, sensual Richard.

Gene has gone quiet. He puts his arms around Richard.

RICHARD: What can I do? If I don't stand it'll be a mess. There'll be a strike. Everybody will lose out. Everybody but Maitland. I can't let that happen. I can't.

GENE: (*His tone is almost kindly*) That's right. You can't, can you? You can't just let anything happen. It's a nightmare for you, all those men, the small men, you know, *your* members … 'My members,' is what you always call them, don't you? Well, they might make up their own minds. Without you. There'd be no knowing what might happen. Just think of the chaos.

Gene turns to the audience.

GENE: Men, like nature, abhor vacuums. They have to fuck all the holes, fill all the orifices, plug all the gaps, leave nothing to chance. Life must be predictable, because they can't trust themselves. They must know what is going to happen so that they can put on the appropriate faces. Forewarned is forearmed.

Gene crosses to chair and puts on his trousers.

RICHARD: What are you doing?
GENE: I'm leaving. I'll stay at Sandra and Jane's tonight. I'll pick up my things in the morning. You'll be at the meeting, so we needn't see each other.
RICHARD: (*Desperately*) You can't go. Not like this.
GENE: I can't stay like this. I can't live like this.

Richard buries his head in his hands and starts to weep.

RICHARD: Don't go! Christ, please, don't leave! Anything …
GENE: I'm not leaving you alone. I'm leaving you with your members. I'm leaving you with … the masses. Who else do you need?

Lights fade.
Curtain.

INTERVIEW WITH JULIE PARKER (THE DRILL HALL, 1981–2011)
Billy Cowan

Q: Were you involved in politics before getting into the arts?

Julie Parker: At drama school, I joined the Workers Revolutionary Party, probably because I was in love with Petra Markham and I used to trot around behind her. I set out, to the great horror of George Hall, head of the theatre course at Central at that time, to get a union going, and I was warned by them that it might be the end of my student career at Central. I didn't give a stuff really. Nancy Diuguid was in the year above me. She

was one of the mainstays of Sweatshop. She was an out dyke, and I'd never met an out lesbian before. I was still in the closet at drama school. All of us at Sweatshop at that time came from theatre backgrounds and we all had to learn the politics. The actual standard of production, the artistic vision and value was paramount. The value of the politics didn't work for us unless we could present [outstanding] shows.

Q: Can you tell me about how the Drill Hall came into being?

JP: After my time with Sweatshop, Nancy Diuguid got hold of me again and told me I was going to come and run a festival with her. There was a place in Bloomsbury called Action Space Drill Hall and Nancy wanted to run a women's festival, 'the first ever of its kind for contemporary times' – that's how she put it. Nancy spoke like everything was going to be the biggest thing ever. And it was. The Action Space team were performance artists and they did site-specific pieces and installations. They also worked with young people, and ran youth groups out of the building. They were going on tour to Germany and elsewhere, so there wasn't going to be anyone using the building for a while and they needed people to look after it, so they gave us the keys. They gave us the Drill Hall for a month and we ran the women's festival. We had something like a thousand women a day going through that building, and we ran workshops, films, performances … we flew women over from Olivia Records, who were the big women and lesbian's recording company in the States. It was phenomenal. What happened from there, then, was that Action Space came back and they took a shine to me and asked if I wanted to stay and become a part of the collective. Later, they split up – one part moved to the East Midlands, and the other half moved up to the north-east. Me and some of the other theatre-based people set up a new company called Central London Arts, and that's the Drill Hall as you know it; when we very much became an arts centre, a theatre and a production house, and a place where anybody and everybody was welcome. The core of the Drill Hall was very much lesbian and queer but we had a huge reputation for doing music theatre. We were the first place that took Graeae, and the Black Theatre Cooperative – an endless list of companies that came to us because nobody else would support them. The rule was, and praise be to Ken Livingstone and the Greater London Council, that if someone came to us, they got paid, and that continued

all the way through. We used to pay, at one stage even beat, the Equity minimum – whatever role someone was doing.

Q: In *Stages in the Revolution* by Catherine Itzin, there's a chapter on Gay Sweatshop and she says that it became two autonomous companies because the females and the males found that their methods of working were incompatible. Can you throw any light on that?

JP: Everybody was finding their way. There were some huge rows and fights about how the men treated women. It's funny now, and it was funny at the time … but stupid things would happen. There was this one time when (just to be political), we discovered we were out on tour on a vegan diet because a couple of the more mouthy members of the women's company had decided that eating meat wasn't allowed. There we were in the middle of Wales, *starving* … I went to the pub and had a Guinness and a beef pie.

Q: Do you think there's a distinction between gay and lesbian work as opposed to queer work?

JP: I think that's a progression in time. In the 1970s, calling somebody queer or describing something as queer, was insulting. It wasn't at that stage that words were being reclaimed. Queer became the new way of describing things … Is there a difference? Of course. *Now* there is a difference. I can describe what queer is in terms of American theatre, but [in the UK] it's a difficult issue. I think the definitions have to come from whoever owns the work. If somebody says to me this is a piece of gay theatre, and they want to call it that, then I probably wouldn't argue with them.

Q: Do you think, then, that all gay, lesbian and queer work is inherently political?

JP: No. When Neil Bartlett, for instance, does an adaptation of Ruth Rendell's *Judgement In Stone* is that a piece of political theatre? No, it isn't. Is it a political statement because he is a queer, 'out', former director and writer? Probably.

Q: Do you think a company like Sweatshop that just does gay work, or a space like the Drill Hall which put on predominantly gay work, makes sense in today's context?

JP: I have to be clear with you, if you go back and look at all of our productions … You say we did gay work predominantly, but we didn't. It was part of the programme, a substantial part, but actually, the range of work that we were doing meant there was a cross-referencing, a cross-fertilisation. We had a huge crossover of stuff. We weren't a gay venue. We never set out to be that. We set out to be a venue that could put on work that might define itself that way, but you didn't have to define yourself in that way. The issue was … is this something that's going to be relevant, has it got artistic vision, has it got the kind of production values we want, is it going to be delivered in the most extraordinary way? If the answer was yes to all of those things, or if you couldn't define what the work was, the odds were it would go into the programme.

Q: Do you think, then, that a company like Sweatshop that got regular funding from the Arts Council just to produce gay work for gay audiences would be relevant today?

JP: There's gay marriage, I can adopt, I can go on childbirth certificates, all kinds of things. I couldn't do that when my kids were born, because there were so many things that were still illegal. On several occasions I got arrested. We're talking 40 odd years ago, it was very different. There was no fringe, and then all of a sudden there was this upsurge of work of alternative theatre, and out of that came black theatre, queer theatre, lesbian and gay theatre, and it was so relevant, because all of a sudden there were members of the community who could see their own lives reflected on the stage.

The argument about whether or not it's relevant now and would you set up a specifically gay company … I probably wouldn't. I would probably set up a company that was going to do a whole spectrum of work. Back then it was crucial because we were trying to bring the politics out of the backroom, trying to establish where it was we were all going. It's just so different now to look back on it and go, was there a need? There was indeed, and it was so exciting for people.

Q: Are there any gay and lesbian plays from those early days of the Drill Hall that you think are relevant now and could do with a revival?

JP: If you turn the clock back to the early 1980s, there's a wonderful writer called Melissa Murray who wrote *Ophelia*, an adaptation of Shakespeare's *Hamlet* with an all-woman cast. It was way ahead of its time, and we did it with a company called Hormone Imbalance. I worked with Hormone Imbalance a lot, we did punk cabarets with them. All of that kind of work that we were doing then, the cross-dressing and the changing ... 30 years on, it is being heralded as the big 'new thing'.

Q: Are there any artists you particularly admire from your time at the Drill Hall?

JP: Working with Bryony Lavery and Nona Shepphard. The way that we reinvented Christmas for everybody by doing this seasonal fairy-tale, which we did six or seven of. We did a whole series again about ten years later because we kept getting fan-mail asking us to do more. There are so many artists to talk about. The day that we actually reopened the Drill Hall, in 1981, with a show called *A Pack of Women* by Robyn Archer, we sold out. We ran it for eight weeks, with 300 seats in there ... we could have ran it for nine months, because it became the most popular show in the West End. I don't think there's a script of that available anywhere in the UK, but there might be an Australian version of it.

Q: Do you think those early companies have won most of the battles for the LGBTQ+ community?

JP: Battles have been won, but bear in mind that wars can start again. I think it's very tenuous. Did I really want to be able to get married? Not particularly. Did I want the rights and the recognition? Yes, I did. Sometimes you yearn for the days of those darkly-lit clubs and backrooms, the kind of slight sense of danger. That was fun ... or not. Wasn't I lucky, because I came to London; I wasn't living in a small town in Derbyshire anymore. I think we are very lucky in terms of what's happened over the years, but a lot of people paid a very high price for all of us, and we mustn't ever forget that. In the arts world it wasn't so long ago we had to fight Section 28, but it would be so easy for those laws to disappear. But it's not about

laws … move out of metropolitan areas and you will find the prejudice absolutely still there.

Q: Have you got a theory why a lot of the LGBTQ+ work today tends to centre around individual performers and not the collective? Is it purely economics?

JP: Money. It's economic, and it's also because of the influence of performance that has come in from the States, whether good, bad or indifferent. The traditional way of making work I think was presented to new generations of performers and artists as not being quite appropriate for work in today's age. It is money as well, and I'm not certain that there are venues anymore where you can go in and people will listen to your ideas, your plans and your visions. If you go back to the 1970s and 1980s, places like Dartington College of Arts and Central were actually teaching you how to go out and set up your own theatre company.

It's a different way now.

I also take issue with Arts Council England – when I started there was a real communication between them and the artists. There was a real understanding of what was going on, and they responded to vision and to work that clearly needed to be seen and made. You wouldn't always agree with them, but you had some respect for them. Now, they actually create the policy, and artists have to fulfil their policy and there is very little room to manoeuvre in that I think, and it's disappointing.

INTERVIEW WITH RUTH MCCARTHY
(OUTBURST QUEER ARTS FESTIVAL, BELFAST)

Billy Cowan

Q: A lot of people creating gay political theatre in those early days just after 1968 were activists before they were theatre-makers. Were you politically active before you became involved in the arts?

RM: I've always been an activist for as long as I've been out and openly queer. Anything from small direct actions – spray-painting walls – to more organisational-based things; I helped set up Lesbian Line in Limerick, where I'm from. When I moved to Belfast in 1991, I got very involved in Lesbian Line here and the local feminist magazine. My

main area of interest was always what I call cultural activism: things like running women's discos; DJing; running club nights – I helped set up *Howl*, one of the first alternative queer club nights in Northern Ireland, that ran for about four years. I did queerzines, one called *Muff Monsters on Prozac*. I worked with a lot of other queerzine-sters, and a lot of that was about me trying to make political and social connections with other queer, alternative, writers/performers/thinkers.

So, yes, I'm very politically motivated, but I've never been party-political; I'm not a member of a political party. I've never subscribed to an ideology ... If someone were to ask, 'What's your political ideology?' the closest to it would be socialist in some way, but then sometimes I also think anarchist ... I don't know, I'm not really interested in 'isms'. What I'm interested in is how systems work, for or against people; how systems change; how they're manipulated. I'm fascinated by all that, and I'm interested in questioning the left as much as I am in questioning the right. I think art does that brilliantly ... it throws out more questions than it gives answers. It can give answers too, can help you find answers. That's what I love: it's provocative, it never stops changing and moving you and helping you grow, whereas politics, sometimes, can stagnate.

Q: Gay Sweatshop was set up to 'to make heterosexuals aware of the oppression they exercise or tolerate, and expose and end media misrepresentations of homosexuals'. What are Outburst's objectives? Are these goals still important?

RM: Ultimately what I would bring it down to is two main aims. One of them is to support the development and exhibition of cutting-edge queer work; and the second one is about raising awareness of LGBTQ+ experiences in all their diversity in an effort to create social change. Drilling down deep into both of those, the first one for me is about how the arts in Ireland are not very well supported. I don't think that's an accident; the arts are one of the areas that has always interrogated things here and that's not encouraged. We tend to be a very anti-intellectual and anti-culture society. Some of our artists are amazing and we're creating great work here, but we need the support and money for that. That's our job here at Outburst, to try and help get funding for the arts. We also need to instil a kind of confidence in and really support a greenhousing of artists. So, it's bringing in brilliant work from outside, letting everyone

see that and enjoy it and love it, but also get a sense of queer experience in other parts of the world which is very different.

The second part goes beyond the arts. 40 per cent of our audiences don't identify as LGBTQ+, and to me that's important. I wouldn't mind if our audiences were 100 per cent gay, because we all need that affirmation. There's nothing wrong with that, but it's also about making straight people feel a bit uncomfortable. I find that we spend so much time trying to make straight people feel comfortable with us. No! Let's make them feel uncomfortable enough that *they* shift a little, it's not always about us shifting. It's about getting people in a room who'll come out at the end of it slightly changed in some way because the work is strong.

What you were saying earlier about the aims of Sweatshop, to challenge the perceptions of straight people, is really interesting because I think now we really need to challenge gay people and perceptions around them … like, what does it mean to them being gay, and what have they built their identity on … have they built it around what they have been told is now their identity … mental health and drug abuse, they're all still rife in the gay community. So, we've got to ask why are there still these problems, and I think a lot of it is that there's been a lot of jumps without a lot of discussion or support around it. So, I think that's partly our role as well.

Q: Why do you think a festival like Outburst that celebrates queer work is still relevant and important when so many LGBTQ+ rights seem to have been won?

RM: I think it's more relevant than ever, but why it's relevant has changed a little bit. When Outburst started it didn't matter about the quality of the content; it was the fact that a queer arts festival existed, the fact that it called itself queer, and especially in Belfast at the time, was hugely political – more than anywhere else. At that stage in London a queer arts festival probably wouldn't have meant a whole lot, but here it meant something huge because the agenda here – especially in the media – was still set by negative reaction. When there's a queer story on, it's usually a reaction to something someone has done in the negative, or something someone's fighting for. There's never space to talk about who we are in a wider sense, who we are beyond just a sexual identity … because, of course, no part of an identity exists in isolation. So, having a space in Northern Ireland to do that is really radical … to have a dedicated space,

where people could see that space and make stuff for it, I think was incredibly radical.

I think what's changing now, why it's more relevant now, and why there's more festivals emerging now – especially in England – is because we're in the middle of a culture war around identity, and it's fascinating to me. I stand back from it a lot, not because I'm afraid of it – in fact, I really want to throw myself in there – but because I'm really interested in hearing the conversations. We talk a lot about intersectionality, but we don't actually practise it in how we look at queer experience a lot of the time and I think there's a big difference. You say rights have been won, and yes they have.

First of all, rights are very important and they set a framework in which people can live peacefully or successfully, and have some sense of stability if they're gay, but it's not everything. I always give the example that Brazil is the country with the highest murder rate of LGBTQ+ people, and it was one of the first countries to introduce equal marriage. You can have legislative change but social change is something else. So … Rights are very important, they're not everything and they certainly don't address underlying issues. Legal stuff doesn't address nuance, and sometimes it has to make things less nuanced.

That's been part of the problem too, as I think there's been a huge loss of identity because of the rights movement, paradoxically. You've got this weird mooring thing going on and then that's what's being bounced back to people, and you've got queer kids growing up who I think don't know whether they're coming or going, because they might be feeling one thing and then they're being told by a liberal media another thing. It's a fascinating time for me, having grown up in the 1980s and been through that second wave of queer rights activism, and now seeing how it's all going. There's a need for space to reflect on all that.

For me the other thing is that queers were always ahead of the pack when it came to creativity, and partly that was outsider status – because we had nothing to lose – but also part of that living differently, being different and thinking differently, lent itself incredibly well to creative thinking. While that may be a romanticised idea, a lot of people would refute it and say, 'No, I just wanted to get on with things.' There's always going to be that side of it. So, the dual purpose for me of festivals like this is creating a space for brilliant art that's still relevant and still pushing and asking questions in a wider sense, widening that field more and more, but also creating the space for us to tell our stories on *our* terms,

to decide what those stories are. We can live now with a semblance of normality, we get on with things; we can be 'out' at work, or be 'out' with our families – a lot of us, not everyone – but, actually, scratch the surface and there's still so much going on there. We still haven't looked at the root causes of homophobia, which are misogyny and much deeper issues around inequity … it's a fear of the feminine or the passive. What the trans experience is now throwing up is people needing to put everything in boxes and fearing what they can't control.

So, I think the job of queer arts festivals now … For me it's a few things: it has a social-political aim, which is ongoing education of people around queer experience and sexuality in general – part of the root problem around sexuality is people's fear of sexuality full stop, whether hetero or homo or whatever it is. Also, looking at that intersectionality of identities – if you're a queer person from West Belfast, your experience is different from a queer person born and raised in Bangor living in South Belfast in a nice house – we don't always talk about the experiences in their real diversity. So, I think there's a lot more to be talked about.

Q: Do you make a distinction between gay and lesbian work and queer work?

RM: Absolutely. I'm not saying one is better than the other, but what I'm more interested in is queer work, and I would say that Outburst is a mixture of both. I would say that LGBT work is work that just happens to have an LGBT theme, such as coming-out stories … something like *Beautiful Thing* is LGBT – and I love that, I think it's gorgeous and I think it's a really important one for young people to see. Whereas I think anything by Joe Orton is queer; it's really subversive and bold and it's *not* trying to make everyone feel good about being gay … queer work for me tends to be more provocative in form, or experimental in form, and more questioning in what it is saying, and not so much afraid to throw up questions and have no answers. I would consider Stacey Gregg's *Scorched* a piece of queer work because it's not a trans play and it's not a lesbian play; it's a play about a young person who's really not sure what their identity is and it asks a lot of questions, and has thrown up a lot of questions in feedback sessions afterwards. I think it's an important piece at the moment, at a time when we've got identity wars around what you can and can't identify as.

Queer work clouds things; it muddies the waters, rocks the boat ...
all those clichés ... but at the same time can be very illuminating. To
me all art, whether it's an exhibition in a gallery or queer work, whether
it's a grand master or someone who's considered a genius ... it changes
you in some way; whether it's that you see something from a slightly
different point of view, or think about something you've never thought
about before, or opened up something in you, a memory – but it *changes*
you, whether you love it or hate it. Queer art does that first and foremost,
and I think that a lot of LGBT theatre was made to give us visibility,
and to give us a sense of pride and a sense of belonging – and I think
that's really important, but I don't find it as interesting as queer work.
That's the difference for me. Queer work responds. That's the other thing
I would say: queer work tends to be more immediate a lot of the time.
During the AIDS crisis there was more queer work because we needed
it and we needed to be talking about that. Some of that was gay work as
well, but it was mostly queer and political work.

Q: Can you give me an example of theatre or performance work that
you've recently seen or produced or curated that you think is definitely
queer and political?

RM: Lucy McCormick's *Triple Threat* – while it's not political at all,
with a capital 'P' – I think it's *very* political; it asks a lot of questions
about popular culture and how our brains have been colonised, and
how religion affects us and how we've forgotten what religion is about.
It brings up so many things and I think it's one of the most wonderful
pieces of work I've seen.

I also love Nanda Massias, a queer performance artist, who did a
trilogy all around the idea of 'the sissy'. That was a very queer piece of
work to me, because again it's that thing where it's not spoken of, or if
it is, it's in hushed tones. It's talked about in a certain way, and the sissy
boy who grows up to be a sissy man is either ridiculed, ignored or told
to just butch-up – told by his own community to butch-up. You will not
see a sissy on the cover of *Gay Times* or *Attitude*, generally; you'll see a
buffed-up man. It's still an object of ridicule even in our own community.
The sissy has never been seen as powerful, though I've always thought
the sissy was powerful.

We're also working on a piece called *Cake Daddy* with Ross Ander-
son-Doherty, Alyson Campbell and Lochlan Philpott. Ross is a fat, hairy

man who wears lipstick and talks a lot about the fat, gay, male body – the fat body in general – and he's doing it through song and stomping disco music. He's talking about a subject that's bringing up a lot of things for people, especially queer men and their bodies. A part of queer work really involves not being afraid to turn around and look the issues in the eye, and here in Northern Ireland we need to do that more than ever.

Q: Do you think a space like the now-closed Drill Hall that was dedicated to producing predominantly gay work throughout the year is still relevant today, and do you think it would get the audiences it needed to survive?

RM: Gay bars are closing left, right and centre; a lot of people who are gay or identify as LGBTQ+ don't necessarily feel as though they need those spaces anymore. When they come to something once a year, when it's a condensed thing, they do seem to go away saying: I really needed that … and they start engaging more. I think in general it's hard to get bums on seats; people stay at home and there's queer films on Netflix now.

When Outburst started ten years ago, our film programme was one of the biggest parts of our programme because while you've always got gay films at the QFT (the alternative cinema here) we were always bringing in the best films and you wouldn't have seen them anywhere else. Now, probably three months after they've been with us about half of them are going to end up on Netflix or Amazon. We have to look at how we present work in different ways. People still come to the films because they love them and they want to see them earlier, but also it's the communal experience of sitting with other queer people in an audience.

I think in the queer world we need to start asking ourselves: how do we make the collective experience of queer work exciting again? It's so hard running an arts venue right now in Northern Ireland; people are being told that there's going to be another 5–12 per cent cut in the arts funding because we don't have a government, so we're going to be on an emergency budget.* I would love to see grassroots, self-run spaces. There's a space in Shaftesbury Square which was an old bank, and Accidental Theatre took it over and now they're putting on all this radical and interesting theatre. They're not funded, it all seems self-funded. I think that kind of model would work, but as a theatre that's constantly producing I think you're better off not having a space.

* At the time of the interview.

Q: Do you think the LGBTQ+ community have won the battle? What battles do you think are still to be fought and won, and what stories are you interested in?

RM: I'm interested in the stories that are not being told, and stories of difference and new ways of looking at all human experience. We talk about diversity all the time in our community and I'm not actually seeing it represented on screen or theatre, so I am looking for new ways of looking at that. I'm looking for more work that's intersectional; working-class queer … work that explores what it's like to be a queer person with Alzheimer's or a trans person with Alzheimer's looking back on their youth … There's so much revisionism going on about queer history and who did what. I think it's important that we tell the basic histories from so many points of view. Have we won the battle? No, I think we've created new battles.

There's still legal things in Northern Ireland because we still don't have equal marriage, there's a lot of issues around trans rights and health issues that really need to be addressed. The battle around education in schools is a huge one, still a massive taboo. Some schools are getting a little better with it, but we're still not there. There's the statistics around mental health here, which are shocking. You're six times more likely to be medicated for depression if you're queer, three times more likely to have suicidal thoughts. 50 per cent of LGBTQ+ people have self-harmed, and I think the statistic's much higher for trans people. So legislatively and socially we've got to change things, and I think all that feeds in off the back of post-Troubles trauma that we haven't dealt with.

The three areas that are most likely to cause depression, trauma and mental ill-health in Northern Ireland are: direct experience of the Troubles; poverty; and being queer. You're looking at a completely different set of experiences than anywhere else in the UK or Ireland. So, there are battles to be won in these areas, in terms of us addressing that and getting the resources to be able to do that. There are also battles within our own community; there's the ongoing trans-lesbian war, which I've stepped back from because I think it will play itself out. While I laugh at it sometimes and I step back, a lot of it is about a lot of pain – stuff like that only comes from pain. So, we have to deal with what is at the root of that, because dealing with the surface stuff isn't going to get us anywhere.

I would also love to see some work now about how queer people are seen as economic units in a way that they weren't before. That's why the Conservatives were behind equal marriage; everything is economic.

Even while trans is hot, there are also certain types of trans narratives that we aren't hearing. I spent a lot of time over the last year touring South America and some of the stories … the trafficking in trans women from the northern countries and poor areas to the city with the hope of getting a job, and they're straight into prostitution; the violence against women. You start talking to people about these things and they're just like: yes, but blah-blah. It's like, no, this is *actually* the reality for most of these people, and it's not a dressed-up version of that where someone escapes it because, actually, most of these women don't.

There are certain things that are still quite troubling, certain stuff around gay men … certain emotional crises. So many of my gay male friends find it very difficult to form relationships. It's very hard to talk about that, because it's getting in the way of the narratives we want to talk about, which is all the nice coupling-up.

Q: I've noticed that gay theatre companies like Sweatshop are few and far between now, and that there's a predominance of individual queer artists … whereas gay work at the beginning was all about the collective and getting together. Why do you think that is … is it purely economics?

RM: I think a lot of it is economics. You talk to any programmer of any festival – it's a lot easier to bring in a solo artist from New York than it is to bring in a troupe of six people, even from London. However, if I love something enough I will go out of my way to get money for it, and a lot of theatre companies that have five or six people will have their own part-funding. I also think that the idea of the collective has died. Hyper-individualism is as much a part of it as economics. Artists need to start looking at it because the loneliness hyper-individualisation is causing as well … no wonder people are traumatised, because they're so desperately alone.

While I don't long for the days of the 1980s with Clause 28 … it was a dreadful time for a lot of people in terms of Thatcherism and Reaganism, but there was more of a sense of collective experience then and I'm not looking at that through rose-tinted glasses – there really was. I think we need to find our way back … The AIDs crisis galvanised us, and I don't want there to be another crisis … but we need something, because the

homophobic bomb drops tomorrow and it's like we've lost sight of each other – how do we galvanise our energies there? Maybe art is the place we do that.

Q: So LGBTQ+ companies, artists, practitioners that you find exciting … If we could just have a recap of some of those names.

RM: The people who I've found most exciting to work with over the duration of Outburst … I love Dickie Beau, David Hoyle, Nanda Massias … Holly Hughes is still making amazing work … Stacey Gregg is an exciting writer, Lucy McCormick is one of the most exciting performers I've seen in a long time. I have to say that I'm still waiting to see the emergence of a new generation of work … people are making work but I'm finding that it's saying it's queer, but it's not – I'm not seeing it.

I saw some interesting trans-work – there was a piece called *Testosterone* that I really liked at Edinburgh, it was very playful and for me it went beyond … It was a trans man's story but it was very playful about masculinity in the locker room, and it was all about how do you become a man and it was very funny but it also asked a lot of questions about masculinity in general. The most exciting work for me, is the stuff that looks beyond just queer identity itself and situates queer experience in a wider world with other impacts coming in.

Q: Don Milligan, a political activist who co-wrote *Men* with Noël Greig says we should be pondering the way in which the progress of gay and lesbian rights appears to have gone hand-in-hand with the process of deindustrialisation and the disappearance of working-class communities. Do you have a theory why that may be the case?

RM: This resonates with what I'm saying about how we need to be looking at queer identity beyond just a rights narrative and a need to look at … neoliberalism. It's such a hot topic, and for me a lot of the rights agenda has been tied up in that because it's been used in a kind of pinkwashing way, because it's a case of: look how progressive we are. When actually in the background … people getting excited about Ruth Davidson being lesbian leader of the Conservatives in Scotland – very pro-gay marriage. I'm like: yes, but what about the fact that they're completely dismantling the health service, which impacts queer people. They're completely

destroying the working classes, and they've killed the unions more or less – the unions are like NGOs now; their edges have been taken off, I think.

While the surface of the whole gay marriage thing is important, I think what's underneath is … inequity. We've won some rights as queer people, but the other parts of who we are as working-class people, or as women, as workers … have all been eroded. Art's task now is to make the connections between all those things and to stop just seeing sexuality as this completely separate identity.

WE WHO ARE HERE TOGETHER: (RE-)MAKING QUEER THEATRE

Chris Goode

In the spring of 2011, I was invited by the theatre company Improbable to host a discussion event, under their celebrated Devoted & Disgruntled rubric, on the topic of queer theatre. What happened was intensely instructive.

First, I felt an acute discomfort being even nominally the host or the public face of such a gathering – a version of the squeamishness that always went with being identified as a gay or queer theatre-maker. Was I going to be seen as queer enough? The right *kind* of queer? What gave me the right to be any kind of curator or spokesperson for a whole constellation of intersecting communities of interest and practice, when I hardly connected at all to so many of those artists and activists?

Secondly, the few dozen fellow queer-identifying makers and allies who came along were a fascinatingly heterogeneous bunch. The friends I brought with me – for whom queerness was a precise and targeted appellation for a particular set of cultural, political and personal commitments, thoroughly and energetically entangled with a whole raft of other cultural ideas: radical (trans-inclusive) feminism, punk, anarchist politics, DIY/squat culture, sex positivity – sat curiously alongside a larger group of writers and actors who evidently read 'queer' simply as a catch-all term for the LGBTQ+ rainbow and whose identification as queer largely boiled down to a concern with gay representation on stage and in the industry as a whole: the need, or desire, to tell gay stories, to create gay characters and combine them to make gay plays.

At the other end of the axis (though of course it's much more complicated than that) were a group of performance artists more associated

with left-field cabaret, live art and the club scene, for whom, manifestly, 'queer' was *over*. To the more-or-less rhetorical question that I'd written into the call-out – is 'queer' an idea that is now exhausted? – their forceful answer was 'yes'. For them, queer could only refer backwards, to a cis/male-dominated scene rendered inert by nostalgia and its own unexamined orthodoxies. The most vocal of them, the brilliant performance-maker Scottee, later posted to his blog an account of the evening under the title 'Call Me Anything You Like, But Not Queer', in which he characterised the event – not unfairly – as 'white homos talking about other white homos.'*

Seven years on, Scottee's aversion to 'queer' as a descriptor of his work has evidently softened, if his promotional output and social media presence are anything to go by. Meanwhile, my own more recent experience, both in working in rehearsal rooms (for example on my stage adaptation of Derek Jarman's iconic film *Jubilee* for the Royal Exchange, Manchester), and at a University of Reading symposium to which I contributed in November 2017, suggests that the legibility of queerness now has at least as much to do with gender identification as sexuality, and that, perhaps by extension, the oppositionality of queerness, as a *resistant* social and political position, is in a certain kind of abeyance among some performance-makers and activists for whom a more broadly coalitional (though acutely intersectional) outlook is an imperative corollary to survival, representation and the attainment of cultural capital.

Clearly, it is as true now as it was when I was starting out as an avowedly queer theatre-maker in the mid-1990s that 'queer' doesn't just connote a kind of restlessness, but is itself restless – relentlessly so – in its movements and morphings. My attention must certainly have been drawn to theatre in the first place partly because of its hospitality, not just to queer aesthetics but to the dynamics of queer sensibility: to an instinctive recognition that theatre gives queers not merely a stage, a platform, or even a kind of refuge, but more significantly, a forum, a crucible, a shape-shifting common ground for acts of reimagining and remaking.

In its emphasis on the relational and the emergent, queerness feels to me profoundly theatrical (and not merely performative): and vice versa, theatre feels intrinsically queer: but this is, of course, to say something

* NB: As of 9 April 2018, this quote is no longer available.

possibly contentious about both theatre and queerness as kinds of space or praxis. The distinction I want to make might be encapsulated through one early example in my own engagement with theatre. (For all that I'm devoted to a model of queerness that starts and ends with the social rather than the individual, often the entry route can only be autobiographical.)

In the winter of 1995, while I was studying at Cambridge and thinking seriously for the first time about theatre as my likely profession, not just a personal enthusiasm, I travelled to London to see Roger Michell's production of Kevin Elyot's play *My Night With Reg*, which had received notable acclaim as a lyrical but fundamentally accurate depiction of a group of gay male friends, mostly thirty-somethings, reflecting on their relationships at a time when AIDS is tyrannically reshaping the foreground of their lives. As a gay man aged 21, I viewed *My Night With Reg* as being only remotely 'about' me – in my youthful arrogance, the greater existential threat seemed to be not HIV but the notion that middle-aged gay people could apparently become every bit as boring and inclined to nostalgia as their straight counterparts. (Well, it's equality, of a kind.) The impression was made not just by the quiet normativity of most of the lives on stage but by the perfectly orthodox proscenium arch staging: even at its most emotionally far-reaching, there was nothing here to disturb.

And then, at the beginning of the third scene, Joe Duttine, as the young painter-decorator Eric, appears naked – not fleetingly or furtively, but still, expansive and beautifully lit: and this, for the first time in the production, really *is* about me: about an invitation being extended towards myself: to look, intimately; to feel the gentle activation, in a semi-public place, of my own homosexual desire. Suddenly, this is not depiction but immersion, a sharing of space and sensibility that floods through the 'fourth wall' and folds me for the first time into the lived action of the play. This is not, any longer, for me, a play that is 'about' queerness (albeit in a distinctly homonormative mode) but a play that *is* queer, that is doing the work of queerness.

But I want to say something more about my own experience of this event. A daytrip to London had become a once-a-term feature of my university life, and in those (for me) pre-internet times, a day out in London was hugely bound up in a whole process of excited discovery and self-actualisation. I might start at the ICA – as much for the bookshop as the galleries themselves – before walking up Lower Regent Street to

Piccadilly Circus, where Tower Records had its flagship store. There I'd stock up on promising-looking CDs by US punk and queercore bands I'd hardly heard of, and perhaps pick up the latest issue of *Holy Titclamps* or some other thrillingly marginal queer zine. And then, at a newsstand just round the corner from Tower, an ancient old bloke sold American hardcore gay porn magazines that hadn't made it as far as the Fens. I'd go off to the theatre in the evening with a carrier bag that felt like it was almost audibly buzzing with queer contraband, and on the last train home I'd still be coming down from the adrenalin rush of going up to so many strangers at cash desks and effectively saying: 'I want this' – which was to say, 'This is who I am.'

Even now that the web and social media have made the processes of tracking the contour lines so much easier, queerness still shows up as so many acts of mapping: of finding communities, making connections, trawling the archive, deciphering the scribbles in ten thousand margins. These acts of electivity both define and expand us. Into the authorised narratives of gayness that people of my generation, at least, grew up with – private anguish, psychic damage, personal testimony, the gaze turned fretfully inwards – 'queer' introduces the disruptive energy of sociality. Ultimately, queer is a way of describing relationships, affiliations, negotiations, tensions, gestures of reaching out. Like theatre, it is fundamentally an ensemble practice.

Starting out as a playwright in the mid-1990s, this was the queerness I sought to stage. I didn't want to write issue-driven drama: in theatre, I felt, there was only ever one issue, and it was always the same: we who are here together in this place, who are we going to be to each other?* This, of course, is immediately a question of form, not (or not only) of content: form is the language through which 'we who are here together' construct and interrogate the premisses of our togetherness. Just as a play that professes political radicalism in the story it tells can nonetheless be a perfectly bourgeois instrument in its form and end up constituting a null political action that serves and endorses the establishment; and just as an act of protest may be tolerated or even celebrated by the state apparatus it challenges so as to neutralise its attack and re-advertise the supposed beneficence of liberal democracy: likewise a piece that treats of gay 'themes' or characters can easily do so in a way that, by dint of its

* The way I render this question here pays conscious homage to the Living Theatre, whose mission statement begins by committing the group 'To call into question / who we are to each other in the social environment of the theatre.'

formal inertia, does nothing to upset the hegemonies of hetero/cis-nor-mativity as they play out in the lives of a middle-class audience.

In my early plays such as *Kissing Bingo* (1994) and *Weepie* (1996) – under the influence, perhaps, above all, of the radiantly strange early theatre and film work of Philip Ridley – there is an intense concentration on unstable and inarticulable patterns of queer desire: a love that dare not speak its name not because it is necessarily proscribed but because its restless ambiguities will not be captured in crude manipulations of transmissible language. As I started to move from 'straight' play-writing towards devising, in search of formal ideas that could contain and harness the political as well as the libidinal energies of queerness, these ambi-guities became ordering principles and making-structures too. I look back delightedly, for example, on how we made the narrative armature of *The Consolations* (1999). The six actors each developed a character in isolation, in response to shared prompts from me, and I then asked each of them to write a lonely hearts advertisement that described what their character might be seeking in their connection with another human, but without disclosing anything about their gender or sexual orientation. These adverts were circulated and each actor chose for their character a potential partner, and in this way the major relational lines for the story were drawn. It made for a wonderfully, woozily polyamorous show, in which the forces of desire were untidy, irrational and always fluid, and the piece itself felt suffused with erotic possibility in a way that was both blatant and yet weirdly elusive.

Right from the start, if there was a queer agenda to my work (and there certainly was), it was about refusing the authorly seclusion of the 'fourth wall' and creating kinds of image and movement, articulated sometimes by text, that wanted to make themselves available to a multi-plicity of desirous readings. This impulse became all the stronger in the mid-2000s when I started to become increasingly frustrated by theatre's timidity around staging eroticism, intimacy and sexual life, compared to the leaps that cinema was taking at around that time. The British Board of Film Classification had begun passing uncut for release films that contained unsimulated sex; some of those films, such as Larry Clark's *Ken Park* (2002), Michael Winterbottom's *9 Songs* (2004), John Cameron Mitchell's *Shortbus* (2006), and the short film anthology *Destricted* (also 2006), I found impressive, and, more significantly, felt that the explicit sex was a crucial part of the *argument*, not just the plot, of each film. I

wanted to be able to approach the dramaturgy of my work with an equal intrepidity and candour.

At around the same time, continuing increases in both broadband and processor speeds, in the context of an ever more competitive market, promoted a phase of upswing in production values and artistic ambition in some regions of the online gay porn sector. Video material was constantly being released that was surprisingly well-crafted and produced, with performers who appeared consciously engaged, and gestured towards more complex interactions of narrative and persona. Again, it was both frustrating and inspiring to find myself wondering why queer theatre couldn't deliver experiences which delivered similar levels of intensity, anticipation, identification and reflexivity.

These two related responses to the searching and thoughtful presentation of same-sex sexuality and intimacy on screen, in registers to which theatre and live performance seemed uninterested to aspire, were informed by a third apprehension. The embedding of queer theory in cross-disciplinary academic discourse, which was already well underway by the time I was an undergraduate, had had one particularly disconcerting effect. By many proponents in this area, 'queer' was now being definitively understood not as a categorical identity or lifestyle choice – and rightly so – but as a modality of reading and interpretation. Queer was no longer something we actively did, but something we applied to the actions of others. In itself this perceptual shift was not unhelpful, but I was disturbed by what felt like a kind of erasure, in which queer was becoming almost totally uncoupled from sex, and reconstituted as a perceptual apparatus with which, increasingly, heterosexual or homonormative readers could amuse themselves before returning home to enjoy their families and the middle-class fruits of their academic tenure, having encountered essentially none of the danger, the risk, the discomfort, the precariousness that had always characterised the living of queer lives within less hospitable communities. I wanted to insist, in the face of this well-intended colonising tendency, on the primacy – in theatre and performance, at least – of the queer body, explicit, dissident and endangered.

And so my practice took a more concerted (and more stridently political) turn in this direction, with the formation in 2008 of a working partnership with the performer Jonny Liron, under the duo name Action one19. Over the following five years we collaborated on a number of pieces in which the explicitly sexualised cis male body was centred

within a turbulent queer-anarchist politics, starting with *Hey Mathew*, inspired substantially by Sara Ahmed's remarkable text *Queer Phenomenology*.[49] Other pieces included *Where You Stand* (2010), which examined the urban constitution of queerness and speculated about the potential radicalism of a queerness that could respond to the rural environment; and *The Infancy Gospel of the Pseudo-Belladonna* (2012), a candle-lit ritual of specialised otherness that was performed only twice, each time before an audience of twelve, in the Situation Room, Jonny's live-work space in a Tottenham warehouse.

Action one19 necessarily had a limited shelf-life but in 2014 transmogrified into the realisation of a long-dreamed ensemble project, Ponyboy Curtis. This was a fluid ensemble of young male-identifying (but not necessarily LGBTQ+ identifying) performers, gathering initially around some ideas about the not-so-secret queer life and iconography of the popular mainstream: the highly romanticised adolescent language of boybands and Hollywood buddy movies, skate teams and fashion magazines. Across the course of three years and five audience-facing shows, the ensemble pushed into more difficult or obscure areas – the political valency of rave and underground dance culture, for example, in *FCKSYSTMS* (2016) – and towards the presentation, especially in the company's penultimate show, *walk pause walk* (2017), of explicit and unsimulated sex, arising, importantly, out of the manifestly trusting and affectionate relationships that had developed within the company by then.

Those Ponyboy shows 'perform' queerness in a way that is unambiguously embodied, though the bodies and relationships through which the work emerges may be highly ambiguated in presentation. But it is an embodied queerness that shows up not only in nudity or fetishised clothing, or in real sex acts (or kissing or embracing or a whole spectrum of physical intimacies), or in the provisional critically-attuned adoption of a range of youthful masculinities, but also, perhaps more importantly, in the formal and systematic life of the company and its work. From the start, Ponyboy's voyage into unusually explicit queer territories was informed by an ongoing development of a much bigger and more complex set of group technologies around improvisation, 'conduction'* (spontaneous composition), collaborative authorship, collective ownership and

* The word is borrowed from the practice, in the context of ensemble-improvised music, of the pioneering Lawrence D. 'Butch' Morris.

self-regulation. It was informed in part by the work I've been doing in participatory formats over the past ten years, in projects like *Open House* (in which the door to a devising room is left open, with an invitation for any passer-by to come in and join the process) or *Wanted* (in which the people of Leeds were asked what they most wanted to see on stage, and we then worked with them to realise their imaginings). To step into a rehearsal room with Ponyboy was to ask profound questions about how we organise ourselves: about what we want to make space for, what we want to come through; about what's not possible 'out there' that might be not only possible 'in here' but actually necessary, life-saving even, in the special intimacy of the ensemble environment. It might be one measure of Ponyboy's determination to run headlong into these questions that the company couldn't survive beyond its third year.

Queerness, like theatre, is both a strategy of dissidence and a deeply felt embodiment of the experience of pursuing that strategy. In other words, it speculatively constructs a frame, and then compels the user to inhabit the space described by that frame. The work of Action one19 and Ponyboy Curtis is perhaps as close as I've got so far to creating structures in which theatre and queerness are as totally contiguous as I think they must be. In a post-show discussion after an early performance of *Hey Mathew* at Bradford's Theatre in the Mill, I told the audience that my sexual orientation was anti-capitalist and my politics were queer; these projects have been a concerted attempt to build a lived-and-breathed space in which that apparently fanciful statement can become dependably true. It is a future-facing agenda that has repeatedly required reaching back towards earlier (in some cases even earlier than 1968) models of queer-making: the examples of John Cage and Merce Cunningham, Julian Beck and Paul Goodman; and, a generation or two later, Derek Jarman and Neil Bartlett, Michael Clark and Sidi Larbi Cherkaoui.

All this would seem to leave us in a wholly different place than the territory of Gay Sweatshop or the post-1975 incarnation of General Will. Do I disagree with their wholly different analysis of what queer theatre might need to do? I do know that, when I was starting out, discovering Methuen's Gay Sweatshop anthology and encountering the same publishers' compilations in its well-trusted Gay Plays series was crucial in establishing one set of continuities. And of course the issue-driven, highly targeted model continues to prevail, not just for queer work but for so much of the 'new writing' establishment, while much self-designated queer performance, especially in solo contexts, follows

a similar strategy of assertion and individual distinction. It is striking to what extent so many of the generation of queermakers now emerging are able to reconcile an admirably nimble analysis of intersectional politics with a willingness to occupy commodity formats and essentially capitalist routes to production without any apparent reluctance. As a maker who came of age amidst a highly oppositional countercultural movement, but whose queerness is offset by so many other markers of racial, gender and class privilege, I am likely as much a dinosaur as Terence Rattigan and Binkie Beaumont were to the Angry Young Men of the late 1950s.*

I notice, however, that an interesting circularity has begun to emerge. For the young makers with whom I've been fortunate to work in recent years, essentialist or even categorical ideas of sexual identity are becoming redundant, except in respect of the broadest possible LGBTQ+ spectrum. A fluidity of personal identification and experience is gradually becoming the mainstream default: in which context, the self-identifying use of a term such as 'gay' or 'lesbian' might well eventually be reactivated as a politically dissident stance. It makes for a heartening, if sometimes exhausting, continuity. Whatever queer theatre may be, we can be absolutely certain it's about to not be that any more either.

NOTES

1. Lucie Regan, 2013, 'BLOOLIPS', Unfinished Histories: Recording the History of Alternative Theatre, viewed 3 March 2018, from https://tinyurl.com/ya6h7qe7
2. Catherine Itzin, *Stages in the Revolution: Political Theatre in Britain Since 1968* (London: Methuen, 1980) p. 140.
3. Iris Dove, 2013, 'The General Will', Unfinished Histories, viewed 3 March 2018, from https://tinyurl.com/yb6bzen4
4. Itzin, *Stages in the Revolution,* p. 141.
5. Dove, 'The General Will', viewed 3 March 2018, from https://tinyurl.com/yb6bzen4
6. Dove, 2013, 'The Zap', Unfinished Histories, viewed 3 March 2018, from https://tinyurl.com/y7hz4rc2
7. Dove, 'The General Will', viewed 3 March 2018, from https://tinyurl.com/yb6bzen4
8. Dove, 'The Zap', viewed 3 March 2018, from https://tinyurl.com/y7hz4rc2
9. Dove, 'The General Will', viewed 3 March 2018, from https://tinyurl.com/yb6bzen4

* I'm grateful to the film critic David Ehrenstein, who was the first person to suggest to me the strain of homophobic, or, more precisely, anti-queer sentiment that characterised the shifts in British theatre culture from 1956 onwards.

10. Don Milligan, 2017, email, 20 December.
11. *Ibid.*
12. *Ibid.*
13. S. Freeman, 'Gay Sweatshop', *British Theatre Companies: 1980–1994*, edited by Graham Saunders (London: Bloomsbury Methuen Drama, 2015) p. 153.
14. Dove, 2013, 'Noël Greig on joining the company', Unfinished Histories, viewed 3 March 2018, from https://tinyurl.com/ybrkc5dv
15. *Ibid.*
16. *Ibid.*
17. Ray Malone, 2013, 'Gay Sweatshop Theatre Company', Unfinished Histories, viewed 3 March 2018, from https://tinyurl.com/027840s
18. Freeman, 'Gay Sweatshop', *British Theatre Companies*, p. 147.
19. Itzin, *Stages in the Revolution*, p. 234.
20. Malone, 'Gay Sweatshop Theatre Company', viewed 3 March 2018, from https://tinyurl.com/027840s
21. Philip Osment (ed.), *Gay Sweatshop: Four Plays and a Company* (London: Methuen Drama, 1989) p. xxii.
22. *Ibid.*, p. xxiii.
23. Itzin, *Stages in the Revolution*, p. 236.
24. Osment, *Gay Sweatshop*, p. xl.
25. T. Stewart, 'The Brixton Faeries and the South London Gay Community', urban75 blog, 15 February 2012, viewed 4 March 2018, from https://tinyurl.com/6n98n9e
26. Sara Scalzotto, 'Brixton Faeries', Unfinished Histories, viewed 4 March 2018, from https://tinyurl.com/y7ayw3zg
27. Regan, 'BLOOLIPS', viewed 3 March 2018, from https://tinyurl.com/ya6h7qe7
28. Jessica Higgs, 2013, 'Hormone Imbalance', Unfinished Histories, viewed 4 March 2018, from https://tinyurl.com/y9640j6j
29. Marguerite McLaughlin, 'Sex War in Elsinore', *Performance Magazine*, Oct/Nov 1979, pp. 6–7, viewed 4 March 2018, from https://tinyurl.com/yckhq2ll
30. Higgs, 'Hormone Imbalance', viewed 4 March 2018, from https://tinyurl.com/y9640j6j
31. *Ibid.*
32. Freeman, 'Gay Sweatshop', *British Theatre Companies*, p. 148.
33. Ray Malone, 'Poppies', Unfinished Histories, viewed 4 March 2018, from https://tinyurl.com/ybt7v44y
34. A. S. Park, 1986, *Compromised Immunity* [Poster], Unfinished Histories, viewed 4 March 2018, from https://tinyurl.com/027840s
35. *Ibid.*
36. Osment, *Gay Sweatshop*, p. lxiii.
37. *Ibid.*, p. xli.
38. *Ibid.*, p. lxiv.
39. Malone, 'Gay Sweatshop Theatre Company', viewed 4 March 2018, from https://tinyurl.com/027840s
40. Osment, *Gay Sweatshop*, p. lxiv.
41. Freeman, 'Gay Sweatshop', *British Theatre Companies*, p. 149.
42. *Ibid.*

43. Arcola Theatre, Arcola Queer Collective, viewed 4 March 2018, from https://tinyurl.com/y7jsuy2w

44. Hope Theatre Company, About Us, viewed 5 March 2018, from https://tinyurl.com/yawzc483

45. Outbox Theatre, About Us, viewed 9 April 2018, from https://tinyurl.com/ybmodw89

46. TheatreofplucK, About Us, viewed 5 March 2018, from https://tinyurl.com/ycx2qvrl

47. Truant Company, About, viewed 5 March 2018, from https://tinyurl.com/y9bx609s

48. Neil Bartlett and Michael R. Schiavi, 'Gay Theatre', *The Continuum Companion to Twentieth-century Theatre*, edited by Colin Chambers (London: Continuum, 2002).

49. Sara Ahmed, *Queer Phenomenology: Orientations, Objects, Others* (Durham: Duke University Press, 2006).

Scene 6
Theatre and Race

INTRODUCTION
May Sumbwanyambe

Over a decade ago, I sat down to watch *The Last King of Scotland* with my father. The film tells the story of a white Scottish physician who finds himself embroiled in African politics after he treats the former Ugandan leader Idi Amin. The plot could be summarised as follows:

> A young white man from the UK graduates from university, flies across to Uganda, impregnates the president's wife, takes the president's wife for a backstreet abortion, and then saves all of Uganda from the evil dictator. No black man or woman in that film has any agency. If this white man doesn't come to Uganda to save the whole of the country, these Africans aren't going to do it for themselves.

Turning the story on its head reveals how preposterous this synopsis truly is. Imagine this film:

> A black man from Africa has graduated from the University of Uganda. He is not even a junior doctor. He comes to the UK, has an affair with Princess Diana, impregnates Diana, takes her for a backstreet abortion, joins the Conservative Party, and saves all of England from some great evil while every single person (police officers, civil servants, retired military etc.) in the country sits waiting and watching hopelessly.

If that film got made, people would not just say 'that's ridiculous' or 'that's preposterous' – people would be genuinely offended. But in 2006, *The Last King of Scotland* was arguably the most successful and celebrated political drama film of the year.

'How did we become comfortable with stories being told like that?' I recall thinking out loud during the credits. 'Stories where no other black person has any real agency apart from Idi Amin?'

Story-telling as a way of voyeurism, story-telling that involves taking white liberals, putting them in the middle of non-white communities and telling political stories from that perspective, is not a phenomenon that has been unique to political films over the last 50 years. We have also seen this approach to story-telling on the British political stage.

If this phenomenon is a sickness, then undoubtedly, the rise of black practitioners, telling their own stories where all people have agency, are making decisions in their own lives and are not subjugated as either caricatures or the foil for some 'great white hope', have been the antidote.

The first recognisable community of black theatre practitioners emerged in Britain in the late 1950s, some ten years before the period of political writing that this book is looking at. Three playwrights in particular – Errol John, Barry Reckord and Wole Soyinka – stand out for their achievements at the Royal Court, and for the position they would come to occupy in the canon of black British theatre.

It is difficult to ascertain the extent to which these writers have influenced practitioners writing during the latter half of the twentieth century. When one looks at the most famous of these playwrights, Errol John, and his play *Moon on a Rainbow Shawl* (1957), and compares it to another political play written by a white practitioner, *Look Back in Anger* by John Osborne (1956), it is clear that, even though the two plays were produced within 18 months of one another, the legacy of the first play is overshadowed by the latter.

It seems to me that the 'kitchen-sink drama' of *Look Back in Anger* has had a more enduring influence, and that it is still very much a reference point for many who work in the industry.

The impact of *Moon on a Rainbow Shawl*, which was awarded 'Play of the Year' by the *Observer* in 1959, is not as clear. Until its recent revival by Talawa Artistic Director, Michael Buffong, at the National Theatre (2012), it had largely been forgotten as a text, even by black practitioners.

While it is possible that *Look Back in Anger* is the better play and has aged better, there are other factors at play here which are important to take into account. It is much easier to see the influence of these early black practitioners on the late 1960s and 1970s.

What John, Reckord and Soyinka represent in terms of political writing in theatre was the tip of the iceberg of an ever-growing immigrant community that had been steadily increasing in Britain since the passing of the 1948 Nationality Act, which granted all Commonwealth subjects citizenship rights in the UK, further changing the dynamics of Britain's

post-World War Two population. Large-scale migration from Africa, the Caribbean and the Indian subcontinent saw the development of new communities across the UK, brought to contribute their skills to sectors such as mining, textiles and transport. As our communities grew through the 1950s, 1960s and 1970s, our presence would demand a space for stories and experiences on the British stage and beyond, that we could call our own.

It was not until the early twenty-first century that I personally became aware of this growing intersection of race and political writing in the British theatre. I was studying for my law degree at Leeds Metropolitan University, when I went to see Roy Williams' *Sing Your Heart Out for the Lads*. It was on tour from the National Theatre at the West Yorkshire Playhouse, and it was the first stage play I had ever seen. I sat and watched it – I think I was meant to be reviewing it for my university paper – mesmerised by the fierce urgency of the politics of the play. It spoke so passionately and directly about what it meant to be living in Great Britain right now as a young black man who had integrated into British culture. I felt that I knew the world that Williams had created, having been brought up in a small, mostly white community during my teenage years, knowing very few black people.

Sitting in the theatre that day, I did not know then that it would be over a decade before I would be making my own 'debut' as a political playwright with *After Independence,* about post-colonial politics in Zimbabwe. All I knew was that I had got a glimpse into a new and exciting world that I really wanted to be a part of.

Seeing Williams' play, and reading the other seven plays he had by then produced in England since making his professional debut at Theatre Royal, Stratford East with *No Boys Cricket Club* (1996), introduced me to the mass of black practitioners who had been enjoying critical and popular success on the British stage, from the 1990s into the first decade of the twenty-first century. Many of these playwrights were British, or at least based in Britain, such as debbie tucker green , Kwame Kwei-Armah and Oladipo Abdoulaye. Others were based on other continents, such as John Kani (South Africa) and Lynn Nottage (USA).

One major difference between this later era of black political writing on the British stage, when looked at in comparison to the mid-1950s and throughout the 1960s, can be seen in the output of women of colour. In the 1960s, black female playwrights were virtually invisible on the British stage. Back then, it seems very much as if Errol John, Barry Reckord and

Wole Soyinka's relative successes provided only a male black practitioner's point of view when it came to publications and productions.

The success of black practitioners in the 1990s has had the opposite effect, with women such as Rachel de la Hey, Bola Agbaje, Michaela Coel, Charlene James and Theresa Ikoko, to name just a few, all enjoying critical and popular success. Therefore, stories written by women have played a much more prominent and proportionate role in the ever-expanding network of political stories being told on the British stage.

The result of this growing plurality of voices and viewpoints has resulted in a profound change in the ambitions and scope of what black practitioners have successfully tackled in terms of subject-matter when writing politically for the stage. Whilst black practitioners have grown beyond the confines of the pseudo 'kitchen-sink' drama of *Moon on a Rainbow Shawl*, I would argue that in the wake of Roy Williams' *Sing Your Heart Out for the Lads*, amongst other plays that were successfully set on an estate in the inner city, political writing from black practitioners has, on our main stages at least, overly focused on the following binary archetype: gun/knife-crime stories set on an estate featuring under-educated black people caught in never-ending cycles of substance abuse and the destruction of their own community.

Whilst one can understand the homage that writers are paying to trailblazer Roy Williams and the powerful truth these stories are tackling, I cannot help but feel that the proliferation of these archetype stories is just as damaging as the reductive and over repeated story of 'Africa' described by the liberal, white 'good guy' in *The Last King of Scotland*.

If it is true that Roy Williams' urban style of play as an identifiable movement of political writing in British theatre has dominated commissioning trends amongst black practitioners, it is worthwhile noting that other schools of political writing from black practitioners have also flourished during this period.

For example, writers like Oladipo Agboluaje have also responded to and explored how first- and second-generation writers of the 'diaspora' can call on both their lived experience of Britain and cultural memories of elsewhere in designing their stories. But whereas the central Roy Williams character is very 'British', the Agboluaje character is often very 'African'. Likewise, Agboluaje's plays often take place in Africa instead of that all-too-familiar, brow-beaten, inner-city estate.

As a British citizen who started his life as a second-generation immigrant in this country, I can say for certain that the Agboluaje

movement of political theatre-writing is where I found my inspiration – and the permission – to write what would become *After Independence*. Before I engaged with Agboluaje's works, I had thought that the only way to have a career as a black practitioner writing political theatre was to set one's play in a gritty urban world – but it was a world that was not my own.

Irrespective of whichever movement of political writing in black theatre is dominant, the central conflict at the heart of most work from black practitioners has undeniably been preoccupied with exploring the impact on the human consciousness of feeling torn between two (or more) very different places. In doing so, black practitioners have successfully examined the politics of what it means to be black in Britain today, or in the past. Looking beyond this period of time, into the future of political writing, it will be interesting to see how variations of this remain at the thematic core of the black practitioner's art.

That there are competing schools of theatre within the black community is testament to how much has changed since those early days in the late 1950s. This can be seen primarily in modern audience's appetites for challenging and topical subject-matter and the ambition of black practitioners to satisfy those political appetites. Nowadays black practitioners are not just playwrights, they are producers, directors, artistic directors. This surge in the plurality of roles, the number of playwrights' voices and high-level decision-makers has coincided with the creation of forward-thinking initiatives like Eclipse Theatre, which began in 2003. The project aims to address the absence of black theatre on the regional middle-scale touring network. Over six years a consortium of regional theatres with Steven Luckie and then Gemma Emanuel-Waterton as Eclipse Producers toured the following: *Moon on a Rainbow Shawl* by Errol John, *Mother Courage and Her Children* by Bertolt Brecht (adapted by Oladipo Agboluaje), *Little Sweet Thing* by Roy Williams, *Three Sisters* by Anton Chekhov (adapted by Mustapha Matura) and *Angel House* by Roy Williams. Also worth noting are the creation of government-funded touring theatre companies such as Talawa and Tamasha.

Talawa was formed in 1986 by Yvonne Brewster, Carmen Munroe, Mona Hammond and Inigo Espejel, in response to the lack of creative opportunities for black actors and the marginalisation of black peoples from cultural processes. With more than 40 award-winning touring productions, from African classics to Oscar Wilde, behind it, the company has performed work by writers like C.L.R. James, Derek

Walcott, Michael Abbensetts, Wole Soyinka, Patricia Cumper, Mustapha Matura, Roy Williams, Jackie Kay, Kwami Kwei-Armah, Trish Cooke, Malorie Blackman, Michael Bhim, Arinze Kene, Theresa Ikoko and Tash Marshall.

Tamasha was formed in 1989 by director Kristine Landon-Smith and actor/playwright Sudha Bhuchar, to bring contemporary work of Asian influence to the British stage. The company's debut production, *Untouchable* (an adaptation of the novel by Mulk Raj Anand, following a day in the life of an Indian latrine cleaner) opened at London's Riverside Studios in December 1989, performed by an entirely British Asian cast and playing alternate nights in English and Hindi.

The positive impact that the leadership from these companies has had on political writing on the British stage should not be underestimated. One only has to look across the border to Scotland, where such diversity-led companies are either, relatively speaking, in their infancy or do not command anywhere close to the same amount of resources to see what the landscape might have looked like in England over the last 30 years without them.

My own experience working in Scotland as a playwright is the best anecdotal evidence of this. As I write, I am also writing a new play commissioned by the National Theatre of Scotland. As such, I am one of very few BAME playwrights who are currently on commission to any of the big, new writing theatre companies based and operating in Scotland. These difficulties of representation are not limited to Scotland. Only two years ago, working with the BBC, Scottish Opera and the National Theatre of Scotland, I realised I was the only black person in the whole of the United Kingdom leading an opera as a librettist at one of the major UK opera companies. Also, one only has to look at the current debates around East Asian representation in England to see that many more interventions are needed to ensure that all ethnicities can benefit from the kind of encouraging progress over the last 50 years that has been experienced amongst political voices emanating from an African/ Caribbean background.

A TAINTED DAWN (EXTRACT)

A Tainted Dawn, written by Sudha Bhuchar and Kristine Landon-Smith, was inspired by eight short stories about the partition/independence of India including 'The Indian Lauren Bacall' by Leila Keys. It opened the

50th Edinburgh International Festival in 1997 which was also the 50th anniversary of the partition. The following scene is from early in the play when a group of medical students are gathered in their college gardens on the eve of independence, waiting to hear Nehru's iconic 'tryst with destiny' speech to the nation on the wireless. They climb a tree to avoid the gathering crowds.

LAURIE: Sanjay, did you see Mira on the campus? It's only five minutes to Panditji's speech.

SANJAY: Not everyone is as besotted with Nehru as you are. Your last obsession was Gregory Peck.

LAURIE: I've grown up.

SANJAY: If you've grown up why don't you change your name back to what it really is?

LAURIE: If your name was Kaiser Jahan Begum, you too would change your name.

GAUTAM: You've changed your name? I thought Laurie was short for something.

JYOTI: It stands for Lauren Bacall. Ooh, Sorry Laurie – I didn't mean to spill the beans.

LAURIE: It's alright. I'm not ashamed of it. Listen Gautam, as a teenager I thought I looked like Lauren Bacall. You know I even wrote to Gregory Peck and asked him to send his photograph and autograph it to 'the Indian Lauren Bacall'. I also told him I was writing to him rather than to Humphrey Bogart because he was taller, more sensitive and I loved the way he smiled.

GAUTAM: Actually, come to think of it. You do look a bit like Lauren Bacall.

JYOTI: Now, Gregory Peck has been replaced by Nehru.

LAURIE: He's such a visionary. A Kashmiri Hindu Brahmin and a half Persian Muslim – Nehru and I. Tonight India belongs to us both.

SANJAY: The man's got vision but sometimes I wonder if his vision goes further than Lady Mountbatten!

LAURIE: Don't spoil it for me tonight. I want to listen to Nehru's speech without any of your wisecracks.

SANJAY: What are you getting so excited about? Brown sahibs are going to replace white sahibs. Things aren't going to be any different.

JYOTI: Don't be so cynical Sanjay, not tonight.

SANJAY: It's true. India would have had azadi [independence] twenty years ago if it wasn't for Nehru and Gandhi's cooperation with the British. What did they get for it? Broken promises, millions of our troops being killed on the fronts.

LAURIE: It's because of them we are here tonight, looking forward to our freedom. I want to experience every moment of India's new dawn. Here in this tree – we've got five languages and three religions. Our little group is a microcosm of secular India. In Nehru's India we're all Indians first. Our culture is a rich mixture. From the Rubaiyat of Omar Khayyam to the Mahabharata, we can embrace it all.

Mira: Ssh … It's countdown!

On the wireless, the clock strikes down to midnight and the students count down to Nehru's speech.

THE PERSONAL IS ALWAYS POLITICAL
Sudha Bhuchar

Recently I was on a film set in a castle in Dorset (not an everyday occasion for me, it must be said!), hanging around as actors do between 'takes' in a makeshift green room with extraordinary views of the rugged cliffs and ocean beyond, when I found myself looking up from the book I was reading. One of the cast, inviting conversation, had asked me what the title was, as I had removed the book sleeve. I found myself hesitating before answering: *Why I'm No Longer Talking to White People about Race*, a book by Reni Eddo-Lodge that had caused much reaction recently. As I had suspected, my answer was a conversation stopper and I felt responsible for the change in atmosphere and wanted to ease the clear discomfort of my fellow actor. I suggested that I should have brought something 'lighter' to read – maybe a magazine. It would have been easier to talk about Donna Tartt's best-seller, *Goldfinch*, which another actor was savouring. Although far from 'light', and now that I have read it, I know we could have had a great conversation about the heartbreak of grief and growing up, the compelling plot, and how a moment can change your

entire life; all emotions and themes that connect us as human beings, without having to navigate the taboo subjects of 'structural racism' and 'white privilege'. As articulated so succinctly in Eddo-Lodge's book, as a person of colour I find myself constantly exercising 'self-censorship' in an effort to avoid difficult conversations and stay sane; choosing those moments when I can truly share my life experiences and those of the people and communities that I find myself writing about. These are the experiences that have led me to writing in the first place, inevitably shaped by migration and growing up as 'other' in the UK.

Why am I attracted to books like Reni's, Gary Younge's *Who Are We and Should it Matter in the 21st Century?* and, more recently, Amy Tan's wonderful memoir, *Where the Past Begins*? I realise it is because I am constantly looking for affirmation that my experience of being 'other' is shared by many writers of colour. Reading these collective lived experiences renews my hope that there is a growing critical mass of literary offerings that challenge us to think of the complexity of 'identity' and 'difference' as a positive prism through which to explore our common humanity, and not a reductive and peripheral lens that only speaks to the people who the stories and studies are about.

I am an unlikely theatre-maker. A shy child and teenager, I am shaped by my itinerant early life in Tanzania, India, Norfolk and finally London. My Punjabi father was a teacher who forged new frontiers by going to East Africa in the late 1950s; soon followed by his new bride, myself and my siblings were born there. It was a turbulent time personally and politically as the end of empire in East Africa was shaking up society and change was in the air. The rise of dictator Idi Amin in neighbouring Uganda and the vulnerability my parents felt as Indians was palpable. We would travel by ship from Mombasa to Bombay (now Mumbai) as my parents made several attempts to go back to India to live. Little did I then realise that those childhood sea journeys would inspire me to write (with Kristine Landon-Smith) *Strictly Dandia*, a play set in North London about the inter-caste rivalries within the Gujarati communities from East Africa. The ship, like East African society, was divided into three classes and the dinner and dances in first class, on which my sister and I eavesdropped, as we Indians travelled in second class, directly inspired a scene in the play where the characters relive their days in East Africa through a nostalgic 'theme' evening which transports them back on board the SS *Karanja*, dancing to the iconic Swahili song 'Malaika' (Angel). This song is known by every Asian migrant from East Africa

as it has underscored our lives in uniquely personal ways. It is played in homes and bars globally and captures the melancholy of migration that I explore in all my work either explicitly or unknowingly. I have begun with this example, but it is only one of many that illustrate why I have ended up embracing a life in the arts as an actor and theatre-maker/producer; using it to make sense of my life and give voice to 'my' people; migrants from the Indian subcontinent's diasporic communities.

While still at school, studying three of what my kids call the 'Asian Four' (maths and the sciences), I stumbled into theatre by accident through a chance meeting with Jatinder Verma, founder of Tara Arts. My life took an unexpected turn and, although I went on to finish my degree in Maths/Sociology, it is making theatre and acting where I feel most at 'home'. This journey of over 35 years includes co-founding Tamasha with my closest friend Kristine Landon-Smith, where we made and commissioned a body of work that includes *Balti Kings* (co-written with actress and fellow East African migrant, Shaheen Khan), *A Fine Balance* (co-adapted by Kristine and me from Rohinton Mistry's famous novel) and *East is East* by Ayub Khan Din. We became inadvertent pioneers, audience developers and artist/entrepreneurs to ensure that the uniquely subjective voices of diverse artists found a voice and a place at the heart of British theatre.

Who I am is the reason that I write, seamlessly connecting threads of my life and the past to the present and our presence in this country. Through theatre I have learnt about history and how as 'British Asians' (a term that is now deemed problematic, but I like to use it, as it represents a unity across faiths) we didn't just rock up on these shores by chance, but were invited, as citizens of the Empire, to rebuild this country after World War Two and to make new homes here. I realised that my parents had used the final opportunity to get British citizenship before the immigration laws cracked down on the children of Empire entering the UK. I have devoured literature from the subcontinent and transposed European classics like Lorca's *The House of Bernarda Alba* to contemporary Pakistan, where it found fresh resonance for me and was titled *The House of Bilquis Bibi*. Every subject that I have chosen to investigate has shaped and informed me and connected me more deeply to my roots, and as a sense of 'belonging' in this country (or anywhere else) eludes me, at least I can search for it through my work.

I care about the characters in the plays that I have written and collaborated on in a way that is deeply personal; knowing how rare it still

is to see them on stage. To then see my work described as 'political' is always surprising. I hope it is because I have invested in how 'small' lives play out against the canvas of bigger world events. The subjects chosen arise from everyday matters: *Balti Kings* came from me and Kristine sitting in a Balti restaurant in Birmingham's Ladypool Road where Balti was first 'invented' and our curiosity about the people in the kitchen making the nation's favourite dish, chicken tikka masala; *Child of the Divide* was inspired by a short story by Bhisham Sahni about a lost child during the time of the partition of India, but I was really speaking to my children's enquiries about who they were in terms of religion, as I am a non-practising Hindu married to a Muslim; and *My Name Is ...* was a verbatim piece about Molly Campbell the mixed-race girl who ran away from Stornoway in 2006 and whose Scottish Muslim father was accused of kidnapping her, which made global headlines.

So, my work is always built from the 'personal'; the 'political' context emerges invisibly in the 'making' of it in collaboration with other creatives at each stage of the process. For example, *Balti Kings* looked at the clash within a family between catering for the undiscerning British palate by offering 'pile your plate for under a fiver' buffets and preserving authenticity at all cost through expensive regional delicacies. Even the term 'Balti' emerged to make it easy for the Brits, as they couldn't pronounce the word 'karahi' which is the pan used to cook these dishes. As Khalida, the widow who stuffs samosas, says disparagingly in the play:

Balti, Balti, these whiteys are crazy after Balti. What is Balti huh? Bucket! In Jhelum where we come from horses eat out of Balti ennet?[1]

Seen through the eyes of the workers in the kitchen; this tussle takes on further poignancy as the loss of home becomes linked to the loss of the 'taste' of home. The kitchen is also a place of refuge and asylum. Nadim, the kitchen 'all-rounder' who is running from a scandal, remains evasive about his reasons for leaving Pakistan:

Matey, I am on the hit list. They don't need reason. In Pakistan, you drive a car too slow you must be drunk; drive too fast police say you stole it. Your eyes are green, you must be terrorist. You know a rich man's elephant went missing. Police searched high and low for it. They couldn't find an elephant so they brought back a donkey. They beat the donkey so hard it finally said, 'OK, OK I admit I am an elephant.'[2]

Although the play was written in 1999, it still resonates, I hope.

In *My Name Is …*, which was crafted from verbatim interviews with Molly and her parents, the audience represents 'me' as I 'record' the story, and the three protagonists interject and overlap with each other to give their 'version' of events and counter the media headlines which they read out, illustrating how their experience had been reduced to the 'Islam versus the West' agenda:

GABY: Abducted! Gaby or Ghazala? Tug of love schoolgirl snatched from school gates and taken to Pakistan for 'forced' marriage.

FARHAN: 'Barbaric' practice among third world immigrants. Fears grow for 'kidnap' bride.

SUZY: Mentally unstable mum left devastated.

FARHAN: British media reporting akin to psychological side of the so-called 'war on terror'.

GABY: I love Scotland, but I love Islam more.[3]

I had changed the names to create some distance from the 'real' story but the family's permission was paramount, as was their endorsement of the play as a vehicle to show the complexity of what they went through: a story that began with two teenagers in love in 1980s Glasgow that ended in a tug-of-love custody battle in the glare of the global media. The characters' 'real' dialogue contrasted with the newspaper headlines and captured the hybridity of speech/language as well as the complexity of the personal situation:

GHAZALA: School kids. If they're Pakistani, they'll say, 'Your mum's a gori' (white) and if they're gorey (whites) they'll say, 'Your dad's a Paki' and even if they were not even racial racist, they would say 'Do you know why your mum and dad got divorced?' 'Yah like she got sick in the head, she got pagal (crazy).' You know how the whole mohalla (neighbourhood), the whole mohalla knows.[4]

The above is a small illustration of the many influences in my work and the thorough research that I draw on with each project. I am grateful to cultural commentators like Yasmin Alibhai-Brown who has articulated,

more successfully than I could, how it speaks to the larger canvas of our pluralistic lives and the agendas around 'difference' and race.

In the foreword to the play-text publication of *Strictly Dandia,* Yasmin writes:

> To tell the untold is always a risk. To use an individual's tale to wider purpose is more dangerous still, especially with themes like immigration, settlement, cultural battles. How can you do this without didactics and homilies and the argument that the events simply could not happen in good Asian lives? Through beguiling drama, cheek, damn good jokes, and an understanding of the intimate moments of big histories. The rising smoke of the kitchen in the unforgettable *Balti Kings* disseminated the pain and strength of immigrants better than any overfunded government report.[5]

And on *My Name Is …* she writes:

> Truth and emotions are revealed here that no journalism can ever reach. At moments of high drama, you feel the walls could collapse and gales would carry away the players.[6]

As a writer of colour, I am not afforded the luxury of just writing my work and handing it to a 'welcoming' venue, which will produce it within their 'one-size-fits-all' season. I must make the conditions for making the work, as well as the work itself: fundraising, attracting partners, producing, giving context and content to assure the receiving venues that there is an audience for the work. I am always amazed to hear mainstream white playwrights talking about how they never think about who their work is for, as 'it will speak for itself'; expressing the sentiment that is widely seen as the highest hallmark of quality. While there is more imperative than ever for theatres to programme diverse work and reach new audiences, the onus is still on artists like myself to 'evidence' our significance. This can be a drain on the soul of a huge cohort of artists. Writer/consultant and coach Gaylene Gould talks eloquently about the dangers of 'cultural neglect'[7] and its effect on the collective spirit and well-being of people of colour. The feeling of always being on the outside peering through the window, waiting to be let in.

Despite the challenges, I realise that the act of creating and positioning the work that I make is profoundly political, even if for me it is

always 'personal' first. When it inevitably plays into bigger agendas, this is not always of my choosing. As an artist of colour I am navigating the burden of representation from my own communities and at the same time managing expectations from the outside that I will somehow always speak to global concerns around race and identity and provide answers. I recently revived my play *Child of the Divide*, about the lives of five children during the partition of India, to mark the 70th anniversary of Indian independence. This anniversary proved to be an important one for the Asian communities in Britain as second- and third-generation immigrants wanted to find out what their parents and grandparents had been through. The films, documentaries and my play were able to provide a transformational role for many audiences of all ages and cultures. My partners included the Partition History Project, which was set up by senior clergy, Professor Sarah Ansari of Royal Holloway University and the Runnymede Trust. I also had a unique collaboration with the National Archives where many original documents of the period are held. I witnessed school children, partition survivors and general theatre-goers making an emotional connection to the work. The production was critically acclaimed and recognised for the additional educational and social significance it provided. It fed into inter-faith dialogue within communities as well as making a compelling case for the teaching of partition to be on the school curriculum as a 'shared' British history and not just a 'wound' for the Indian subcontinent and its people. As one of the children in the audience at the Polka Theatre confided in me, 'Now I know that what my grandfather had told me was wrong.' His grandfather had given him a one-sided narrative about Muslims being the only people who had committed atrocities against their neighbours. I have now been invited to take *Child of the Divide* to Canada, where I hope it will have a further life.

Although I cannot profess to be as talented as writers like August Wilson, who I admire very much, I share with him the feeling that one finds oneself on a crusade to chronicle the lives of our respective communities. His words inspire me as he explains that he set out to look at 'the unique particulars of black culture … I wanted to place this culture onstage in all its richness and fullness and to demonstrate its ability to sustain us … through profound moments in our history in which the larger society has thought less of us than we have thought of ourselves.'[8]

My current work has now led me to another deeply personal and unexpectedly political place. It is a piece called *Golden Hearts*, which

will look at the inheritance of loss in Asian families like mine as a result of heart disease. Again, I have found that my experience of losing three close family members to heart disease is mirrored in entire communities. In 2016 I was artist in residence at East London Genes & Health, which is a 20-year study that will map the genes of British Bangladeshi and Pakistani volunteers in East London to understand the unusually high incidence of heart disease within these communities. The politics of 'inequality' is displayed here in the under-representation of these communities in medical studies to date, making it difficult to draw conclusions about differences in health and provision. My personal 'meditation on loss' is inevitably becoming a bigger story of the effects of migration on the health and mental well-being of migrants. As one of the people I interviewed summed up, 'If you take a rose from this country and transplant it in Karachi or Bombay; it will die. So, it is with our people.'[9]

Over the years, my role as an artist has become one of 'service' as well as a personal journey. Reading a recent interview with Zadie Smith, I had a eureka moment of connection when she was asked if she had a dual role as an author and a 'voice' for her community. I will share her answer in full here as it sums up beautifully what I am trying to articulate:

> I can't think of community in the singular. Doesn't everyone exist in a Venn diagram of overlapping allegiances and interests? I'm a black person, also a woman, also a wife and mother, a brit, a European, a member of the African diaspora, etc. … a comedy-nerd, a theory dork, etc. …
>
> I am delighted to be all these things and everyone will find themselves in a similar plurality of communities.
>
> The whole debate can fall into a bit of a trap. No one identifies white authors by their race so why should I put up with being called 'the black British author'. Yet by that logic, the rhetorical pressure falls on this idea of neutrality. As if to be white is not to possess a race or an identity – is simply to be 'the author' whereas to be black is precisely to have an identity. And then from there you're forced into a corner where you find yourself arguing that to be truly great, truly 'the author', you must have your blackness forgotten, you must aspire to people seeing 'beyond' it, 'past' it … I don't desire this supposed neutrality. I am all the things I am and also an author. It's all inseparable.[10]

Coming back to the film in Dorset, despite making the decision to park the conversation about race with my fellow actors, I had a wonderfully collaborative and creative experience. I was invited to bring my full self to the project, with freedom to improvise and inhabit my character, including the odd cuss in Punjabi when appropriate. And although my storyline is not at the 'heart' of the piece, I hope the perspective I offered will enhance the world of the film and that a 'real' portrayal of multicultural life will become increasingly prevalent in mainstream culture.

I will end with a mantra from Lin Coghlan, a wonderful writer and mentor, which acts as a guiding principle for me: 'Write the play that you know only you could have written.'* As long as I have the creative energy, I will conserve my full voice for those works and bite my lip where self-preservation is at stake.

POKFULAM ROAD PRODUCTIONS:
A POLITICAL THEATRE COMPANY?

Jingan Young

IDA BRAMBLE: Dumplings, noodles, pak choi, char siu. Roast beef, spam hash, Yorkshire puddings and steamed fish.
MONA HING: You have mixed taste. I like it. I like talking to you.[11]

Pokfulam Road Productions (PRD) is an unfunded London and Hong Kong-based non-profit theatre company founded in 2013. The company has produced over a dozen showcases of new writing but has to date, never made a profit. All box-office revenue has gone directly to covering the cost of venue hire.[12] In 2016, PRD produced the first 'Foreign Goods Last Forever' (FGLF), a showcase of new writing with the specific aim of providing a platform for the severely under-represented group of British East Asian Artists (BEA) on UK stages. Regarding the first and second FGLF showcases, the company negotiated a profit share with the award-winning new writing theatre in South London, Theatre503. Although we were unable to offer actors and directors Equity rate salaries (on the rare occasion I was able to provide food and travel expenses from my own personal expenses account), the creative practitioners voluntarily waived their fee in order to participate in these important and ultimately sold out, critically-acclaimed performances.[13] During this

* Her mantra as a dramaturge, in personal conversation.

period, PRD has relied upon the donation of free rehearsal space by arts institutional schemes such as the Old Vic New Voices Network, China Exchange Cultivate Programme and the Arcola Theatre's BAMER Lab.

In mid-2016, I opened a discussion with Oberon Books to publish British East Asian writers in a collection named after the showcases. Over two years of discussion, we agreed that several of the plays produced by the first two FGLF showcases would be revised, developed and published in *Foreign Goods: A Selection of Writing by British East Asian Artists*.[14] The anthology features monologues, short and full-length plays by Julie Cheung-Inhin, Kathryn Golding, Stephen Hoo, Amber Hsu, Lucy Chau Lai-Tuen, Cathy SK Lam, Tan Suet Lee and finally, a play written by myself. It also includes a beautiful foreword by my mentor, the award-winning American playwright and screenwriter David Henry Hwang.

I will examine PRD's background as an unfunded theatre company, the methodology behind the development and production of the FGLF showcases and the artistic development and collaboration with British East Asian artists and stories in the UK. Lastly, I will explore the journey towards the publication of *Foreign Goods*, and the subsequent recognition of this work within the mainstream from institutions such as the BBC.[15] Through the examination of these independent, unfunded and guerrilla productions, I aim to open up discussion around unfunded fringe theatre in London. More recently, following *The Stage* critic Mark Shenton's announcement that he will no longer review fringe productions that do not pay actors, it has once again become a controversial topic of public debate. Shenton claims 'being professional means paying and being paid', as this will move towards 'stopping the exploitation of actors'. He states, 'Those that are unwilling – or unable – to pay could simply re-designate themselves as amateur houses.'[16] Shenton's refusal to acknowledge the struggle of minority communities in the arts which includes the persistent lack of funding, promotion and commissioning of British East Asian and South-east Asian work, confirms the mainstream's ignorance surrounding this community's position within the theatre industry. Although we vehemently believe in and aspire to pay professional creatives for their work, placed in the wider social and political context we find this not only impossible, but simply unrealistic, largely due to the refusal of arts-funding bodies and private donors to take a financial risk and invest in the clear potential of our cultural output.

Currently, in London fringe theatre, there are numerous short-writing showcases and competitions, in many forms, not solely focused on

producing marginalised voices.* After several rejections from public funding bodies, alongside a lack of contacts within the private financial sphere, I and my assistant producer, Max Percy, have gone unpaid for our employment in the areas of production, casting, marketing, stage management and dramaturgy. But without these FGLF showcases, the conversations surrounding the potential to publish the work of British East Asian artists would undoubtedly not have transpired. As David Henry Hwang states, in his foreword to *Foreign Goods*:

> Though plays are written to be performed, publication endows this most ephemeral of art forms with some degree of permanence. Moreover, printing expands a work's audiences, encourages future productions, and acknowledges its literary worth.[17]

There is also a great commitment to simply putting on a great show. The writers, directors and actors who have been involved since the inaugural FGLG showcase collectively believe that through collaborative effort we together may create that glorious, ephemeral being that is live theatre. More importantly, it allows creatives who come from ethnic minority backgrounds to take risks in a professional environment and to be given that rare opportunity of failing. British theatre does not currently offer substantial support or commissioning to enable BEA artists to thrive. Therefore, does the absence of funding and aim for profit render PKD and its subsequent mainstream outcomes (mainstream publication) political?

Background

The origin story behind the PRD's moniker is a personal one. Pok Fu Lam is an area located on the south side of Hong Kong island. It is a valley situated between Victoria Peak and Mount Kellet, around Telegraph Bay. Pok Fu Lam translates from the Chinese as 'Thin Shielding Forest' and the road of the same name runs between two districts: Sai Ying Pun and Wah Fu, along a coastline that winds around an abundance of green and grey, where it frames low-rise homes, schools, cemeteries and nursing

* Founded by Nadia Nadif, Lauren Johnson and Joel Sams, the UK theatre company Untold Stories produces a regular new-writing showcase 'Untold Stories'. The writers and production teams receive no pay or profit share from the performances. See their website, Untold Stories, http://untoldarts.co.uk/

homes. This is where I grew up, lived, attended kindergarten, primary and secondary school. My own father passed away in Queen Mary Hospital – located at 102 Pok Fu Lam Road – after he was killed crossing the road in 1996. In 2011, my mother moved from my childhood home of Sandy Bay to an estate near Wah Fu on Pok Fu Lam Road.

Pok Fu Lam and the southern district of Hong Kong remain an intrinsic part of my identity. It seemed fitting that my first production company would be named after the place in which I was raised. In one sense, my own artistic sensibilities reflect playwright Kathryn Golding's reflective monologue on growing up Eurasian in London in her play *Suzy Wong: Fitting in and Fucking Up*:

> There were no black kids at our school and only a handful of Asians. It was equal parts privilege and a pain in the butt. School wasn't a happy time for me. If you're an Asian kid, or you have an Asian parent, Saturday's just another exciting fun-filled day. And by that I mean more school. Chinese school [is] kind of like Sunday school but instead of Sundays, you go on Saturdays. And instead of learning about God, you learn how to be a model Chinese citizen.[18]

Although there are several funded East Asian theatre companies operating in the UK such as Yellow Earth Theatre, Moongate Productions and Red Dragonfly,* PRD's mission statement 'Collaboration. New Writing. Political Animals' also refers to our commitment to working with non-EA artists who are interested in BEA stories, in order to reach contemporary audiences. Through our limitation of not being able to employ artists on the basis of their reputation or credits, we have discovered an array of talented directors and actors, burgeoning and established.

'Foreign Goods Last Forever' at Theatre503

The phrase 'Foreign Goods Last Forever' was plucked from an essay written by my father in the year he died. The work appeared in a collection of Hong Kong writing in English. It was his mother's favourite phrase and referred to the donations of food and goods provided by

* See Further Reading at the end of this book for more information on these companies.

the US Army and the Red Cross during the time they lived as impoverished Chinese refugees in Diamond Hill during the 1950s. Although my grandmother was referring to the imported 'chocolates, chewing gum, beans, blankets and beds', to me the expression symbolises the convergence of East and West. It reflects my upbringing in Hong Kong, a city of multilingual voices and multicultural communities and my decision to move to Britain in 2009 to study and pursue a career as a writer. Born in Hong Kong before the 1997 handover, my childhood memories contain a mixture of red UK Royal Mail post boxes, re-runs of *Judge John Deed* on television, Dim-Sum Sundays, visits to the Forbidden City and my mother treating me to special shopping trips to M&S. This phrase, embedded in the work by a man I hardly knew, appears to echo my own ongoing attempt to reconcile my third culture identity. In one sense, it signifies a relationship I will never have with my father as an adult. It seemed apt that I would apply this as the title for the showcases that could potentially change the conversation around the representation of BEA artists forever.

The first FGLF showcase was produced solely by myself and took place at Theatre503 on the evening of 29 November 2016. It featured new plays by female BEA writers: Naomi Christie, Suet Lee, Amy Ng, Lucy Sheen and Naomi Sumner. Through an aggressive marketing campaign and with the alliance of the directors, of non-EA descent (Tessa Hart, Ian Nicholson, Freyja Winterson, Alice Kornitzer and Kim Pearce) we were able to sell out the production and garner extremely good press, including *The Stage* Critics' Picks of the Week.[19] In the pre-production stage, we procured free rehearsal space from the China Exchange in Soho and Old Vic New Voices Workrooms in Bermondsey. Chris Omaweng, who would later become one of our champions, wrote in *Londontheatre1*:

> There was something for everyone in this eclectic mix of new plays from female playwrights, all performed with minimal staging, allowing the scripts, and some great acting, to really shine. It is a pity this was a 'one night only' event. A week's run to allow more people to see an event of this nature would be more suitable. As it was, it was a worthwhile and intriguing event.[20]

Following the enthusiasm and support from Theatre503 to produce two further shows over two nights, FGLF 2 took place on 24 and 25 April 2017. Discussions with 503's then producer Jessica Campbell, allowed

us to create a relevant political theme – 'Visions of England' – in order to hone the submissions of short plays that were submitted to us over the few months through an open call-out for scripts. We then finalised the work that would go into production, which consisted of short plays and extracts from full-length plays from Amy Ng, Amber Hsu, Julie Cheung-Inhin, Amal Chatterjee, Stephen Hoo, Kathryn Golding and Cathy Lam. The themes ranged from the controversial 'yellowface' to a young Chinese woman with 'white fever'. Rehearsal space was again donated through the China Exchange and Old Vic New Voices. David Henry Hwang also allowed us to stage his short play *Trying to Find Chinatown*, in its UK premiere. There was also a post-show discussion after the second performance featuring women in the industry. The talk was chaired by Theatre503's Artistic Director Lisa Spirling and featured Helena Zhang (China Exchange), writers Lucy Sheen and Naomi Sumner, and the academic Amanda Rogers. Omaweng returned to review the showcase, stating 'Put simply, I was impressed. This wasn't a case of establishment bashing and whining about white privilege ... Far from navel-gazing, this is theatre as its most thoughtful and outward-looking ... But as a whole, this was a remarkably inspiring evening.'[21] It was sold out for the two productions and received enthusiastic feedback from audience members on social media.

In 2018 we took our third FGLF showcase to Studio 2 of the Arcola Theatre. We opened up the submission process to non-BEA writers but required the theme of the piece to be associated with the community in some way. The plays were written by Amal Chatterjee, Ness Lyons, David East, Simon Farnham, Clare Reddaway, Christian Graham, Stephanie Martin (words) and Calista Kazuko (music) and finally, a performance art piece created by Caleb Yap and Charlotte Chiew. The studio has a 100-seat capacity; on the Sunday evening we sold 120 tickets.

Publication

Published in January 2018, *Foreign Goods* has been described as an 'essential introduction' because its function is not to provide a survey of existing BEA work, as the plays within the book were developed, workshopped and produced by our company. The resulting published collection of plays from the FLGF showcases was a result of two years of debate, argument, compromise and, ultimately, my decision to tailor a rhetoric which, to my great joy, convinced Oberon Books that British East Asian voices deserved to be recognised.

The contributors to this landmark collection, who, alongside their directors and actors, went unpaid for their work during the FGLF showcases, are Amber Hsu, Cathy Lam, Kathryn Golding, Julie Cheung-Inhin, Lucy Sheen, Stephen Hoo and Suet Tan. In Cheung's *No More Lotus Flower*, a British Chinese actress relays the obstacles throughout drama school and her effort to fight against being stereotyped:

VOICEOVER:	Do you speak Chinese?
VOICEOVER: (JULIE):	No.
VOICEOVER:	You don't speak Chinese?!
VOICEOVER (JULIE:):	No.
VOICEOVER:	So how much Chinese do you know?
VOICEOVER (JULIE):	None.[22]

Kathryn Golding's *Suzy Wong: Fitting in and Fucking Up* and Lucy Sheen's *Under a Blood Red Moon* similarly explore the conflicts in reconciling one's identity. These and the other writers' stories are unique, relatable, unbound by clichés and fearless in their resistance to stereotypical East Asian representation. Stories on the unreliable nature of memory, the politics of ageing, poetic imaginings of the migrant's journey, conflicts in defining your sexuality, humorous cross-cultural tales as told by an aspiring actor, the housing crisis and a fetish for the West do not reflect the mainstream archetypal representations. They introduce the reader to an unknown and yet familiar world. In this way, the book is a political attempt to change the conversation surrounding representation.

Conclusion: Is PRD political?

If this contribution enthuses artists who feel they are marginalised, I would implore them to take *action* and to create work they wish to see onstage, regardless of the personal cost. The playwright David Mamet once spoke about finding meaning in the chaos and called upon us to rediscover meaning in that which was once obscured by lies.* PRD has never once demanded that its stories be heard through virulent protest but rather through positive and collaborative exchange, and this

* 'Drama is about Lies. Drama is about repression. As that which is repressed is liberated – at the conclusion of the play – the power of repression is vanquished, and the hero … is made more whole.' See David Mamet, *Theatre* (New York: Faber & Faber, 2010) p. 69.

approach has proven successful in reshaping the neglected and negative representations of East Asian stories which, unfortunately, still feature grossly distorted stereotypes and continue to pervade the public consciousness in the UK. As the BBC's Helier Cheung reported:

> Companies often cite colour-blind casting or the 'universality' of a play as a defence, but at the same time, British East Asian actors aren't being incorporated into other areas ... there's a sense that they are only allowed to play themselves in a certain kind of way – often involving Pidgin English or being an immigrant ... there is still a 'huge' problem on TV, where East Asians tend to be depicted as 'a kind of exotic other' or 'thuggish brutes, dull, or stern patriarchs'.[23]

Despite its unfunded status, PRD has championed these 'unheard' voices by producing new work in a professional context, utilising trained and non-trained actors and directors, resulting in the garnering of new and enthusiastic audiences. The publication of a selection of BEA plays goes a step further in recognising and legitimising the presence of BEA writing on stage. As Hwang poignantly concludes in his foreword, 'As always, the cultural specificity of these works infuses them with universality. Good theatre allows us to simultaneously perceive both superficial differences and the underlying humanity we share ... these plays deserve to be read, performed and studied. They celebrate the arrival and promise of a vital new form: British East Asian Theatre.'[24]

PRD and the vital new work surrounding *Foreign Goods* constitute a wholly political act and one we hope has contributed in some way to furthering the increase in the production of BEA stories.

NOTES

1. Sudha Bhuchar and Shaheen Khan, *Balti Kings* (unpublished, 1999).
2. *Ibid.*
3. Sudha Bhuchar, *My Name Is ...* (London: Bloomsbury Methuen Drama, 2014).
4. *Ibid.*
5. Yasmin Alibhai-Brown, 'Garbas, Dandias and Bhangras', *Strictly Dandia*, by Sudha Bhuchar and Kristine Landon-Smith (London: Methuen Drama, 2004).
6. Yasmin Alibhai-Brown, 2014, 'Tamasha Theatre's *My Name Is ...* sheds light on devastating fall-out from mixed-race marriage', *Independent*, viewed 9 April 2018, from https://tinyurl.com/y8bqvnxx

7. Gaylene Gould, 2015, 'D-word Screening Day – Keynote Speech', YouTube, viewed 9 April 2018, from https://tinyurl.com/y9xpj4xa

8. August Wilson, *Jitney* (New York: Overlook Press, 2003) blurb.

9. Sudha Bhuchar, *Golden Hearts* (work in progress).

10. Kathryn Bromwich, 2018. 'Zadie Smith: "I have a very messy and chaotic mind"', *Observer*, viewed 9 April 2018, from https://tinyurl.com/y9xpj4xa

11. Lucy Sheen, 'Under a Blood Red Moon', in Jingan Young (ed.), *Foreign Goods: A Selection of Writing by British East Asian Artists* (London: Oberon Books, 2018) p.126.

12. Pokfulam Rd Productions, *Productions*, viewed 9 April 2018, from https://tinyurl.com/yd8rctph

13. Chris Omaweng, 2016 'Foreign Goods Last Forever at Theatre503', *Londontheatre1*, viewed 1 February 2018, from https://tinyurl.com/y97ejn2p

14. Young (ed.), *Foreign Goods*.

15. Helier Cheung, 'British East Asian Actors "Face Prejudice in Theatre and TV"', *BBC News*, viewed 9 April 2018, from https://tinyurl.com/yc5rgu50

16. Mark Shenton, 'Why I Will No Longer Review Shows that Don't Pay Actors and Crew', *The Stage*, viewed 9 April 2018, from https://tinyurl.com/yafyomrx

17. David Henry Hwang, 'Foreword', *Foreign Goods*, p. 11.

18. Kathryn Golding, 'Suzy Wong: Fitting in and Fucking Up', *Foreign Goods*.

19. Natasha Tripney, 2016, 'This Week's Best Theatre Shows: Our Critics' Picks (November 29)', *The Stage*, viewed 9 April 2018, from https://tinyurl.com/y80x253p

20. Omaweng, 'Foreign Goods Last Forever at Theatre503', viewed 1 February 2018, from https://tinyurl.com/y97ejn2p

21. Omaweng, 2017, 'Foreign Goods Last Forever 2: Visions of England – Review', *Londontheatre1*, viewed 9 April 2018, from https://tinyurl.com/y7sxqvng

22. Julie Cheung-Inhin, 'No More Lotus Flower!', *Foreign Goods,* p. 31.

23. Cheung, 'British East Asian Actors "Face Prejudice in Theatre and TV"', *BBC News*, viewed 9 April 2018, from https://tinyurl.com/yc5rgu50

24. Hwang, 'Foreword', *Foreign Goods*, p. 11.

Epilogue:
Where Next for Political Theatre?

Billy Cowan and Kim Wiltshire

In a 2011 article, 'Political Theatre's Final Curtain', Tiffany Jenkins, Director of Arts at the Institute of Ideas, bemoans the fact that, despite a slew of plays tackling social and political problems, drama has lost its power to make a difference. The type of political theatre she refers to is the issue-based play usually written by an individual playwright and performed in a traditional theatre space where the 'middle classes, who stopped protesting on the streets long ago … sit in the dark, watch a political display, and reassure themselves that they are doing something'.[1] According to Jenkins, this type of representational theatre is 'just a coping strategy that sedates us'. It is the kind of theatre that turns us into 'voyeurs' where we sit back and watch our world while 'reassuring ourselves that we care'.[2]

Jenkins recognises that the problem does not lie wholly with the playwright and the theatre-makers. It also lies with us, the public; that we have no appetite for action. In a post-Thatcher world, we live out her capitalist motto, 'There is no alternative', and have been led to believe that the world cannot be transformed, and certainly not by theatre.

Jenkins' assessment of political theatre chimes with that of Florian Malzacher who, in 2015, said that we are a 'society paralysed by the symptoms of post-political ideologies' and that 'the belief in the possibility or even desirability of political imagination is fading'.[3] Unlike the 1970s and 1980s, when political theatre engaged successfully in public debates, Malzacher believes theatre's political potential has been 'disabled',[4] and that, as society settles into the twenty-first century, theatre-makers need to chart a new way forward to make political theatre relevant again. In *Not Just a Mirror*, Malzacher shows us that this might already be happening, that we are 'in a period of trying out, of finding out – artists as well as the audiences'.[5] He highlights the work of 15 political theatre-makers from across the globe who are pointing us to the future of political theatre, from Teater NO99 in Estonia whose *Unified Estonia*

project (2010) 'hacked democracy' by creating a fictitious political party (polling 25 per cent of the electorate!) that satirised populist, right-wing, political parties who promise everything yet have no real ideas[6] to Palestine's Freedom Theatre who, from the very centre of Jenin Refugee Camp, 'uses the arts to address the chronic fear, anxiety, and depression experienced by children and youth.'[7]

So, what about 2018 and beyond? And what about the UK? Are our theatre-makers still 'finding out'? Are they still stuck in representational mode, preaching to the converted in cathedrals that worship the individuality of the playwright? Well, in just a few short years, the world seems a very different place from 2015, and certainly from Jenkins' view in 2011. Brexit, Trump and the rise of many right-wing parties across the globe has heralded a new era of what is often described as 'populist politics'. In 2017 we saw the launch of the #MeToo campaign, discussed above by Mighty Heart, and a schism began opening up between certain radical feminists and the transgendered community, debating gender and who has the right to claim which identity (often boiling down to an argument about whose experience has the most validity). In the UK in 2018, austerity is still adversely affecting local councils, the NHS, and many of our poorer communities. Life expectancy is dropping, particularly in the post-industrialised areas of the North; childhood poverty and homelessness is the highest it has been for many years, if not decades, and job security seems a socialist ideal that may never be achieved again. In Salisbury, in March 2018, the poisoning of Sergei Skripal and his daughter led to fears that the West could be entering a new Cold War, catapulting us right back to the 1960s. It seems there are plenty of new battles to be fought, new wars to be won. Is theatre in the UK up to the challenge?

Well, the signs are positive, as some of the theatre-makers highlighted in this book attest to. We have companies like Clean Break who, since their formation in 1979, continue to change the lives of women affected by the criminal justice system through their educational arts programmes; 20 Stories High are transforming the lives of young, working-class people in Liverpool by giving them opportunities to tell their own stories and become professional actors through their Young Actors' Company; and there is Newcastle's Open Clasp, whose show *Rattle Snake* is used by Durham Police to train frontline officers in better responding to sexual and domestic violence, therefore helping women in a very real way.

Of course, the type of political theatre that achieves most media attention is the theatre of representation and spectatorship that takes place in traditional theatre spaces; the type of theatre that many of those early political theatre-makers believed reproduced capitalist culture, and the theatre that Jenkins criticises in her 2011 article. In post-Brexit London, this type of theatre also seems to be in a healthy place according to Dom O'Hanlon of the *Clyde Fitch Report*.[8] He highlights the work of playwright James Graham and his plays *Ink* and *Labour of Love* that deal with the birth of the *Sun* newspaper, and the fluctuations of the Labour Party respectively. He also draws attention to Jez Butterworth's *The Ferryman*, a family drama set during the Troubles in Northern Ireland, Christopher Shin's *Against*, about violence and spiritual malaise in America, and J.T. Rodgers *Oslo*, about the Oslo Accords that attempted, but failed, to draw up a peace framework for the Middle East. In October 2017, Mike Bartlett's 'Brexit' play *Albion* opened at the Almeida Theatre where 'a fight over national identity' became 'a fight over an English country house'.[9]

The political earthquake that was Donald Trump's election victory in 2016 has also acted as a call to arms for new political theatre-makers. At the 2017 Edinburgh Festival there were at least 23 shows about Trump, including *Trumpus Interruptus*, a fantasy that explores Trump's Impeachment; *Trump'd*, a musical comedy set in 2030 when Trump finally gets round to building the Great Border Wall of Mexico; and British comedian Simon Jay's one-man show *Trumpageddon*.[10] Although some of the contributors in this book might, rightly, question the usefulness of this type of theatre, performed in traditional theatre spaces, it can still be taken as a positive sign that new theatre-makers are being policitised. At the very least it shows us that people are not happy about the world they now find themselves living in and are trying to do something about it.

So, it seems that political theatre in its many forms, including representational theatre, as mentioned above, and the collective and participatory type of theatre highlighted elsewhere in this book, is very much alive and responding to the political issues of our increasingly polarised society.

Whatever its form, political theatre can only remain relevant and necessary if it raises questions about our society and allows us to imagine alternative ways of living together. It must also continue to highlight inequalities and injustices and help those who suffer find a voice and a means to fight those inequalities. It must enable us to understand our

differences and to envisage a world in which we can all live together peacefully.

In her prologue to this book, Lyn Gardner ends by quoting John Fox's hopeful message that in 1976 it was still possible for people in the West to create a concrete alternative. It is sadly ironic then that in the second decade of the twenty-first century, Thatcher's motto, for some, feels more like a reality than a threat. However, as the interviewees, academics and theatre practitioners who have contributed to this book have shown: the idea of an alternative world is still very much alive.

NOTES

1. Tiffany Jenkins, 'Political Theatre's Final Curtain', *Independent*, 28 December 2011, viewed 5 April 2018, from https://tinyurl.com/y8qps723
2. *Ibid.*
3. Florian Malzacher (ed.), 'No Organum to Follow: Possibilities of Political Theatre Today' in *Not Just a Mirror: Looking for the Political Theatre of Today* (Berlin: Alexander Verlag, 2015) p. 17.
4. *Ibid.*
5. *Ibid.*, p. 20.
6. Eero Epner, 2017, 'Hacking Democracy with Theater', YouTube, viewed 5 April 2018, from https://tinyurl.com/yd75gbfw
7. Malzacher, 'No Organum to Follow', p. 190.
8. Dom O'Hanlon, 2017, 'Political Theatre Thrives Once More In Brexit-Era London', *Clyd Fitch Report*, viewed 5 April 2018, from https://tinyurl.com/yc9exvfz
9. J. W. S. W, 2017, '"Albion" is a State-of-the-nation Play for Brexit Britain', *The Economist,* viewed 5 April 2018, from https://tinyurl.com/ybcn4dqa
10. Rachel Lewis, 2017, 'Donald Trump Takes Centre Stage at the Edinburgh Fringe Festival', *The Times*, viewed 5 April 2018, from https://tinyurl.com/yc2lr9hb

Further Reading

Books and Articles

Ahmed, Sara, *Queer Phenomenology: Orientations, Objects, Others* (Durham: Duke University Press, 2006)

Barnett, Marcus, 'The World Within a World', *Jacobin*, https://tinyurl.com/y9jsaue9 [accessed 9 April 2018]

de Beauvoir, Simone, *The Second Sex* (London: Vintage Classics, 1997)

Bogad, L. M, *Tactical Performance: The Theory and Practice of Serious Play* (London: Routledge, 2016)

Bolton, Gavin, *Acting in Classroom Drama: A Critical Analysis* (England: Trentham Books, 1998)

Brenton, Howard, 'Petrol Bombs Through the Proscenium Arch', *Theatre Quarterly*, 5.17 (1975)

Bull, John, *New British Political Dramatists* (Basingstoke: Macmillan Education, 1984)

Bull, John (ed.), *British Theatre Companies: 1965–1979* (London: Bloomsbury Methuen Drama, 2016)

Children and Their Primary Schools: Plowden Report. Central Advisory Council for England. (1967) HMSO London.

Davis, Geoffrey V. and Fuchs, Anne (eds), *Theatre and Change in South Africa* (Netherlands: Harwood Academic Publishers, 1996)

Friedan, Betty, *The Feminine Mystique* (NY: W. W. Norton and Co., 1963)

Half our Future: The Newsom Report. (1963) HMSO London

Harvey, Sylvia, *May '68 and Film Culture* (UK: BFI Publishing, 1980)

Harvie, Jen, *Fair Play: Art, Performance and Neoliberalism* (UK: Palgrave Macmillan, 2012)

Heathcote, Dorothy, *Collected Writings on Education and Drama*, ed. by Liz Johnson and Cecily O'Neill (UK: Heinemann Educational, 1984)

Hillman, Rebecca, '(Re)constructing Political Theatre: Discursive and Practical Frameworks for Theatre as an Agent for Change', *New Theatre Quarterly*, 31.4 (2015) 380–96

Howe-Kritzer, Amelia, *Political Theatre in Post-Thatcher Britain: New Writing: 1995–2005* (UK: Palgrave Macmillan, 2008)

Itzin, Catherine, *Stages in the Revolution: Political Theatre in Britain Since 1968* (London: Methuen Publishing, 1980)

Jackson, Anthony, 'I've never been in a story before!': audience participation and the theatrical frame, in McCaslin, N. (ed.) *Children and Drama*. Studio City, Ca. 1999, pp. 183–99.

Jackson, Anthony, *Theatre, Education and the Making of Meanings: Art or Instrument* (UK: Manchester University Press, 2007)

Jackson, Anthony and Vine, Chris, eds., *Learning Through Theatre: The Changing Face of Theatre in Education* (London: Routledge, 2013)

Kershaw, Baz, *The Politics of Performance: Radical Theatre as Culture Intervention* (London: Routledge, 2001)

Knabb, Ken (ed.), *Situationist International Anthology* (CA: Bureau of Public Secrets, 2006)

Malzacher, Florian (ed.), 'No Organum to Follow: Possibilities of Political Theatre Today' in *Not Just a Mirror: Looking for the Political Theatre of Today* (Berlin: Alexander Verlag, 2015)

Marranca, Bonnie (ed.), *The Theatre of Images* (New York: PAJ Books, 1996)

McGrath, John, *A Good Night Out – Popular Theatre: Audience, Class and Form* (London: Eyre Methuen, 1981)

Megson, Chris, '"The Spectacle is Everywhere": Tracing the Situationist Legacy in British Play-writing Since 1968', *Contemporary Theatre Review*, 14.2 (2004), 17–20 <https://tinyurl.com/y8ccyubd> [accessed 28 March 2018]

Pal, Swati, *Look Back At Anger: Agit Prop Theatre in Britain* (Saarbrucken: VDM, 2008)

Peacock, D. Keith, *Thatcher's Theatre: British Theatre and Drama in the Eighties* (London: Greenwood Press, 1999)

Pearson, Mike and Shanks, Michael, *Theatre/Archaeology* (London: Routledge, 2001)

Rancière, Jacques, *The Emancipated Spectator* (London: Verso, 2009)

Prentki, Tim and Selman, Jan, *Popular Theatre in Political Culture: Britain and Canada in Focus* (Bristol: Intellect, 2000)

Redington, Christine, *Can Theatre Teach?: An Historical and Evaluative Analysis of Theatre in Education* (Oxford: Pergamon Press, 1983)

Rowell, George, and Jackson, Anthony, *The Repertory Movement: A History of Regional Theatre in Britain* (UK: Cambridge University Press, 1984)

Saunders, Graham, *British Theatre Companies: 1980–1994* (London: Bloomsbury Methuen Drama, 2015)

Sian, Katy P. (ed.), *Conversations in Postcolonial Thought* (New York: Palgrave Macmillan, 2014)

Slade, Peter, *Child Drama* (London: University of London Press, 1954)

Stourac, Richard, and McCreery, Kathleen, *Theatre As a Weapon: Workers' Theatre in the Soviet Union, Germany and Britain, 1917–1934* (London: Routledge, 1986)

Thompson, James, *Applied Theatre: Bewilderment and Beyond*, 4th edn (Oxford: Peter Lang, 2014)

Tomlin, Liz, *British Theatre Companies: 1995–2014* (London: Bloomsbury Methuen Drama, 2015)

Wooster, Roger, *Theatre in Education in Britain* (London: Bloomsbury Methuen Drama, 2016)

Plays (Published)

Bhuchar, Sudha, *My Name Is…* (London: Bloomsbury Methuen Drama, 2014)

Brecht, Bertolt, *Fear and Misery of the Third Reich* (London: Methuen Drama, 2009)

Burke, Gregory, *On Tour* (London: Faber & Faber, 2005)

Butler, Leo, *Lucky Dog* (London: Methuen, 2004)

Elyot, Kevin, *My Night With Reg* (London: Nick Hern Books, 1994)

Friel, Brian, *Translations* (London: Faber & Faber, 1981)

Fugard, Athol, *Sizwe Bansi is Dead and The Island* (New York: Viking Press, 1976)

Grieg, Noël, *Poppies (A Gay Sweatshop Play)* (London: Gay Men's Press, 1983)

Grieg, Noël and Griffiths, Drew, *Two Gay Sweatshop Plays: As Time Goes By and The Dear Love of Comrades* (London: Gay Men's Press, 1981)

Hanna, Gillian, *Monstrous Regiment: Four Plays and a Collective Celebration* (London: Nick Hern Books, 1991)

Hauptfleisch, Temple and Steadman, Ian (eds), *South African Theatre: Four Plays and an Introduction* (Netherlands: HAUM Educational Publishers, 1984)

Ibsen, Henrik, *A Doll's House* (London: Bloomsbury, 2013)

Kramer, Larry, *The Normal Heart* (London: Nick Hern Books, 2011)

Lustgarten, Anders, *If You Don't Let Us Dream, We Won't Let You Sleep* (London: Bloomsbury Methuen Drama, 2013)

Maponya, Maishe, *The Hungry Earth* (Polyptoton, 1981)

Maponya, Maishe, *Gangsters* (Polyptoton, 1985)

McGrath, John, *Six-Pack: Plays for Scotland* (Edinburgh: Polygon, 1996)

McGrath, John, *Plays for England* (Exeter: University of Exeter Press, 2005)

Miller, Arthur *The Crucible* (London: Penguin New Edition, 2011)

Mtwa, Percy, Ngema, Mbongeni and Simon, Barney, *Woza Albert!* (London: Bloomsbury, 1983)

Ngema, Mbongeni, *Asinimali* (US: G.B. Press, 1986)

Nunnery, Lizzie, *The Sum* (London: Faber & Faber, 2017)

Orlandersmith, Dael, *Yellowman* (London: Vintage, 2002)

Osment, Philip (ed.), *Gay Sweatshop: Four Plays and a Company* (London: Methuen Publishing, 1989)

Peimer, David, *Armed Response* (Chicago: Seagull Books, 2009)

Purkey, Malcolm and Stein, Pippa, *Sophiatown* (US: University of California Press, 1988)

Samuels, Julia, *I Told my Mum I was going on a R.E. Trip ...* (London: Bloomsbury Methuen Drama, 2017)

Wandor, Michelene (ed.), *Strike While the Iron Is Hot: Three Plays on Sexual Politics*, (London: Journeyman Press, 1980)

Wertenbaker, Timberlake, *Our Country's Good* (London: Methuen, 1988)

Wilson, August, *Jitney* (New York: The Overlook Press, 2003)

Young, Jeff, *Bright Phoenix* (London: Methuen Drama, 2014)

Theatre Companies

7:84 Theatre: www.nls.uk/learning-zone/library-favourites/784-theatre-archive

20 Stories High: www.20storieshigh.org.uk/

Belgrade Theatre: www.belgrade.co.uk

Big Brum Theatre: www.bigbrum.org.uk

CAST: www.elta-project.org/cast.html

Clean Break: www.cleanbreak.org.uk
Cockpit Theatre: www.thecockpit.org.uk
Dilly Arts: www.dillyarts.org.uk
Laid Bare Theatre Project: www.laidbaretheatre.co.uk
Leeds TIE: www.leedstie.co.uk
Liverpool Everyman: www.everymanplayhouse.com
M6 Theatre: www.m6theatre.co.uk
Mighty Heart: www.mightyhearttheatre.com
Moongate Productions: www.blacktheatrelive.co.uk/companies/london-moon-
 gate-productions
National Theatre: www.nationaltheatre.org.uk
New Victorian Theatre: www.newvictheatre.org.uk
North West Spanner: www.johncrumpton.co.uk/page36.htm
Open Clasp: www.openclasp.org.uk
Papergang Theatre: www.papergang.co.uk
The People Show: www.peopleshow.co.uk
Rash Dash: www.rashdash.co.uk
Red Dragonfly Productions: www.reddragonflyproductions.co.uk
Red Ladder: www.redladder.co.uk
Take Back Theatre: www.takebacktheatre.com
Theatre Centre: www.theatre-centre.co.uk
Tonic Theatre: www.tonictheatre.co.uk
Truant Theatre: www.truantcompany.com
Vamos Theatre: www.vamostheatre.co.uk
Yellow Earth Theatre: www.yellowearth.org
Young Actors Company (YAC): www.theyoungactorscompany.com
Women & Theatre: www.womenandtheatre.co.uk
Women's Theatre Group/Sphinx: www.sphinxtheatre.co.uk
Young People's Theatre (YPT): www.youngpeoplestheatre.ca

Web Resources

Arts Council: www.artscouncil.org.uk
Working Class Movement Library: www.wcml.org.uk
Unfinished Histories: www.unfinishedhistories.com

Whilst there will be important plays and texts relating to political theatre that we have omitted here, the texts and websites listed here and cited throughout this book, will form a solid basis for further exploration into this subject area.

Notes on Contributors

All the people listed below contributed to the book as an interviewee, as a writer of a section or introduction, or as an editor.

Sudha Bhuchar: Sudha is an actor/playwright and co-founder of Tamasha Theatre, where she served as co-artistic director for 26 years. Landmark plays include *Fourteen Songs, Two Weddings and a Funeral* (winner of Barclays/TMA Best Musical) and *Strictly Dandia* (both with Kristine Landon-Smith). Solo plays include *The House of Bilquis Bibi* and the critically acclaimed *My Name Is...*, which she adapted for Radio 4. Sudha's acting career includes *EastEnders, Doctors, Casualty, Stella* and *Coronation Street*. Recent theatre credits include *Khandan* by Gurpreet and *Lions and Tigers* by Tanika Gupta. In 2017 she launched her new company, Bhuchar Boulevard, with a critically acclaimed revival of *Child of the Divide,* marking the 70th anniversary of the partition of India.

Danielle Boneheyo: Danni is a Creative Writing student specialising in political flash fiction. She is currently the editor of *Black Market Re-View* magazine and co-founder of *Across & Through* magazine. She is a recipient of the Edge Hill Excellence Scholarship for her photography, which influences much of her writing.

Billy Cowan: Billy is an award-winning playwright and artistic director of Truant Company. His first play *Smilin' Through*, produced by Birmingham Rep, was nominated for Best New Play 2005 by the *Manchester Evening News* and his play *Caretakers* won the Stage Edinburgh Award at the Edinburgh Fringe Festival in 2016. He is a senior lecturer of Creative Writing at Edge Hill University.

Rod Dixon: Artistic Director of Red Ladder Theatre Company, a national touring theatre company based in Leeds, which was formed in 1968. Before working with Red Ladder, Rod was Associate Director at the Barbican Theatre in Plymouth and as a freelancer directed several shows at Plymouth Theatre Royal including *Union Street* with a cast of 230 local people. Rod ran the Hub Theatre School in Cornwall and before that was an actor with several touring companies including Kneehigh Theatre.

Bob Eaton: Bob began his career in 1971 as Assistant Director at the Victoria Theatre Stoke. He then spent several years working, mainly as an actor, in Alan Ayckbourn's Scarborough company. In 1979 he became Associate Director of Manchester's Contact Theatre and in 1981 was appointed Artistic Director of the Liverpool Everyman. In 1984 he became Artistic Director of the London Bubble and in 1996 Director of the Belgrade Theatre, Coventry. Since 2006 he has been heavily involved in the rejuvenation of Liverpool's Royal Court. He has written over 30 plays and musicals, including *Our Day Out*, with Willy Russell, and with Sayan Kent, a new musical, *Maggie May.*

Charlotte Fitch: Charlotte is a student at Edge Hill University on the MA in Creative Writing programme and part of the internship team working on this publication. Previously, Charlotte worked in the education sector, where she was Clerk to the Governors at Winstanley College.

Lyn Gardner: Lyn writes about theatre for the *Guardian* and is associate editor of *The Stage*.

Chris Goode: Chris is a writer and maker for theatre and live performance, and the artistic director of Chris Goode & Company. His work has been seen across a wide range of scales and contexts – from Sydney Opera House, Tate Modern and the Royal Court, to the most underground spaces on the London fringe. He is the author of *The Forest and the Field: Changing Theatre in a Changing World*.

Anna Hermann: Anna has been working in the field of theatre and social change for 30 years, specialising in theatre and education with marginalised groups in the UK and abroad. She has been with Clean Break since 2002 as the Head of Education, leading the company's ground-breaking work. Anna is the author of *Making a Leap: Theatre of Empowerment*: a practical handbook in creating issue-based theatre with disadvantaged young people. She has an MA in Arts Education and a PG Cert in Race and Ethnic relations. She is a founding member of the steering group of National Criminal Justice Arts Alliance, a regular visiting lecturer at Applied Theatre courses nationally, and between 2006–18 was a trustee of Leap Confronting Conflict: a UK-based charity specialising in youth and conflict.

Jill Heslop: Jill is a performer, writer and producer with a passionate interest in feminism, social change and the arts. She was Creative Producer for Open Clasp between 2013–17 and produced the multi-award-winning play *Key Change* (Best of Edinburgh 2015; *New York Times* Critics' Pick 2016). She has a background in music both as a performer with contemporary folk band Ribbon Road, and as a promoter of political song and spoken-word events and festivals, and has a great interest in using the arts as a forum to discuss and debate contemporary issues. She is currently undertaking a research fellowship focusing on women who are creating change in working-class communities in the north-east of England.

Rebecca Hillman: Rebecca works as a lecturer at the University of Exeter. Her teaching, research and theatre practice are informed by her work as a trade unionist and political activist. She is interested in the role of art in social and industrial movements past and present, and how this has (and hasn't!) been documented. Rebecca has worked on a series of events to rebuild links between the labour movement and political artists in the UK, and to bring activists from a range of backgrounds together to share approaches. She is a trustee for the Future's Venture Foundation, a charity that funds radical art interventions.

Harriet Hirshman: Harriet is a second-year Creative Writing MA student. She is a short story writer and dreams of working in publishing. She is an intern for the Edge Hill Prize and at Edge Hill University Press and until recently was the editor-in-chief and the short fiction editor on the *Black Market Re-View*.

Robert Holmes: Robert is a second-year undergraduate on the BA (Hons) Creative Writing programme at Edge Hill University, and was a judge for the Reader's Choice Award at Edinburgh Festival in 2017. He is particularly interested in political philosophy and history, is an advocate for LGBT+ history being taught in schools. He worked as senior copyeditor for this publication.

Tony Hughes: A Keele University graduate, Tony taught drama for eight years in Greater Manchester and Leeds schools. In 1978 he joined M6 Theatre Company, Rochdale and spent eight years working in TIE as actor/teacher and director. He then joined the Met Arts Centre, Bury as Deputy Director, leading on programming and expanding the building. In 1991 he was appointed Principal Arts Officer for Bolton Council, introducing arts and creative industries teams across council departments. He retired from his final post as Bolton Council's Culture Special Projects Manager in 2005.

Anthony Jackson: Anthony is Emeritus Professor of Educational Theatre at the University of Manchester. He pioneered the teaching of theatre-in-education at higher education level; was co-founder of Manchester's Centre for Applied Theatre Research; and directed the Performance, Learning and Heritage research project, investigating the uses and impact of performance as a medium of learning in museums and at historic sites (2005–8). A recipient of the Judith Kase-Cooper Honorary Research Award from the American Alliance for Theatre & Education (2003), he has guest-lectured in Europe, the USA, South Africa and Australia. His publications include *Theatre, Education and the Making of Meanings* (2007); *Performing Heritage: Research, Practice and Innovation in Museum Theatre and Live Interpretation* (ed. with Jenny Kidd, 2011); and *Learning Through Theatre: the Changing Face of Theatre in Education* (ed. with Chris Vine, 2013).

Kaden James: Kaden is currently a student at Edge Hill University, studying for his BA (Hons) in Creative Writing. He helped to set up the literary magazine *Across & Through.*

Ruth McCarthy: Ruth is Artistic Director of Outburst Queer Arts Festival in Belfast. For the past 12 years she has supported the creation of new queer work in Northern Ireland, as well as developing events with established queer artists and writers for venues such as Ulster Museum, the MAC and the Lyric Theatre. Since 2015 she has worked in partnership with the British Council to support new initiatives and partnerships with LGBTQ+ artists and producers in the Global South, including Brazil, the Caribbean, Peru and Uruguay. She is a member of the British Council Arts and Creative Economy Advisory Group and a Director of the Black Box venue in Belfast.

Kathleen McCreery: Kathleen was a member of Red Ladder Theatre from 1969–75. She went on to co-found Broadside Theatre (1975–81) and to write, direct, act and teach in the UK, Germany, Zimbabwe, Ghana, South Africa, Lesotho and Ireland. Her play *When I Meet My Mother* was chosen for *In The Continuum and other plays* (Weaver Press, 2009), and *The Chambermaids* was published in *Workers' Play Time* (Workable Books, 2017). A trained counsellor, Kathleen has recently facilitated projects ranging from mental health to

Travellers' rights. With Richard Stourac, she co-authored the book *Theatre as a Weapon* (Routledge and Kegan Paul, 1986).

Catrina McHugh: Originally from Liverpool, Catrina moved to Newcastle in 1993 after falling in love with a Geordie, Newcastle and the north-east. Driven by a passionate belief that great theatre can bring about social change, she co-founded Open Clasp in 1998. She has experienced working creatively with the most disenfranchised women and successfully works with communities to create risk-taking and exciting theatre, providing powerful stimulus for discussion and debate. She has been hailed as the 'female Lee Hall only better'. Catrina was awarded an MBE for services to disadvantaged women through theatre in 2017.

Mighty Heart: a Manchester-based feminist theatre company who create performance, events and community interventions. Through integrated outreach experiences, they promote and foster social action.

Don Milligan: Don was a rank-and-file trade unionist for many years, an active communist, and a veteran of the gay liberation movement. He is the author of *The Politics of Homosexuality* (Pluto, 1973); *Sex-Life: A Critical Commentary on the History of Sexuality* (Pluto, 1993); and is co-author with Michael Fitzpatrick of *The Truth About the Aids Panic* (Junius, 1987). Don writes the column 'Off The Cuff' and posts numerous articles on a wide range of topics on 'Reflections of a Renegade' at www.donmilligan.net .

Mica Nava: Mica was a founding member of the Women's Theatre Group and worked with the group from 1973–4. She subsequently became an academic and is now Emeritus Professor of Cultural Studies at the University of East London. Her books include *Changing Cultures: Feminism, Youth and Consumerism* (1992) and *Visceral Cosmopolitanism: Gender, Culture and the Normalisation of Difference* (2007). She is currently working on a memoir and a film script about race relations in 1950s London.

Lizzie Nunnery: Lizzie's first play, *Intemperance* (Liverpool Everyman 2007), was awarded 5 stars by *The Guardian* and shortlisted for the Meyer-Whitworth Award. She co-wrote *Unprotected* (Everyman/Traverse 2006), and was awarded the Amnesty International Award for Freedom of Expression. *The Swallowing Dark* (Liverpool Playhouse Studio/Theatre503 2011) was a finalist for the Susan Smith Blackburn Award, as was *Play With Songs, Narvik* (Box of Tricks Theatre, National Tour 2017) which won Best New Play at the UK Theatre Awards 2017. Other recent work includes *The Sum* (Everyman 2017) and *The Snow Dragons* (National Theatre 2017). Lizzie is a singer and songwriter, and has written extensively for BBC radio.

Julie Parker: Trained as an actress at Central School of Speech and Drama in 1970s; Fellow of the Royal Society of Arts; original member of First Gay Sweatshop Women's Company touring in the original production of *Any Woman Can* by Jill Posener. Company member of Action Space 1978–81. Set up and ran London's iconic Drill Hall Theatre from 1981–2011; leading producer and promoter of LGBT work in the UK and Internationally during this time; one of the founders of Stop Clause 28 arts lobby in the 1980s. She ran Outhouse

London with her long-time friend, co-producer and partner in crime, Mavis Seaman from 2011–18.

Sue Parrish: Sue is Artistic Director of Sphinx Theatre Company, where she has been since 1991. A founding member of the Conference of Women Theatre Directors and Administrators and of the Women's Playhouse Trust, Sue has remained involved in developing the feminist dialogue in theatre, producing a range of plays and theatre conferences, including ten years of the Glass Ceiling conferences from 1991, four Vamps, Vixens and Feminists conferences and two years of Women Centre Stage.

David Peimer: Born in South Africa, Professor Peimer was a Fulbright Scholar at Columbia University. His many publications include his last play in the book he edited: *Armed Response: Plays from South Africa*; editing the digital nook, *Theatre in the Camps, The Theatre of Images* (Columbia University). He has won numerous prestigious awards for play-writing and directing. He has directed theatre in South Africa, New York, the EU Parliament in Brussels, Pinter Centre (Goldsmiths) where he is Senior External Researcher, Prague Quadrennial, Global Shakespeare Congress, Vaclav Havel's Prague Theatre, Liverpool Slavery Museum, and others.

Mark Roberts: Mark is a Creative Writing graduate from Edge Hill University, Class of 2018. In 2017, he helped to found and lead Fox Hat Theatre Company whose first play *Hold Up* was a sold-out event. Writing both for theatre and the screen, his recent scripts include *Without Skies* and *Heiress of Sparta*, both of which deal with historical and political dynamics.

Lindsay Rodden: Lindsay is a writer and dramaturge, born in Scotland and brought up in Liverpool and Co. Donegal, Ireland. She currently lives in North Tyneside, following a year's writer-in-residency at Northumbria University and Live Theatre. She is a member of the Royal Court's Northern Writers' Group. Writing includes: *The Story Giant* (Liverpool Everyman, adapted from the book by Brian Patten); *Cartographers* (Theatre by the Lake); *A Modest Proposal* and *Sunday Morning, Dandelion Seeds* (women playwrights' collective Agent 160); *Man With Bicycle, '73* and *Writing in the Dark* (The Miniaturists); as well as numerous collaborations with musicians and other artists.

Julia Samuels: Co-Artistic Director of 20 Stories High (20SH). For 20SH, her work includes creating/directing *I Told My Mum I was Going on an R.E. Trip* (subsequently adapted for the BBC); creating/directing *Tales from the MP3;* directing *She's Leaving Home, Black* and *Headz* by Keith Saha, *Whole* by Philip Osment and Laurence Wilson's *Blackberry Trout Face*. 20SH Youth Theatre shows include: *Rain* (with 84 Theater, Tehran), *A Private Viewing, The Elasticated Sound System* and *Dark Star Rising*. Previous to her work with 20SH, Julia worked in the education departments of the National Theatre and Theatre Royal, Stratford East and has also worked as a freelancer for companies including North West Playwrights, RSC, Z-Arts and Theatre Centre.

May Sumbwanyambe: May is an Associate Lecturer at Edinburgh Napier University and a former recipient of the Headley Trust Scholarship at Guildhall

School of Music and Drama. As a playwright he has won several awards for his work, most recently the Alfred Fagon Audience Award for his critically acclaimed stage play *After Independence*, and BBC Pick of the Week for its subsequent adaptation for BBC Radio 4. He is currently writing new works for the National Theatre of Scotland, the BBC, Scottish Film Talent Network and Crab Apple Film Company. He also works as a Peer Reviewer for Creative Scotland.

Justine Themen: Associate Director at Belgrade Theatre and leads on Diversity, Artist Development and Community & Education. Her creative and strategic work was instrumental in the Belgrade receiving the UK Theatre Award for the Promotion of Diversity in 2016. Recent directing work includes *Rise* (2017) and *Red Snapper* (2016) which emerged from the theatre's acclaimed Critical Mass new writing programme for writers from BAME backgrounds. She is a fellow of the prestigious Clore Leadership programme. Before Coventry, Justine worked in Suriname as a theatre consultant, director and film-maker. Her documentary, *Abigail*, was selected for the Travelling Caribbean Showcase, a UNESCO heritage initiative.

Kim Wiltshire: Kim is a playwright and academic who specialises in issue-based theatre, especially issues around young people, gender and sexuality, through her company Laid Bare Theatre, with plays such as *Project XXX* and *The Value of Nothing*. She is Programme Leader for the Creative Writing course at Edge Hill University.

Jingan Young: Jingan is an award-winning playwright. She is currently reading for a PhD in Film Studies at King's College London. She was the first playwright commissioned and produced in the English language by the Hong Kong Arts Festival for *Filth* (Failed in London, Try Hong Kong). She was one of the first recipients of the Michael Grandage Futures Grant for play-writing and was a member of the BBC Writersroom invitation-only group *London Voices*. She is founder and artistic director of Pokfulam Road Productions and regularly commissions new writing from East Asian writers in the UK and China.

Index